The Pulpwood Queens Celebrate 20 Years!

It's all about the story!

Tom,

Susan Cushman, Editor

Introduction by Kathy L. Murphy

Foreword by Robert Hicks

Afterword by Jonathan Haupt

BROTHER MOCKINGBIRD · DIAMONDHEAD, MISSISSIPPI · 2019

Library of Congress Control Number: 2019944023

Cover Art by Nicole Seitz

For information please contact:
Brother Mockingbird, LLC
www.brothermockingbird.org
ISBN: 978-1-7330543-3-1
First Edition

In Memory of

Tiajuana Anderson Neel

1953–2019

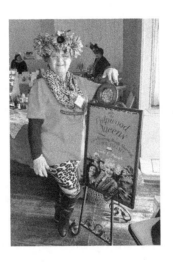

*The Pulpwood Queens made our mother blossom and be
her happy self.*

Love, Tiajuana's kids,

Cissy, Amanda, Michael, and Whitney

Tiajuana Anderson Neel came into my life through the love of books. I cannot remember the exact day, but once you met her, she was unforgettable from that moment forward. Back then, nearly twenty years ago, she had short, spiky hair the color of merlot. She

dressed completely in the Pulpwood Queen's signature attire: hot pink and leopard print. She had her name in gold and diamonds, her ever-present "Tiajuana" always around her neck. Her finger-nails, for lack of a better term—dragon lady—long and painted to perfection in colors, swirls, glitter, and gold. Don't judge a book by its cover. Read the book.

Tiajuana was the most generous woman I have known. She was a giver. She gave of her time and her inordinate amount of organizational skills to me and others. She was the full package, an extraordinary woman doing extraordinary things, all giftwrapped to us as a present—to always be present.

Yes, she was the Executive Director of The International Pulpwood Queen Book Club Reading Nation, but more impor-tantly she was my true-blue friend. Before I could ask, "How soon can you be here?" she was pulling into my driveway, and y'all, she lived a good forty minutes away. She got me through four surger-ies, a divorce, and my daddy dying, with never a complaint. And of course she got me through umpteen Girlfriend Weekends, han-dling a million details with smooth professionalism, humility, and contagious enthusiasm.

But here is the real deal: Tiajuana didn't do this just for me; she helped everybody. And she would leave me in the dust as her Lincoln peeled out of my driveway if her family called and needed her. They always came first, as it should be.

To explain my love of my very best friend in one page is impossible—it is almost as hard as saying goodbye, as I did to my

dear, dear friend at the hospital. I could write a *book* about Tiajuana.

What have I learned from all of this? That life is fleeting. Things can change very quickly, so as you are reading this, gather those loved ones. Tell them how much they mean to you. Hold hands and give big hugs.

She was not flawless. (She snored, but then so do I.) What truly matters is we did not focus on our imperfections. We laughed a lot, loud and hard. One look at Tiajuana and I knew exactly what she was thinking. She could make me spit my coffee across the car with just one remark. She kept me in line and in turn I tried to tell her every time we were together just how much she meant to me. She meant the world and I know that she knew exactly how I felt. We loved each other.

That's it, folks; it's down to one thing—big love that all began with the love of sharing a story. All the stories that we discussed in book club over the years and all the stories that we shared in our lives were our common bond. She will always be irreplaceable. Until we meet again, I will be singing her praises. Tiajuana Anderson Neel was my dearest friend.

Kathy L. Murphy

CONTENTS

FOREWORD

Driven by Passion

Robert Hicks

I was minding my own business one Sunday morning when my friend and fellow writer Marshall Chapman called me. She was on her way back from Kathy L. Murphy's Pulpwood Queens Girlfriend Weekend in Jefferson, Texas. If you are reading this collection you most likely have an advantage over me back then as I had no idea what Marshall was talking about. I didn't know who Kathy L. Murphy was, let alone who the Pulpwood Queens were or what Girlfriend Weekend was. Truth is, while I had heard of Jefferson, Texas, the rest of what Marshall said sounded like so much gibberish.

She was convinced that I needed to go that next year, despite me explaining to her that there must be some reason that it was called "Girlfriend Weekend." At one point in the conversation, with an air of frustration, Marshall said, "You just don't get it, do you?" And if truth be known, I didn't. Then.

Yet, if Marshall is anything, she for sure is persistent. Somehow, it was already set in the stars that I needed to go to Girlfriend Weekend and experience what Marshall was having a hard time explaining.

So that next January, with my publisher's blessing and

support, I was off to Pulpwood Queens Girlfriend Weekend. While I am known as a storyteller for what my dad used to call E. F. E.— Exaggeration for Emphasis—it is no exaggeration to say that my life was forever changed by Kathy, her Pulpwood Queens, and their Girlfriend Weekend.

You see, I am driven by my love of passion, in whatever I do and in the lives of others. It becomes clear within minutes of a phone call or that first meeting with Kathy that if you were to take passion out of her, there would be clothes on the ground.

Passion is what has driven Kathy as a mother, as a reader, as a hairstylist, as an artist, as a friend, and as the creator of the largest book club ever. I can't think of any individual who has ever been a better friend to those of us who scribble than Kathy. Okay, for truth in lending, maybe Bennett Cerf was, but he's been dead a long, long time.

Kathy is a writer's best cheerleader, and she has shared her passion for books over the years to her countless fellow book club members. Books and writers have been "made" by that driving passion.

I have an even deeper, personal connection with Kathy and her beloved friend, Tiajuana, who passed away in April. When I was sick, really sick, last year, they showed up at my hospital bed in Nashville. Kathy brought me one of her paintings and wanted to come back to nurse me back to health when I went home. Somehow I knew that there are many more authors out there that she would be willing to care for in this same selfless way.

So while I am not the type to enjoy costuming up, my time

over the years (yes, I've been back) at Girlfriend Weekend has been nothing less than inspiring. There you are, surrounded by a writer's greatest cheerleader and a hundred or more of her fellow book-clubbers telling you why they love your book. Not bad at all. Is there any wonder why Pat Conroy once stripped down to his boxers so he could sign his khakis and auction them off at Girlfriend Weekend?

So here you have it, a brilliant collection of writing by women and men who have loved Kathy and the wacky world she has given all of us. I owe Marshall Chapman BIG for inviting me into that world and I will forever love Kathy for all she has given me. Read on and enjoy. You are in for a real treat.

ACKNOWLEDGMENTS

The Pulpwood Queens are celebrating twenty years in 2020, but my experience with them started in 2010, the year that River Jordan took me as her guest to Girlfriend Weekend. I will be forever grateful to River for introducing me to Kathy Murphy and this wonderful organization of writers, readers, and others who love books. Who knew that eight years later I would return as an invited author and panelist, when Kathy named two of my books as PQ Book Club selections for 2018, and again in 2019 when she selected another of my books and invited me to return. Just a few weeks after I got home from GF Weekend 2019, Kathy contacted me with her ideas for this anthology and asked if I would be the editor. I will forever be grateful to Kathy for this opportunity!

Many thanks to Robert Hicks for the wonderful Foreword, which he wrote under duress as he was struggling with a difficult illness.

Jonathan Haupt, director of the Pat Conroy Literary Center, heard about the project and offered to help with editing—a daunting task for a volume with so many contributors! His keen eye for details made this a better book, and I'm sure that any errors that remain are my own and not his oversight. We are also fortunate to have his reflections in the Afterword for the book. Many thanks also to Susan Marquez for proof-reading.

Sixty-eight contributors—some of them *New York Times* best-selling authors—took time from their busy schedules to share their stories. Writing essays for this collection while balancing publishing deadlines and book tours, they selflessly added their talents and memories, sharing not only their love and respect for Kathy Murphy, but especially for the readers with whom they formed many lasting friendships.

Many of the contributors are Pulpwood Queens Book Club members—some of whom aren't "writers"—but they shared their memories, as did numerous people who are childhood friends, librarians, webmasters, publicists, interns, magazine editors, and others who have known Kathy personally or have been a vital part of the Pulpwood Queens organization. Most especially, of course, I am thankful to Kathy's dear friend and executive director of the Queens, Tiajuana Anderson Neel, whom we lost too soon on April 19, 2019, just a few weeks after she wrote her essay for this book. In her typical behind-the-scenes humble way, she helped me early on with recruiting contributors for the anthology.

Huge thanks to the gifted writer and artist Nicole Seitz who did the amazing art for the cover of the book! And just as we were getting started recruiting contributors, Melissa Carrigee of Brother Mockingbird Publishing approached Kathy and me with an offer to publish the anthology. Four best-selling Pulpwood Queens authors took time to read the essays and write wonderful blurbs to help promote the book: thanks so much to Lisa Wingate, Paula McLain, Jamie Ford, and Patti Callahan Henry! The word that keeps coming to my mind as I pen these Acknowledgments is *gen-*

erosity. All of the people involved with this wonderful project have given generously of their time and talents, and you are holding the results of their gifts in your hands right now. Enjoy!

Susan Cushman, Editor

INTRODUCTION

On January 18, 2000, I opened the only hair salon/bookstore in the country, Beauty and the Book. That previous October, I was downsized from my job as a book publisher's representative. I was devastated since that had been my dream job.

I loved traveling and calling on all my independent bookstores, college bookstores, museum and gift shops in four states—Oklahoma, Arkansas, Louisiana, and Texas. I got to travel to New York, Chicago, Atlanta, and Los Angeles for sales conferences. I was living a book lover's dream. You can read all about that story in the first chapter of my first book, *The Pulpwood Queens' Tiara Wearing, Book Sharing Guide to Life*, titled "If Life Hands You a Lemon, Make Margaritas."

I soon realized that was not the plan God had for me; He redirected me to another route on my journey. I enthusiastically forged ahead and opened my new dream job, Beauty and the Book.

Mere months after I opened my shop, I was invited by the local book club to come join their meeting. I believe they were discussing a book I had already read. I was so excited to be invited to join this club. We had a four-course luncheon prepared by the host in her incredibly beautiful southern plantation home. The conversation was lively, and I thought I was in my ultimate world. I was wrong.

At the end of the meeting the hostess served us cordials in the front parlor of her lovely home. I was charmed. As the conversation turned to one of a more personal nature, I blurted out in my typical Kansas upbringing way, "So what are we reading for next month?" There was a pause in all conversation as everyone looked to the hostess.

The petite hostess jumped up off the settee and grabbed me by the elbow to lead me determinedly out into the galley of her historic home.

"Kathy," she whispered and continued, "I am so sorry but I think you have misunderstood our invitation. We did not ask you to join our book club, as there can only be eight in our book club. That is all that will fit around our table. We just invited you as a guest, you see? Unless someone dies or moves away that is all that can be in our book club."

I was horrified and embarrassed. I had invited myself into an exclusive book club, one in which all of the members were already selected. I realized I had been invited as perhaps a curiosity, but still truly an outsider. I was from Kansas. I had once been asked at a social coffee given for me when I first moved to Jefferson by the good ladies of the community, "Where are you originally from, my dear?" and then when I answered, "Kansas," grasping their handkerchiefs to their chests, they exclaimed, "You mean you are a Yankee!" I started to laugh then I realized they were serious, and I muffled my guffaw into my napkin. They did not say this in a good way. My goodness, I immediately rushed out and signed up to take a course in Texas history as obviously I was undereducated

when it came to the history of East Texas. I can hardly remember studying the Civil War in school, let alone relying on my past studies with our high school coaches who taught us history. They were more likely to show us recent football game films than ever fill our heads with visions of the blue and gray battling it out in the War Between the States. It was my *The Help* moment, the book-to-film moment written by our Pulpwood Queen author Kathryn Stockett.

As I returned to the room no one in the exclusive book club would make eye contact with me. I quickly excused myself as I retorted, "Oh, look at the time, almost time to pick up my daughters from school." As I drove home in shock about the whole situation, I thought, who made up that rule that only eight people could be in a book club? I began to formulate a plan, not one of revenge but of action to empower other readers like the underdogs, the unaccepted people like me. I was reminded of the fraternity rush scene in the film *Animal House* where they put all the misfits in the side room. I was right there with them.

Once home I got out a notepad and pen and I had an epiphany. I would start my own book club, one that was inclusive not exclusive, one where the underdogs, the misfits, the real readers could join and not ever be beholden to these "unspoken rules." I wrote the Pulpwood Queens of East Texas "where TIARAS are mandatory and the ONLY rule is to read our good books!" We would be the "beauty within" queens as we were the antithesis of "beauty" queens. Our purpose would be to promote authors, books, literacy, reading, and help undiscovered authors get discovered in a big way. I would become the Pulpwood Queen, the

Champion of the Underdogs, those who were never invited to join the club. I also would work very hard at challenging long-held misconceived stereotypes, like all Kansans are Yankees.

This story did not make my first book because twenty years ago I did not have the courage to say anything to this book club, but I would now for sure. I have been empowered by the stories of the books we have read. They have not only saved me, they have given me my true voice.

That was twenty years ago, and nearly every one of those book club members has since joined my book club. Funny how that works, welcoming everyone. I took the high road; God told me to do so.

One thing I have learned in my life is that when something awful happens to you that you never saw coming—something that prevents you from pursing a dream—it was not meant to be. Something else would be put in your path, and for me it has been this amazing opportunity. I would never have started my Pulpwood Queens Book Club and I would never have met some of the best friends I have ever had in my life.

For our 20th anniversary of the Pulpwood Queens and our annual book club convention that we call Girlfriend Weekend here are the stories and poems that celebrate the power of sharing the written word and the power of building a community, our tribe of readers and writers. To read a book is one step towards understanding, to share it with others, more of the picture comes into light, but to bring the authors and readers together as I do brings the entire picture into true focus.

We are the only book club that involves all our authors in everything we do from teleconference, Skype, Facetime, and actual visits by the authors to various book clubs to having our official authors participate in person in all we do at our annual book club convention. We even have our authors wait our tables during the Author Dinner and take them with us on our literary tours, too!

I know now in my heart of hearts that God has had a big plan and mission for me. My life has been like a roller coaster, and I often think of the late great Buddy Holly song, "Everyday," which was one of my father's favorites:

> *Everyday it's a-gettin' closer*
> *Goin' faster than a rollercoaster*
> *Love like yours will surely come my way*
> *A-hey,a-hey-hey[1]*

I thank all who have joined me in this journey, the hundreds and hundreds of Pulpwood Queens and their leaders, the Timber Guys Book Club members, our beloved authors, my family, and all the magnificent supporters we have met along the way. We are making the world a better place one book, one reader, one chapter at a time to connect all of us with real conversations, sharing our authors' stories and our own. Life is all about the story and we are living it large. Nothing stands in our way.

One thing I know for true, my whole life has found purpose and meaning because of all of you. For as long as I walk this path on this planet Earth, I devote my God-given gifts and talents to promoting my authors, their books, literacy, and reading.

Tiara Wearing and Book Sharing,

Kathy L. Murphy

Founder of the Pulpwood Queens and Timber Guys Book Clubs and author of *The Pulpwood Queens' Tiara Wearing, Book Sharing Guide to Life* (2008) and *The Pulpwood Queen Goes Back to School* (2020), the continuing story of being a life-long learner and reader

1. (Buddy Holly, Everyday Lyrics, Metro Lyrics)

THE ESSAYS

The Glamour of the Writing life

Christa Allan

Writing is such a glamorous calling.

I roll out of bed, stumble to the kitchen with my bed hair pointing like road signs at a country intersection. I pop in a pod for my coffee and while I wait, I wonder why the dishes didn't gather in the dishwasher by themselves last night. I grab my mug from the Keurig and find my laptop on the kitchen table—because my desk is so covered with papers and books I can barely see the top of it. I open to my manuscript and stare at the screen and wait for my muse to appear. She's apparently getting a massage some-where because she's not around. An hour later, the doorbell rings. I realize I still haven't brushed my teeth, and I'm still braless in my jammies. And my top is inside out.

The doorbell alerts our ten-pound beast that his securi-ty watch has started. Then my husband wakes up. And for hours, I'm surrounded by the beast barking at the sky or the ground or the flap of butterfly wings. The husband is watching something on television that requires massive bombing, high-speed car crashes, and high-pitched screaming.

And I write, and I write, and I write, and I write.

But here's the thing.

I know that all this is totally worth it because the third

week of every January I'll be making my way to another Pulpwood Queens Girlfriend Weekend.

I heard about Kathy L. Murphy before I ever attended a Girlfriend Weekend. Trying to get a book in her hands was like a holy pilgrimage. The journey might be long, but the payoff of meeting Kathy and of her selecting my book made it all worthwhile.

Seven years ago, I attended the Southern Festival of Books in Nashville and roomed with Kellie Gilbert, a sweet writer friend. At the end of one of the panels, we bumped into Kathy and Tiajuana Neel, her fearless sidekick and future executive director of the Pulpwood Queens. We talked and talked until the wee hours of the morning. And I understood why Kathy is a rock star in the world of authors and readers.

Kathy is relentless in the best of ways. She is determined to create a culture of literacy, and her book clubs have to share that commitment as well. She adores writers and readers, and her respect for them is boundless. Kathy incites energy and excitement, and she has created a safe place where authors can dress like Dr. Seuss characters and book clubs can assemble as a group of beauty school dropouts for the Great Big Ball of Hair Ball.

In the six years that I've attended Girlfriend Weekend, I've come to know authors I never would have expected to meet, much less be able to share meals with, learn from, be encouraged by, and welcome as friends. A few years ago, Caroline Leavitt—an author I've had a girl crush on for years, bought and read every book she wrote and would've read her grocery list if she published it—was an invited author. I was verklempt! And because of that weekend,

she and I still keep in touch with one another.

I've met readers that have become my friends, and who reach out to invite me to their book clubs and check in just to make sure I've not fallen into writer disrepair trying to finish a book.

Now I write a book a year just to be invited back to Girlfriend Weekend again and again.

That's the glamour!

It Is Always about Story
Johnnie Bernhard

Under a cloudy January sky, the little car hugged ribbons of concrete as it moved through the backwater towns of the Mississippi Delta. Shotgun shacks, strip malls, and abandoned cars planted in red dirt flashed through the windshield. As if my travelling companion could read my mind, she breaks the silence between us. "Community comes in many different forms."

I nod at Melissa, while listening to the faint heartbeat of the South's small towns. Interstate 49 weaves through them, and I think of all the stories held in those little houses, schools, and churches, along the side of the road. Generational stories of exhausted mothers and frustrated daughters, homecoming queens with forever sixteen smiles, and those girls, the girls every town knows, who launched themselves somewhere else, inventing a better self with each new zip code. These towns hold stories of men who never got out, and those who did and never came back.

It is always about story.

The faded gentility of the Deep South rests in the economic development of the historic downtown, a few city blocks of a lipstick and rouge facade. We are lost in Alexandria as we search for a place to eat. Beyond the historic district corridor are payday loan stores and dollar stores, far cries from yesteryear's small-town

bank and five and dime. Every gas station is anchored to a fast food restaurant and convenience store advertising boiled peanuts and pickled quail eggs. We buy food here. Road food is like bar food, it all tastes the same. The middle-aged redhead behind the register has a voice like unfiltered Camels and Jack Daniels. *Tell me your story. The story of a little girl and all the in-between.*

It is always about story.

There's a woman in East Texas giving mouth-to-mouth resuscitation to a small southern town by inviting readers and authors across America to join her in celebrating literacy. I've never been to Jefferson, although as a native Texan I have scoured that massive landscape in search of stories and family I refused to let slip away.

Some authors made three connecting flights, rented a car, and drove over an hour to get there. Melissa and I follow the backroads of the South, seven hours in a small SUV, the hum of wheels on asphalt beneath us, while in our ears we hear the whispers of stories as we pass each town, cross each river, drink more coffee.

It's somewhat of a larger than life suggestion to ask people to come here, in the middle of nowhere. The median, the norm would be to plan a literary event in New Orleans, Atlanta, or Dallas, but she's not average. She's Kathy L. Murphy, the Pulpwood Queen. She wears a tiara and alternates between a cowboy hat and a coonskin cap with a leopard print cape. Her memoir, *The Pulpwood Queens' Tiara Wearing, Book Sharing Guide to Life,* is a testimony to surviving eccentric parents by the saving grace of a library card and the Holy Spirit. That bare bone truth, stripped of

pretentiousness, speaks to the core. I am drawn to it, like every reader and writer joining me for the weekend. In the center, the heart of that core is the late Pat Conroy, whose words serve as a healing salve to the heartbroken left in the wake of a turbulent childhood.

It is always about story.

As we near our destination, peer pressure growls within. How can I wear the mandatory tiara while giving reference to the weekend's theme, How the West Was Won, with a cowboy hat? I visualize the tiara pushed into the crown of the cowboy hat as we cross the state line, entering Texas. It's the official start of the Pulpwood Queen Girlfriend Weekend.

Our revival tent for the weekend is the City of Jefferson Convention and Visitors Center. True to its spiritual allusion, its 9,000 square feet will envelope tears, laughter, and testimony for three days, two nights of reunion and unification. Social media acquaintances greet each other in living, breathing reality. Readers meet their favorite author while being served a plate of barbeque. And then there's all that talk about love. Lost love. Unrequited love. Broken love. Parent love. Great love. Pat Conroy's memory lives in every author who sits at the modest stage, stripped bare of self-consciousness, telling her story, and the story of her protagonists in every story written alone, bent at a keyboard, possessed by an image or something she once heard.

It is always about story.

There are many stories and authors, all exceptional in different ways. For some, it is a rich sense of place only the writers of

the South can perfect. Other authors create exquisite words within the narrative, like the peeling of a perfectly ripe apple, stripping away slowly, cautiously a truth we knew was there, but were too afraid to voice. Lisa Wingate and Tim Conroy resonated both qualities.

Lisa Wingate has written thirty novels. Her latest, *Before We Were Yours* is a long-term New York Times Bestseller, having remained on the list over one year, with more than 1.4 million copies sold. From a small town in Texas, she is genuine. An authentic storyteller, she begins her keynote with the story of her grandmother, a complicated woman, not necessarily lovable. We all listen, visualizing the grandmother, following the cadence of the author's words as she reveals the story of a girl from the wrong side of the tracks eventually rescued by an older man. Oh, the cruelty of small-town gossip, and the little girl heart that never quite mends inside the old woman's body. Generational. Grandmother, mother, daughter, until the day the storyteller understands that passage of time and the broken heart of her grandmother.

It is late Saturday afternoon and a cold front has pushed itself to the revival tent with chilling rain and a somber mood. The conference room is darkened as Tim Conroy, along with his fellow Pat Conroy protégés from *Our Prince of Scribes*, narrates his family's story, as black and white photos stream of five boys, two girls, a mother, and a father–a family exposed to strangers in its aching beauty and sorrow. Generational. Among those pictures stands Pat Conroy, sometimes alone, with classmates or with mentors, as he begins his career, and the crushed spirit of a boy is resurrected

by the written word.

It is always about story.

Tim Conroy reads his own poetry. He is unflinchingly brave, void of self-pity or self-promotion, despite living in the shadow of his gifted and reverent brother. So achingly true is his delivery of words I cannot help but cry, often laughing at the same time. I'm feasting on every morsel of beautiful words I receive without embarrassment, because Monday will arrive along with the famine of routine. It's a place where poets and storytellers are only characters you read about in a book.

The conference breaks until the evening event. I join Melissa for dinner in downtown Jefferson. Before we order, we talk about generational stories and the ordinary people who must make extraordinary decisions.

"I've got to write my mother's story, but I don't know how to begin."

Before I can respond, her cell phone rings. She digs in her purse and it surfaces. I can hear the voice of the other end. It is loud, clinical in its delivery. "Your mother died this afternoon."

She stands up. The jolt of her sudden movement causes the glasses of water on the table to spill over. I grab a wad of paper napkins from the dispenser on the table, pushing the water off the table onto the floor.

"What? What are you saying?"

She runs toward the front door of the restaurant, screaming into the phone. I follow her until she puts her hand up to stop me. I question whether I should honor that, as I return to the table,

anxiously watching her from the large plate glass window of the restaurant.

She comes in and apologizes to me, then grabs her purse from the wet table, explaining that she'll drive me back to the conference.

"I'm not going, Melissa. Let's go back to the room. You can take a shower. I'll make you some tea."

"I feel bad if you don't go. Let me take you."

"No. Let's rest tonight. Tomorrow will be a hard day for you."

She's in shock. By evening, she sits in the living room of the house we rented for the weekend. She is a little girl with wet hair, wearing pajamas and cradling a pillow in her lap. She has called her husband and siblings. The last call she makes is the most difficult. It is to her son, a young soldier far away from home. I hear her say, over and over, "It's okay. Don't cry, honey. It will be okay."

Sunday morning is cold and damp. We begin driving south, across the Mississippi River, to the flat coastal plains of the Gulf of Mexico. We stop at a combination gas station and barbeque joint. Melissa orders fried okra to go. The paper boat of fried cornmeal-coated vegetable rests between the two bucket seats. She smiles at me, "Happy food."

She begins to talk. She talks about her mother, father, siblings, husband, and children. I suddenly hear her say she wanted more love from her mother, just as her mother wanted more love from her mother, the woman who abandoned her as an infant.

"It's not like that with my children. I am the period to that

sentence written by my mother and grandmother."

I touch her shoulder, then stare out of the passenger window, realizing there never is enough love in this life. It never overflows or fills the brim, satisfying our broken hearts and spirits. This is why there are poets and storytellers. They reassure us we are not alone. Their exploration of the human condition unites us as humans. It is what Pat Conroy called Great Love, and it is what held writers and readers for a weekend in a small town in East Texas.

It is always about story.

There's Something about Those Pineywoods

Tamra Bolton

Growing up in the Pineywoods of East Texas, I was surrounded by the lumber industry and its peculiar vernacular. So when I heard about a club of gals calling themselves something woodsy like "The Pulpwood Queens," I had to know more.

The idea that timber royalty lived in my neck of the woods intrigued me. I might never have known about them except a fellow writer from Georgia told me about Kathy L. Murphy, the "head queen." She said, "You've got to meet this gal. She is amazing!"

After a call to the editor of a local magazine to see if he would be interested in a story, I contacted Kathy to ask for an interview. The bubbly voice on the phone enthusiastically invited me for a visit.

The hour and a half drive passed quickly and soon I pulled up to a small cottage tucked against a wooded hillside. An appropriate setting for one who called herself a Pulpwood Queen, I thought as I got out and walked up the stone path.

Kathy met me at the door with her signature smile and swept me into her world with a flourish of her wrist. Immediately, I was surrounded by vibrant color and a myriad of whimsical toys, games, and shelves of—what else—books.

While Kathy made a pot of coffee, I carried the antique tray with our cups to a low-slung table next to her overstuffed couch. Settling into our seats amidst the brightly patterned pillows, we sipped our steaming cups as Kathy told me her fascinating life story. How she went from hairdresser to book publisher representative to hairdresser again. About her marriage and divorce, the loves of her life, her two girls—Madeleine and Lainie—and how she started Beauty and the Book, a combination beauty shop and bookstore.

Curious as to how the book club played into all this, I asked Kathy where the idea came from. She gave me a sideways glance and cocked an eyebrow. "Well..." she drawled, "I tried joining a local book club, but that didn't work out too well." She laughed. "So, I decided to start my own, and that was the beginning of the Pulpwood Queens Book Club."

Wondering why she chose that name, I didn't have to wait long for an answer, as Kathy continued. "Living in East Texas surrounded by pine trees and the timber business, the name seemed like a perfect fit." Kathy smiled and I agreed.

We talked like old friends for several hours and discovered we had much in common, including a fierce love of books. As we chatted, I noticed an item on her mantle that piqued my curiosity. When I asked her about it, Kathy smiled a wistful sort of grin and went over to the mantle, picking up the clear bottle. "This has dirt in it from my grandparents' farm in Kansas. I loved that place and I like having a little part of it with me. My grandparents influenced me a great deal and I am thankful I had them in my life." That's

when I knew Kathy and I were definitely kindred spirits. Any gal that felt that sentimental about her past and cared enough about a place that she wanted to carry a bit of it with her had to be alright. I feel the same way about my grandparents' place and our family farm. I decided that Kathy and I are just plain ole country girls at heart.

Before I left Kathy's that spring afternoon, we had become fast friends. Since that day, I have been able to attend several Pulpwood Queens Girlfriend Weekends and had more fun than the law should allow. Not only have I been blessed to have Kathy as a friend, but I've also met several people that have become dear friends too.

One year, I came to the Great Big Ball of Hair Ball as the White Witch from C.S. Lewis' *The Chronicles of Narnia* and won the title of the Great Big Ball of Hair Ball Queen. I even had the silver tray with mounds of *Turkish delight* to tempt the other costumed party goers. It was the most fun I've ever had dressing up!

The best thing about the Pulpwood Queens and about Kathy is they all treat you like instant friends. Kathy has the uncanny ability to make everyone feel as though they are royalty. She is a down-to-earth gal with an indomitable spirit and a heart of gold.

One of the best adventures I've had since Kathy and I met was in March of 2016. There was record flooding that month across the state and in the midst of the deluge, I got a call from Kathy.

"Tamra!" Kathy gushed. "There is this wacky rock festival I

want to go to this weekend. Can you go with me?" I had no idea if the rain would stop long enough for us to get anywhere, much less see a festival, but when Kathy says "Let's go!" you go, and hang on because you know it's going to be a wild ride.

I had never heard of rock-stacking and an Earth Art festival sounded like a throwback from my hippie days, but I was all in.

We left on Friday morning at about 5:40 a.m., in the rain, and got to Llano, just northwest of Austin, around noon. Since we didn't check in to our B&B for a few hours, we spent the afternoon exploring the downtown and looking over the festival site.

While we were down by the Llano River, raging from the recent floods, we met a kid from Arkansas who is a professional rock-stacker. Kathy and I learned a lot about this unusual art form and enjoyed trying out a little rock-stacking of our own. It started raining again, so we went to check into the B&B. We thought it was lovely until our silver-coiffed hostess informed us that breakfast would be served promptly at 9:00 a.m. Kathy and I looked at each other in horror—we instantly calculated that was four hours without coffee—totally unacceptable. Thank goodness, we saw a coffee service area in an alcove close to our room. We would be OK.

The next morning, we were up at 5:00 a.m., drinking coffee and getting ready for the day, when we decided to go to the local watering hole, Fuel's Coffee Shop, downtown and kill some time until breakfast. (We were both thinking, *this had better be an amazing breakfast to make us wait this long!*) When we got to the coffee shop, we had good coffee and a great time talking to a guy

from California who makes a living stacking rocks (who knew?), an artist who lives and travels in a retro-fitted school bus, the Llano mayor, and a city councilman. This is where we also ran into a funny looking little guy who was wearing a cap with foam 'rocks' stacked on it. Kathy and I thought the hat was clever and we asked if we could take his picture, not knowing that was a mistake we would come to regret. Kathy and I racked our brains to try and think of who he reminded us of. We decided he was a cross between crazy Uncle Albert from *Mary Poppins* and the Mad Hatter from *Alice in Wonderland*.

Reluctantly, we left the locals, visiting rock stackers, and artists downtown and went back for our long-awaited breakfast. We had edible hibiscus on our fruit compote and some lovely orange cranberry muffins, but nothing we could really sink our teeth into. Kathy declared it "a little uppity, nice, but too fancy." I agreed when I became hungry less than an hour later. We packed quickly and headed back down to the festival area since we only had about four hours before we had to head home. We visited every booth we could, talked to the artists, and took dozens of pictures. It finally stopped raining about noon and we decided to enter the only competition that was taking place before we left—the rock-stacking for height.

We could bring five rocks to the judging area, but we had to pick out the others from a large collection of rocks surrounding the judging ring. We had two minutes to choose and stack as many rocks as we could. I ended up stacking the most rocks, fourteen, but two other competitors stood one or two of their rocks on end,

giving them extra points to win. I ended up in third place. The guy from California we had met earlier and the kid from Arkansas won first and second. Kathy was so excited; she couldn't believe I had placed against two professionals. Neither could I! Guess it wasn't bad considering I had less than an hour of rock-stacking experience. We both got a laugh out of that.

We also built some artsy stuff just for fun. Kathy made a gorgeous rock tiara and I built a small heart and arrow. We were having a blast! Apparently, we looked like we were having a little too much fun because the crazy foam-hatted rock guy from that morning spied us and decided to attach himself to our merry company, much to our chagrin.

He kept photo-bombing Kathy every time I tried to take her picture, and then he sat down beside me when Kathy was taking my picture and leaned over towards me. Kathy's eyebrows shot to the sky. I leaned the opposite way and said, "Hey! Personal space!" He looked surprised but he didn't leave. We finally managed to shake him when we went to get something to drink and take our picture with the Flintstones car.

It was a whirlwind trip but one to remember. We decided we had to go back, but this time we would beware the 'Foam Hatted Rock Guy'!

I will be forever grateful to have met Kathy and become one of the Pulpwood Queens. *Long live the Queen and long live our love of books!*

The Door, Colored Strings and Duct Tape

Lea Anne Brandon

"I could just sit here for an hour or two and then go home. John would never know...."

Sinking down just a little deeper behind the steering wheel, I stared at the fingerprint-smudged glass door of the Lemuria Bookstore's DotCom building. I unsuccessfully willed it to vanish. I watched two old friends—shortly followed by three women I didn't know wearing dime store tiaras—hurry inside the independent bookstore's meeting room, each one loaded down in varying degrees with oversized purses, books, and wine bottles tucked under their arms, while balancing various containers of appetizers, bags of chips, and boxes of crackers. The glass door opened and closed. Opened and closed. Each time, laughter leaked out.

For me to walk through that door, on this early spring evening, should have been no big deal. It was just a silly little book club meeting, after all. The BB Queens of Jackson, Mississippi. The Booze and Books Queens chapter of the Pulpwood Queens International Book Club. I'd been invited by one of those two old friends who were now inside. I could hear them already having fun. Odd. I'd almost forgotten what happiness sounded like.

"Come and join us," my friend had said. "You'll enjoy yourself. We laugh. A lot. Wise women, great books, and really good

wine."

It should have been a no-brainer. I loved to read. I used to write, and was pretty good at it. But for me to walk through that door and into an unfamiliar world of girlfriends and conversation and giggles was definitely a big deal. For me. That night. A really big deal.

For the past five years, I had barely gone anywhere by myself. Or, rarely done anything just *for* myself simply because I wanted to. The *me* that used to be had virtually disappeared. Vanished into a depressed and emotionally depleted mire of ceaseless physical and emotional caregiving for my mother. She had suffered a stroke, which led to advanced dementia before recently dying from an arterial aneurysm. At its very best, our co-dependent mother-daughter relationship had been warped and unhealthy, but her precipitous slide into senility had not been gentle. After the stroke, she didn't soften into a passive patient during her recovery. Instead, she had become even meaner than ever before, angrier, more vindictive, controlling, demanding and vengeful—and I was the singular focus of her fury and vitriol.

As a result, I froze. Shut down. Withdrew from my life. I had become a hermit for all practical purposes. Cut my connections to people and places and things I loved the most. Disappointed a lot of people, including myself. But, despite my best efforts to keep my immediate family's life unscathed by my mother's trauma, I essentially missed out on most of my only son's senior year in high school, and now he was gone. Thoroughly happy on a beautiful college campus. Bless him.

My marriage was shredding from the pain as well. John had suffered in silence, for the most part, until he simply couldn't take it anymore. He'd finally put his foot down on my mother's worsening abuse and my apparent inability to stand up for myself. "Get it together. You're killing yourself. You are exhausted and we can't keep this up," he pronounced. Thankfully. John had been my rock, my anchor, my sole strength through the entire emotionally devastating experience with my mother. But once he made this declaration, I finally saw—all too plainly and way too vividly to ignore—that he was hurting too and that he couldn't take seeing me so broken. Defeated.

Not any longer.

So, I decided to try. For his sake, if not my own. And this night out, this book club adventure, was my first step to reclaiming myself. Albeit a baby's step.

"Let's do this," I declared out loud to myself, after just a few more minutes of cowering self-doubt. I opened the car door. My left foot hit the pavement and my right hand picked up the platter of pimento cheese and celery sticks. I donned the pink-jeweled plastic tiara I'd just bought for $4.95 at Walgreens and locked the car behind me. Straight ahead to the door.

"Yay! You came!"

Well, yes. Yes, I did.

It was the kind of day when even the lost believed. When possibilities were larger than reason, when potential was grander than circumstance, when the long, dark days of doubt were suddenly cast off and laid to rest. Brushed away with a smile and certainty. And in this moment, from this place, you knew the real magic could happen.

River Jordan's novel *Saints in Limbo* probably wasn't the first book we read and discussed after I joined the BB Queens book club, but it was most definitely the first volume to grab me by the gut with its opening prologue and pull me into the storyline never to emerge the same. A southern gothic tale-telling of Velma True. Aside from the magical and mesmerizing weaving of River's wordsmithing, it was Velma's spiderweb of strings that drew me in and held me there. The intricate splay of colored threads Velma had tied to her front porch and stretched out as a fragile but oh-so-comforting lifeline to distant and not-so-distant destination points in her world. As long as she was tethered to the familiar— her porch—Velma could venture forth. Step by step by cautious step.

As could I.

My faithful pilgrimage to book club at 5:30 p.m. on the third Monday of each month was the beginning of a tedious process to remember who I used to be and recall what I once enjoyed doing. It was my beginning—my first colored string reaching out into the big, noisy, people-filled world I formerly inhabited. Gathered around our meeting table, sipping wine and sharing our in-

sights into what we thought about the books we had read, I and many others in our group of diverse and divergent women found our true voices. Individually, we had little in common to the whole, but from month to month we became connected and woven together with our love of beautiful words, exquisite storylines and well-crafted sentences. It didn't matter to anyone in this group of women of various ages how much money we had deposited into our savings accounts or how grandly decorated our entryway foyers were.

We were readers alike. And we became friends.

This book-loving sisterhood slowly warmed my soul. Rekindled my passion for story. My knees grew less wobbly. My voice became clearer. Louder. It dared to utter an opinion. Amazingly, I found the fortitude to disagree with another's conclusion. Without any resulting malice or crippling ramification. Just the beautiful rush of intelligent banter.

I was becoming real again. I slowly began to daydream of possibilities of things I might be able to pursue again or words I might, somehow, once again put onto paper. And, even more slowly, I began to forget, bit by hideous bit, the long dark days that had almost consumed me. Like Velma, I was venturing forth in my own time and at my own pace.

The fateful midsummer evening River Jordan traveled from Nashville to visit our little book club and read delicious excerpts from her newly minted *Saints* became an unexpected watershed in my redemption story.

Velma ... was taking it as it came—one day at a time. She knew what she could and could not do. It was as simple as that.

River's melodic baritone voice showered over me and I was baptized a born-again believer. It was all I could do not to cry. Something inside of me cracked just a little and light began pouring in. Those were the sentences I could write. Pictures I could paint. A story I could tell.

If only I would dare. If only I could accept the grace and the gift and the calling. Maybe. Maybe one day. Maybe one day I would write again.

Almost a decade older and grayer and a bit thicker through our middles than we were when we first came together as a fledgling book club, the more-matured BB Queens recently gathered around our once-a-month meeting table as we always did. This night, half of us were soaked to the bone by an early wintertime monsoon, which had turned our umbrellas inside out and drowned our streets into one giant, icy lake. The rest of us had come early for happy hour, completely missed out on the storm, and had declared liquid to be a favored state of matter.

I was among the former. Squishing into the meeting a half-hour late sans tiara and Kindle. I'd left both in the car and wasn't about to dodge the deluge and lightning to retrieve either one.

"I need a glass of Pinot Noir. Please."

Discussion, that night, wasn't glowing. Praise and super-latives were rare. Of those who had finished reading the selection for the month, most were not thrilled with either the plot or the character development. We quickly concluded our official busi-ness—doubtful that we would read the next book by the same au-thor—and moved on to more enjoyable things. Namely, the food and drink before us, and casual conversation about each other's lives, what had recently transpired and what might be yet to come.

Highlighting our to-do plans was the upcoming Girlfriend Weekend. Our book club's annual adventure is a rowdy, writ-er-centric three or four January days in Texas. Who was going? Who wasn't? And, why not?

While talk droned on about making cow costumes and who wanted to dress up like saloon girls and who didn't, my mind slipped away. I looked into each of the faces around the table that night and, quite curiously, found myself almost at the brink of tears. I had come so far with these women by my side and we had all weathered so much together. We were truly the walking wounded in leopard print and hot pink boas, each figuratively pieced together with rolls of Duct tape, bottles of wine and bush-els of sisterly love. Through our books, we had traveled around the world and back, fallen in and out of love at least twice with Ernest Hemingway, joined the French resistance, visited a WWII Japanese internment camp, become enraptured by both an old mother cow and obsessed over a quirky hermit who played a taped-up gui-tar and sang like Elvis. We had danced together in the moonlight, prayed for strangers, solved a mysterious murder or two, planted

a perennial garden that restored a dysfunctional southern family and floated a shanty down the muddy Mississippi with castaway orphans, and drifted the romantic Seine with a hopelessly lovesick bookseller.

But as I observed the faces in front of me—going woman-by-wonderful-woman around the table that night—I also recalled the shadows and valleys that we had journeyed through together. Not transported through the darkness by the written word, unfortunately, but as characters in our own real-world, flesh-and-blood life stories. A husband who died too soon from a massive heart attack. A daughter who passed away after a long, heart-wrenching battle with cancer. One founding member had been hit by a car the previous week and was bruised, bandaged and drugged. At least two marriages were history, both because of stinking, rotten, cheating spouses. One girlfriend had just had heart surgery. Another was now on oxygen full-time. There had been a stroke that almost claimed one husband and another that had. One of our newest members had recently been told her husband had only weeks to live. Lung cancer, dammit. Two of us had lost jobs out of the blue, and were scrambling to find a new venture to hold us until retirement. And my sweet John had survived several health scares of his own but thankfully was still closer by my side than ever.

Each one of us at the table was battered and bruised, but without exception, we were all stronger than we were way back when we first started out together as barely connected strangers. Tough broads, some might say. Mighty warriors. Persevering souls.

Over the years, when a crisis would hit any of the Queens, the clarion sounded. We gathered around the wounded and held her tightly together until she could move and breathe on her own. We baked cakes and fixed casseroles. Arranged flowers and cleaned up each other's kitchens. We bought and brought wine. We hosted wakes and sat up long nights at the hospital. We took turns carefully gluing each other back together again and taping up the weak spots when we cracked and broke. We had laughed. And cried. We celebrated and we sniped at each other too.

We were writing our stories.

Together, we had turned the pages. And we weren't done yet.

A New Comfort Zone

Missy Buchanan

As I stood at the lectern to give a keynote message in a room filled with bestselling authors and avid readers, I wondered how in the world I had strayed so far from my comfort zone. My typical audience is an older demographic of silver-haired folks who use canes or push walkers and talk more about hip replacements than Amazon book reviews. Now here I was in historic Jefferson, Texas, gazing out at a sea of strangers wearing leopard print and tiaras. Their expectations were palpable, and I was nervous.

A few weeks before, I had tried to convince the Queen herself, Kathy L. Murphy, that I didn't fit the standard mold of a Pulpwood Queen author. I don't write novels. I am a nonfiction author who typically pens thoughts about life in a senior living community. I am never awakened at night thinking about plot twists or character development. For heaven's sake, I don't even have a literary agent. Now on my ninth book, I realize I was lucky to have found my publishing niche as an author-speaker who encourages older adults to age faithfully.

But having known Queen Kathy for at least a decade, I should have remembered her innate ability to lovingly wrangle folks into doing things they thought improbable, if not impossible. So on that cold January day in 2013, I stood at the microphone on

the Pulpwood Queen stage and whispered a silent prayer for an understanding audience.

I don't remember much about that keynote speech except that I shared the back stories of writing *My Story, My Song*, the memoir of Lucimarian Roberts, the elderly mother of Robin Roberts of ABC's "Good Morning America." I explained how the 80-something Mrs. Roberts had contacted me at home to ask how I knew what was going on in her mind when I wrote my first book, *Living with Purpose in a Worn-Out Body*. It was because of that first book that Lucimarian and I became dear friends, which then led to me writing her life story. In that keynote message, I talked about the responsibility I felt to capture Lucimarian's voice, especially as it related to her personal stories of racial injustice and what it was like to be the wife of a Tuskegee Airman whose military career prompted their family of five to move over twenty-five times.

I knew I had somehow struck an emotional chord when I caught a glimpse of some of the Pulpwood Queens brushing away tears as I told them the story of Lucimarian's funeral only four months after the book's big launch event in Pass Christian, Mississippi. And I remember being overwhelmed when they rose from their chairs and applauded as I left the stage.

Before the weekend was over, I had done a litany of other improbable things. I donned a black-feather fascinator and draped my mother's old mink coat over a vintage dressing gown and strutted a makeshift fashion show runway with newly made author friends. I shared laughter and ate a cornbread sandwich with members of a Pulpwood Queen book club at a local café during a

lunch break. On the night of the Great Big Ball of Hair Ball, I spent a half hour putting on the hoop underskirt and billowing brocade skirt and blouse before fastening rows of buttons on the jacket of my rented Gilded Age costume. By the time Sunday morning came, I was exhausted yet quietly energized as I sat alongside Kathy and other Pulpwood Queens at the worship service in Jefferson's picturesque Methodist church.

On the three-hour drive back to my hometown that Sunday afternoon, I turned up the radio and let the memories of the weekend scroll through my mind like a slide show. I couldn't help but laugh out loud at the thought of trying to describe Girlfriend Weekend to someone who had never been. How do you explain such things after all? Now these many years later, I'm still not sure how to explain Girlfriend Weekend except to say, "Come. Get out of your comfort zone and experience an event that brings young and old, conservatives and liberals, urbanites and country folks together and transforms strangers into soul mates."

Where Stories and Storytellers Flourish

Julie Cantrell

Imagine a magical place that's a little bit Mardi Gras, a little bit Oz, and a little bit Willy Wonka. Now plunk it in the middle of a small town in rural Texas, where people say *Good morning, y'all* and laid-back locals gather for breakfast at one of the adorably vintage diners where they greet the cook by her first name as she serves up heaping plates of buttered grits, salsa-topped eggs, and homemade biscuits the size of cat heads. Now add a flamboyant queen, a court of literary powerhouses, and a jester or two for good measure. Sprinkle in a generous dose of laughter, hugs, Wild West barbecue, sweet tea, and a charitable fundraiser. With that, you might have a sense of what happens at Girlfriend Weekend. But you'd still be wise to experience it for yourself because it's quite like the Grand Canyon or Machu Picchu or the seven wonders of the world. It can't really be captured by photographs or essays or even the best-told legends. Like anything worth its weight around the campfire, Pulpwood Queens Girlfriend Weekend is as Texas as it gets, with the kind of enchanted spin that only Kathy L. Murphy could master.

My first entrance into the world of the Pulpwood Queens came just after the release of my debut novel, *Into the Free*. I was green as green could be, and I had no idea what I was about to

walk into when I drove from my home in Oxford, Mississippi, to the beautiful river country of northeast Texas. There, past the dirt roads and cattle ranches where longhorn steers stared menacingly from the fence lines, I found Kathy and her delightful partner-in-crime, Tiajuana Neel.

These two women made a beautiful first impression, welcoming me into their tribe with genuine warmth and enthusiasm. I was captivated by their energy, which seemed never to deplete, as well as their charisma, which shone through in Kathy's outrageously colorful outfits and Tiajuana's rhinestone-studded fingernails. Their artistic hairstyles also made their mark on this girl who had surrendered all control to my own unruly curls decades earlier and whose beauty regimen had long been *rise and shine and don't stop to look in the mirror.*

It was clear. These women knew not to take life too seriously and seemed to understand that anything can become delightful with the right mindset—even getting dressed each morning. But most of all, I was impressed by Kathy and Tiajuana's authenticity. There was nothing superficial about them, and I knew right then they were my kind of people. Happy. Joyful. Grateful. And we seemed to hold a shared belief in "the more the merrier."

If ever there was an inclusive group of people, the Pulpwood Queens was it. And because I had never wanted to join a group that excluded anybody, I felt instantly at home with Kathy's tribe. As the weekend progressed, I met hundreds of readers who were passionate about all things literary. Many of them were literacy advocates like me, volunteering in their own communities to

help people of all ages and skill levels learn to read. Others were writers who may or may not have had desires to share their own work someday. And others were there just for the party, because as I would soon learn, nobody throws a better party than Kathy!

I also met many talented authors that weekend and while I respected them greatly, I have never been the kind of person to be awestruck by fame or fortune. I knew my own "bestseller" status had meant nothing more than I had been granted a stroke of good luck. I was still the same humble farm girl who had taken up writing as a way to work from home and spend more time with my children. Motherhood. Marriage. Family. Farming. Faith. Those were the things that had always taken priority in my life, so I had never entered the realm of writing with hopes of becoming famous or rich or revered. In fact, I wanted nothing to do with any of that because I had seen too many people fall through that rabbit hole never to return to their true selves. Thankfully, the authors I met at Girlfriend Weekend had the same outlook as me, and they proved to be a lovely group of gentle souls, down-to-earth and eager to welcome me into their fold.

What a relief! You see, in the beginning, I had simply written the story my soul begged me to write, and I had no intention of ever telling anyone I had written it, much less of pursuing publishing. But my characters would not settle until I gave this little story to the world. They haunted me in the carpool lane. They chased me during various after-school practices, while flipping pancakes, and every night in my dreams. I finally had to accept that, for reasons beyond my understanding, this story had been given to me

and it was not mine to keep. I was merely the vessel, ordained to transport it from the universal bards into the hands of readers. Eventually, I surrendered, finally realizing this story was far bigger than me and in fact had very little to do with me at all. I would dare to share it—one of the scariest things I've ever done—and in doing so, I would trust that the words would find the right readers at the right time in the right way. Beyond that, I had no expectations. None. That was truly all I aimed to do when I signed that first publishing contract. And it's still all I aim to do as I continue my publishing journey today.

When that first novel hit shelves, I did not understand the "game" of publishing, as many have called it. Nor did I understand the cruelty that some people can dish out when a debut novel finds its way to the *New York Times* bestseller list. The words from a few fellow authors were harsh and unexpected, and while I have never told anyone about these heartbreaking blows, Kathy seemed to know they were par for the course. She hugged me and told me how much my story meant to her, and in her kind reassurances, she offered the balm I hadn't even realized I had been seeking. In that one noble act, she made me believe I not only had delivered a story that had worth, she made me believe I had every right to be there with the "real authors," and that yes, I had every right to be recognized as one of them too, just as much right as the other scribes in the room, even though I had never taken a writing class. Kathy dared to believe in me, and whether she knew it or not she gave me the confidence to start believing in myself. My admiration for her ran deep from the beginning, and she has served as a

steady friend and mentor to me ever since.

That first weekend proved life changing for me. Those authors and readers I met in Jefferson have shaped my spirit in ways I never could have imagined. Many of them have become some of my closest friends in the years since, and I now look forward to returning each January to Girlfriend Weekend, as if it's a family reunion of sorts, a place for me to reconnect with my soul sisters.

After my initial Girlfriend Weekend, I returned home with a new lens. This trip had been my first time to travel away from my family and it awakened me to an entirely new reality, one in which women could be completely, uninhibitedly free to express ourselves as intelligent, brave, creative spirits who loved to dance and laugh and dress in silly costumes just for the fun of it. There was no judgment allowed at Girlfriend Weekend. No shame. No criticisms. No condescending arrogance. No pressures to conform. All sorts of opinions were voiced, openly, and no one dared bat an eye as words flowed and ideas were shared.

And that's Kathy's magic. She has this incredible ability to bring together people from all walks of life—from the most liberal-minded creatives to the most conservative-minded southerners. People who have never roamed more than a few miles from where they were born to globetrotting internationals who are recognized as our nation's literary elite. People who have never written anything and those who have stood on stages as one of the world's most accomplished authors. She then puts us all together in feather boas and rhinestone tiaras and leopard skin leotards, dancing with us under a disco light where we all dare to celebrate

our combined love of story.

Story. That's what it all comes down to in the end. The fact that every one of us has a story. And by writing and reading and sharing and listening, we learn to love one another through the power of story. Story heals us and inspires us and, ultimately, story unites us.

Kathy took a gamble on me when I was fresh out of the chute. I was the underdog, the one with the unproven track record, the long shot. But Kathy believed in me because she believed in my story. And I know I'm not the only one she has supported whole-heartedly through this crazy maze of publishing. Kathy not only dared to read my book, she dared to share my book with others by selecting it for one of her recommended book club reads. In doing so, she helped my novel find readers who likely would have never discovered my work otherwise.

In the end, this *little story that could* launched my career as an author. And for each of my books published after *Into the Free*, Kathy has shown the same loyal support and enthusiasm. If there's anything rare in this world anymore, it's that kind of steady friendship that aims to elevate another soul while selflessly seeking nothing in return. That's Kathy, and as we all know, such a positivity reverberates, and thus, the Pulpwood Queens as a whole exude this same kind of generosity where *love one another* is the only rule.

If you ever get a chance to meet Kathy, you'll be glad you did. And if you ever get a chance to join us at the Pulpwood Queens Girlfriend Weekend, please come. All are welcome here, and we'd love to hear your story.

Pat Conroy's Checkbook

Tracy Lea Carnes

My debut novel came out in 2009 with little to no fanfare. *Excess Baggage* spent years trying to find an agent and a publisher. It was an uphill climb. So, when Kathy L. Murphy asked me one Saturday afternoon in her combination bookstore and beauty shop in Jefferson, Texas, called Beauty and the Book, if I would like to be a featured author at her annual Girlfriend Weekend the following January, I was beyond ecstatic, not only to appear alongside so many authors I loved and admired, but to have an opportunity to get my little book out there. That's what Kathy does: she champions authors and their novels, and now she was championing mine.

I didn't know exactly what to expect at the weekend, but I was ready for the challenge and the excitement to promote my book. What most people do not understand about novelists is that not everyone who writes a novel becomes an overnight success or a *New York Times* best-selling author. It takes a lot of promotion and readers to make an author successful. It takes someone like Kathy to believe in you and your work and put you up there on a platform with the likes of Jamie Ford (*Hotel on the Corner of Bitter and Sweet*), Patti Callahan Henry (*The Bookshop at Water's End*), Jenny Gardiner (*Sleeping with Ward Cleaver*), Ad Hudler (*Man of the House*), and yes, even Pat Conroy (*The Prince of Tides, South of*

Broad, Beach Music). The list of fabulous authors at the event was a Who's Who of the modern literary scene. And then there was me.

I picked up my welcome package at the Excelsior Hotel that Thursday afternoon which included an apron for the event and a nametag. We were all instructed to sign our names on the apron, as we would then wear them that evening as the wait staff for the dinner. All authors, regardless of experience, were required to serve the conference attendees their first night's dinner. Some authors were better at serving than others, but one such author was excelling at dinner service—Pat Conroy himself. With a water pitcher in hand, he adeptly filled the water glasses of every attendee and regaled them with all sorts of stories. In passing I told him, "Hey Pat, if the book writing business doesn't work out for you, I think you might have found your calling!" He laughed, nodded his head, and kept right on with the dinner service. He was simply a natural.

Later that evening, the authors finally got a chance to sit down and have their own dinner. Jenny Gardiner and I fixed our plates and found a place to sit down and eat in the small dining room of the hotel where we were relegated. There was an empty chair beside us, and Pat seemed to gravitate toward us. Without missing a beat, he looked at us and asked if we'd like to hear a story about his morally lenient friend, Bernie. What were we supposed to say, "no"? Bernie, as it happens, was Pat's lifelong best friend, Bernie Schein, a well-known author and humorist in his own right. While all of us authors were doing the "and what's your book about?" banter, perhaps Pat was well aware that all of us

knew exactly what his books were about as there wasn't an author in the room who hadn't read him already. So, to deflect the attention off himself and bring it around to his beloved best friend, Bernie, was a generous move only a humble man could pull off. It was clear to us at that table why Pat Conroy was so beloved and so well read. He was honestly unpretentious and down-right charming—larger than life but extremely down to earth as well. It was there in his writing and it was there in that room. He was just another author like the rest of us, and his friend, Bernie, if only through story, was in the room with us too.

Once the dinner was finished, Pat stood up and proclaimed that he wanted to buy copies of all our books, even my little novel. He whipped out his checkbook and began writing checks to purchase all of our books—all of them. He wanted them for his library. I passed on having him write me a check and simply gifted him the book. I would have never, ever, cashed that check anyway. It's why I now have an even greater admiration for the author of my favorite novel, *The Prince of Tides*. Pat Conroy was the real deal and he proved that, not just to me, but to everyone in attendance that year.

In the presence of the great Pat Conroy (and his checkbook), who now possessed my little novel, *Excess Baggage*, and so many other wonderful writers, I stood on the stage at Girlfriend Weekend 2010, promoted my book, and even a new stage play I was in the process of writing. I gained the confidence that I, too, was worthy of standing on that stage and presenting my work. Pat Conroy and all the other authors at Girlfriend Weekend made

me feel welcome and worthy. I had a wonderful signing that afternoon, with Pat cheering me on. That made my day. I was an author and he treated me as a peer. That was everything to me.

It was because of this magical experience of Girlfriend Weekend that I decided to include it, with Kathy's blessing of course, in my new novel. In the novel, tentatively titled *The Dance*, my protagonist is a young up-and-coming author who suddenly finds fame and notoriety by covering a huge movie star for an article during the Sundance Film Festival and who ultimately attends Girlfriend Weekend as a featured author. I decided to immortalize Kathy as a character in the book who champions the main character's novel, like she did my own. It just seemed like the natural thing to do as a thank you. I don't think I could make up a character as wonderful, charming, and larger than life as Kathy is in real life. The book concludes, as every fabulous Girlfriend Weekend does, with the Great Big Ball of Hair Ball. Everyone should get to hang out with her favorite authors over a weekend and have a happy literary ending to remember. I will always be thankful for Kathy including me in Girlfriend Weekend 2010, for promoting my novel, and for my wonderful memory of Pat Conroy and his humble checkbook.

Tornado!

Kathryn Casey

It's the 2010 Girlfriend Weekend. I stand at the entrance to the Great Big Ball of Hair Ball and watch the Pulpwood Queens and authors arrive. The party's theme is *The Wizard of Oz*, and the room fills with blue-and-white gingham-clad Dorothys, raggedy scarecrows, complete character sets with thick-maned lions and clanking tin men. A Glinda strolls by. Then Ad Hudler, one of my fellow authors, shuffles in with his head encased in a green cardboard box. A curtain covers the front. He pulls a cord and it opens. Ad's face painted emerald green, he's OZ, the great and powerful. A maniacal look in his eyes, Ad says with a whiff of pomposity, "Some people without brains do an awful lot of talking, don't you think?"

A Wicked Witch laughs so hard tears spill down her cheeks ruining her thick black eyeliner.

I'm an Oz aficionado. A display case in my office overflows with Wizard mementos, including a sign warning people that I have flying monkeys. I don't see how the Hair Ball can get any better.

Then Kathy L. Murphy walks in the room.

Her long blond hair hidden beneath a knit cap that erupts into a spray of ominous black netting, the PQ's matriarch wears a tented grey dress. Her eyelids painted dark, at her neck a Guern-

sey cow appears caught in a strong wind, a tractor on a chain dangles helplessly, and the pin on her chest reads: "I'd rather be in Oz."

The Pulpwood Queen has come to the ball as the tornado.

It's hard to imagine a higher-energy group. The enthusiasm at a Hair Ball flows like champagne spilling over a thousand champagne glasses stacked in tiers. The music pounds, the PQs toss off worries, dance and enjoy the night. One such evening, I was in a line of five authors who mimicked the Supremes dancing to *Baby Love*. Another year, I dressed as the Cheshire Cat and joined in on a pantomime routine while Jefferson Airplane's *White Rabbit* bellowed through the room.

Still, as important as laughter and good times are—the older I get the more vital I consider both—another aspect of my Pulpwood Queen adventure is even more satisfying: the camaraderie of readers and authors, the leisurely unstructured time to kick back and talk to folks who love books as much as I do.

At Girlfriend Weekend, I listen to readers, who tell me what they look for in a book. They explain why they enjoyed one book, while they never finished another. We share stories about our families, our lives, our pasts and our presents, our wishes and our dreams. It's a rare opportunity to connect with others on a very personal level.

As a profession, author has a rather lofty image. When I tell folks I've written sixteen books, they see it as a glamorous life, picturing book signings and lectures.

That happens, off and on. But the bulk of my existence is spent alone in my office, tethered to my computer, sitting in my

worn desk chair. I've used my keyboard so much that some of the keys are blank, the letters worn off.

Writing is a lonely life. Many of us write in our pajamas in the morning and eat leftovers for lunch, at times while trying to figure out how our characters finagled us into a dead end. That's a problem when we're only a third of the way into a book. It's enough to birth a migraine.

So we writers suffer in solitude, stewing over the unfortunate turns our writing takes.

At least, that's the way my life used to be. Before Kathy and the PQ family adopted me.

The Pulpwood Queens have become my secret support system. I've talked over plot twists with members. Some have done first reads on my books, given me feedback on whether or not the plots are coming together. These women from across America who wear tiaras and boas, cowboy hats with bedazzled bands, have been generous with their time and honest in their opinions, valuable gifts for any writer.

Over the years, our relationships have grown, and I've come to consider many of the Pulpwood Queens my dear friends.

Then there's the Pulpwood Queens network of authors. There's an intimacy there, a connection between many of us. Year after year, we've traveled to northeast Texas and spent a weekend talking and sharing. Publishing is a competitive world. But in this community of authors, we've developed deep friendships. We understand the intricacies, the pitfalls of writing, and the tribulations of fighting to be noticed in a crowded field. Many of us help

and rely on each other. When one of us has a setback, we commiserate. When one of us hits the bestseller list, we cheer.

Thanks to the PQs, I'm a member of a vibrant community anchored by the love of books. For this, I will be forever grateful.

Mamma Mia, the Pulpwood Queen!

Stephanie Chance

It was the unforgettable year of 2015 when I finally met the legendary queen of authors and books, Kathy L. Murphy. For years I'd heard my customers from all over the United States excitedly proclaim, "We're heading to Jefferson, Texas, to meet the Pulpwood Queen, the creator of the largest book club in America, and the famous Beauty and the Book, the world-renowned beauty salon and bookstore in one. And if we're lucky on arrival, we'll get our hair styled and hear all about the latest authors from the queen herself, Kathy Murphy."

The entourage of tourists became a weekly encounter, those exiting off to Gladewater, Texas, for a quick stroll through the many antique shops and then on to the historical, dreamy town of Jefferson where the Queen of all authors lived and operated her magnetic enterprise, Beauty and the Book and the Pulpwood Queens of East Texas Book Club.

My first encounter with one of the many faithful flocks of Kathy's devoted followers left an everlasting impression branded deeply upon my heart. The enormous intensity of men and women traveling hundreds of miles across the United States to get to Jefferson with hopes of grabbing a glimpse of this bigger than life lady, a rock star sensation, who was and is the beacon of light,

transmitting signals across the world to every living author and reader, was absolutely amazing. And if that wasn't enough, this tiara-wearing rising star, the Queen of book-world royalty, was indeed it seemed, attracting every living creature from the four corners of earth.

I remember Mrs. Williams from Houston arriving at my shop on a sunny afternoon many years ago. She entered the front door with six talkative ladies behind her heels, all of them sporting leather bottom shoes. They echoed a loud ruckus throughout the store, a distinct noise—clickety-clack—alerting my ears. Racing around the counter to greet them, my eyes flashed above to the excessive adornment, the wigs, the crowns of some sort, and the stretchy leopard print pants. I could not help glancing at their hair, the bling, and the diamond-studded tiaras. Should I ask the occasion? I couldn't help myself. I had to know.

"We're on our way to Jefferson, Texas, to the largest gathering of authors, the Pulpwood Queens Girlfriend Weekend. It's a huge extravaganza with the Queen of books, Kathy L. Murphy, the creator of the biggest book club in America. We'll be there three days with our favorite authors, hearing all about their latest books, getting to know them personally, reuniting with book-loving friends, and being with the Queen. We get to dine with them, party with them, and, did I mention the celebrities? It's wall-to-wall, hundreds of them galore. And Saturday night, oh, my... we'll be attending the grand finale, the party of all parties, the Great Big Ball of Hair Ball.

"Ma'am, you have no idea the fun you're missing. You've

got to go. It will change your life forever. It did ours. And by all means, don't miss the Great Big Ball of Hair Ball. It's enough excitement to send an Olympic winner into heart arrhythmia, full-blown palpations, beating harder than my little Jimmy beats on his drum during competition. I wouldn't miss it for the world. No, never. We always book our rooms in advance, a year ahead. You have to get the package early, no delays."

They rambled on, talking over each other, divulging all the hype from last year's event, telling me about Kathy, the Queen herself, the world-wide success of reaching national television and more. They were giddy girls, eagerly anticipating another three days, elbow to elbow with hundreds of authors and fans.

I waited in breathless anticipation while they relived the gathering; my chance of ever talking again was highly questionable.

"Excuse me," I attempted again. "Why the crowns, the tiaras, the—" I tried, but it was useless. Before speaking another word, they departed my shop faster than they had entered as one of the ladies glanced at her watch, seeing the alarming hour of the day.

"Let's hit the road, girls! We'll miss the best seats. Let's get to Girlfriend Weekend!" Panic struck and they were out the door in less than two seconds, in their car, buckled up, with four tires squealing as they peeled off to Jefferson.

Word travels fast in East Texas when Joan Rivers, Oprah Winfrey and hundreds of book-loving fans flock to the charming little city of Jefferson to meet the hottest hair stylist in town with

a shop flanked with wall to wall books and enough leopard print attire to cover the Empire State Building.

Not only was this tiara-wearing Pulpwood Queen the hottest topic around, she was also making front page national headlines across the country, appearing on "Good Morning America" and sipping iced tea with celebrities. People were going crazy over this epic sensation, the beautiful blonde bombshell, Kathy L. Murphy.

How many times do I still meet people, customers, who are heading to Jefferson every January for the three-day event that truly changes their lives? The count is endless, the people are endless, and the stories are endless. Every year after the whirlwind gathering, shaking East Texas to its core, the effects continue to resonate throughout the universe, giving the fans, the readers, and the authors more than enough adrenaline, an energy infused high, and a serotonin blast, indescribable to mankind. The weekend provides enough literary knowledge and magnetized camaraderie for those attending to make it for another twelve months, until the next one. If this invigorated event was bottled, measured out in spoonfuls, well, mamma mia, the world's problems would be instantly solved. It's a power packed gathering of the Pulpwood Queens, a three-day extravaganza, presenting the cream of the crop, the authors chosen by the Queen herself.

After the release of my book *Mamma Mia, Americans Invade Italy*, I hit the jackpot. Kathy waved her magical wand and selected it as a chosen read for her famous book club. The words spoken from the royal highness sent shockwaves across the nation. The bells sounded throughout, ringing loudly, and Cinderel-

la-like, I was going to the largest and most exciting extravaganza of all, the Pulpwood Queens Girlfriend Weekend with hundreds of authors and fans, and the grand finale being the Great Big Ball of Hair Ball.

And just like that, I was proudly branded with the official seal, the pink round stamp of authenticity. The Queen had validated my work, and instantly inducted me into the walk of fame of big hair, wigs, costumes, tiaras, leopard prints, tons of make-up and an annual theme of dress-up, which is announced each year. My life was forever changed.

Mamma mia, what an honor it truly is, indeed, to be a Pulpwood Queen, to be among the most talented authors from around the world, to hear them talk intimately for three days at the most exciting and fun gathering of all in Jefferson. And to be with the Queen herself, Kathy L. Murphy, the powerhouse Einstein who pioneered this life-changing event for all lovers of books, readers and fans, who created the fastest growing book club in America with over 765 chapters. She's the tireless spinning wheel for authors, their voice, paving the way for us who live to write and publish our stories. Kathy is a tiara-wearing, fun-loving ball of fire with more talents than a hundred people put together. Not only can Kathy whip out a book with her life story, she can mold and design ceramic goddesses, fabulous creations displayed in universities, paintings hung all across America, even in Italy. Her talents are endless and her smile and vivid personality are contagious.

Even though it's only been two weeks since this year's epic event, I'm still feeling the aftershocks of it all, the 2019 Pulpwood Queens Girlfriend Weekend, with hundreds of book club members

and authors galore. The theme was How the West Was Won. And, I'm sure all of the details will replay throughout my mind as I reminisce every single moment.

Walking into the entrance, seeing wall-to-wall authors, book club readers, fans, and the Queen herself, Kathy, adorned in western attire, I inhaled a thousand pages of talent. My eyes struggled to keep up with the ping-pong commotion of fun and laughter. And for a brief moment, I think it was so, saddled up horses ran through the room. It was cowboy hats to boot scooting look-alike whiskey saloons. It was a whirlwind, a melting pot of personalities. And, I think it was Judithe Little who hollered, "How do you do?"

As my eyes refocused there appeared another root-tooting star, Julie Perkins Cantrell, a smiley face of roasted vanilla, a beautiful author with eyes of black diamonds, wearing a chocolaty brown hat balancing perfectly atop of her head full of black bouncy curls. I looked for her horse, a giddy-up stick between her denim jeans. Where did it go?

Strolling to the left side of the convention center, I enthusiastically floated around, meeting and greeting. My boots were fringed with excessive bling, and my wig of blonde strands, such a massive pile of synthetic hair, was strapped to my head with colorful effects, a wide turquoise-red band, shouting out to the room that a bizarre resemblance to Pocahontas had arrived. The energy was explosive and the attendees were massive, a dot-to-dot hug fest of friends, and faces seen on covers of books, magazines, billboards, all fraternizing as one big ball of twine.

Stories Make Us More of Who We Can Be

Judy Christie

Stepping into the Shreveport Municipal Auditorium is a sort of mystical experience. The flamboyant 1920s art deco building reels you in, your eyes riveted to the stage where the ghosts of famous musicians surely keep watch, performers such as Johnny Cash, Hank Williams, and a fellow you may have heard of, Elvis Presley.

In this very room, Elvis got his start.

And in this very room, I met Kathy L. Murphy.

I regret that I don't recall what Kathy was wearing, because she does not merely dress, she gets into costume, but I remember what she said as she spoke from the spot that has hosted so many creative heroes in decades past:

Stories are powerful. They enrich our lives. They make us more. More than we were before. More of who we are. More of who we can be.

As readers thronged around Kathy on this summer day in 2009, I drew a deep breath and watched from across that famous floor. I wasn't stalking her. Really. I was trying to talk myself into approaching her about my debut novel. But, gulp. In these parts, her Beauty and the Book shop and her tribe of Pulpwood Queens had mythical power. As for me, I was a woman who had just written her first novel at age fifty and had never worn a tiara in my life.

Kathy was on her way out of the building by the time I summoned the nerve to introduce myself. I practically ran over to intercept her. Talking at 78 rpm, I told her about my first novel, *Gone to Green*, a southern story, similar to some she had talked about that day. Might she ... possibly... maybe... take a peek at an advance reader copy? She graciously took it, not hinting that she received scores of books every year from authors eager to see what she thought. Because Kathy has a superpower—spotting great books.

Nothing against Elvis, but Kathy became one of my creative heroes that day. While I didn't realize it, by accepting that ARC, she was taking me by the hand on a journey of friendship and stories that would last well into the future, that would bring me into a family of readers and writers at the annual Pulpwood Queens Girlfriend Weekend, see me dressing up as a fried green tomato and posing with author Fannie Flagg, serving tables with the legendary Pat Conroy, signing books for Pulpwood Queens who drove sixty miles for one of my book launches, and sprawling in a Baton Rouge hotel room telling stories with Kathy and her feisty sidekick Tiajuana Neel, whose hairdos live on in one of my novels and whose spirit lives on in my heart.

Kathy also wrought more magic when she invited me to speak at an inspirational book festival she was trying out. While that festival, in the fall of 2009, ultimately merged into Girlfriend Weekend, its power lived on in my life. It was there that I encountered author Lisa Wingate, who became a new friend when we stayed up way past my bedtime in the front room of a Jefferson, Texas, B&B talking about the craft of writing. Nearly a decade later,

Lisa and I became writing partners and sold a nonfiction book to Random House.

Ah, thank you, Kathy.

Your leopard-print, feather-boa-wearing Pulpwood Queens book-love weekend has taught me that you're never too old to wear a costume...or three. That stories still matter in an exuberant, life-changing way. That when you bring readers and writers together, you get the energy of Elvis up on stage.

Elvis...Hmm. What year will I wear *that* costume?

Big-haired Fun
An Ode to the Pulpwood Queens and Timber Guys

Tim Conroy

Transcending cultures, labels, and lifespans,

Pulpwood Queens and Timber Guys

embrace word-hounded writers

who create our stories alone in book-rich rooms

to ease our isolation and to be heard—if we can.

Queens and Guys discuss the essence of "good books,"

and learn from every notion.

We need each other's differences to flourish.

There are revelations of the heart and mind

when you wear tiaras and leopard print among your tribe—

As Kathy Murphy rouses, *let's have some big-haired fun.*

The Girlfriend Weekend is a reunion and a welcome,

where lone wolves can turn social

with howls of acceptance and chewed wisdom.

Prayers here in North Texas

are made of poetry, honesty, foolery, and faith,

to be read aloud before a barn dance.

You can't pigeonhole these authors into types

when book club characters are dynamic.

Yodeled and blessed, spirits of readers and writers soar

toward new creations and through our shared travails—

As Kathy Murphy whoops, *let's have some big-haired fun.*

In the Beginning

Christopher Cook

After living for several years in France and Mexico, I returned to the United States for a while about twenty years ago to catch my breath. I'd written a novel and needed to sell it. I was broke and in debt, so I took a paying job as editor of a statewide magazine in Texas. First thing on my plate upon arrival in Austin: find good feature story ideas for the magazine. So I began poking around and a rumor caught my attention—a rumor about a woman up in northeast Texas, somewhere around Caddo Lake, somewhere on the outskirts of the small town of Jefferson, who ran a business that was both a beauty salon and bookstore. She also had started a book club called the Pulpwood Queens.

That sounded like a dandy feature idea to me and I decided to assign it to a freelance writer. Then I changed my mind. The story was just too damn good to give to another writer. If one of the perks of an editor's job isn't claiming first dibs on the best stories, then what's the point of being an editor? I decided to write the story myself, which of course required thorough research and an interview. Which naturally meant a road trip. So I packed a bag, jumped into my Dodge pickup truck, and headed northeast toward the East Texas Pineywoods and the hamlet of Jefferson, population 2,000 or so. I recall hitting the road with a surge of

excitement. There's no adventure like chasing down a good story, as any writer knows. Add a bit of travel into the mix and... well.

And that's how I met Kathy Murphy. Then, as now, Kathy was no mere beautician. Nor was she a simple bookseller. No, she proved to be something much, much more: a geyser of ambitious ideas, a whirlwind of energy, an explosion of creative possibilities. In short, a force of nature.

It didn't take a genius to realize Kathy was starting a venture that had the potential to grow much larger. But in those days—in the beginning, I mean—the endeavor seemed modest, a project likely limited by the parameters of time and place. Because even under the best conditions, success is an iffy proposition. The world is cruel and most ideas—even *great* ideas—die on the vine.

On the other hand, Kathy clearly wasn't your average human being. Her whole attitude was so upbeat and positive. She seemed full what the French describe as *joie d'esprit*. You found yourself really *wanting* her to succeed because her success would validate this world as a place worth living in.

Her beauty/book shop back then was called Beauty and the Book. It was a single room tacked onto the side of a large, sprawling home, itself tucked beneath towering pines on a large wooded lot fronting a rural county road. It was not an auspicious location for a business of any sort, I thought. Inside, the shop was stuffed with shelves and books interspersed with salon chairs and mirrors, the air perfumed with the aromas of both printed paper and beauty products.

As for her book club—the Pulpwood Queens—it was just a

handful of local women who shared Kathy's love of reading. They met regularly at Kathy's home for potluck dinners and discussions of books they were devouring together. Merging the social aspects of eating and visiting with the intellectual aspects of reading good books seemed to me a fine way to build and celebrate community.

All in all, Beauty and the Book and the Pulpwood Queens and the woman behind those endeavors made for a fine human interest story. So I spent a day with Kathy in her shop, a prolonged interview of sorts, while she told me her story and gave some customers haircuts and permanents. Then I returned to Austin and wrote my magazine feature. It was a fun story to write because Kathy was a fascinating person and her beauty/book shop business was both unique and inspirational.

When the feature was published, the response from our magazine readers was enthusiastic. And I moved on to writing my next feature story—it had to do with coon hounds or the Big Thicket Preserve or some such idea that appealed to me—while editing the many other stories that crossed my desk as magazine editor.

Meanwhile, up in Jefferson, Kathy's venture continued to grow. Especially the Pulpwood Queens Book Club. Maybe *explode* is a better word. Because as it turned out, word of mouth is a powerful marketing tool. And the limiting parameters of rural East Texas proved meaningless in the burgeoning new digital world of the Internet and World Wide Web.

In short, it seemed like overnight Kathy's undertaking had grown ten-fold. Or more. Other chapters of Pulpwood Queens

were popping up all over the United States. Kathy was being interviewed by national publications. Somewhere in there she appeared on the ABC network's "Good Morning America." She also was promoting literacy and someone mentioned her name in association with Dolly Parton.

I couldn't keep up. Next thing I heard, Kathy had published her own book, *The Pulpwood Queen's Tiara-Wearing, Book-Sharing Guide to Life*. Then I heard she had an online book club talk show. Then her own talk show on cable TV. I halfway expected her to show up on *Dancing with the Stars*. It certainly wouldn't have surprised me.

The Pulpwood Queens Book Club had grown to something like 2,000 members and 400 chapters, including one in a prison and several in foreign countries. Every year they held a huge party called Girlfriend Weekend that culminated with the Great Big Ball of Hair Ball. And big-name authors were competing to have their books chosen as a book club selection.

Kathy's enterprise was approaching the size of her dreams. She was very busy. The demands on her hours and days were intense. But she hadn't forgotten me. When my first novel (*Robbers*) sold and was published, she chose it as a Pulpwood Queens selection. So I made another road trip to Jefferson and was delighted to celebrate there with a book club reading and some of the best potluck dining a man could ever want. I was gratified to see that Kathy was as much a force of nature as ever.

A couple of years later, she also chose my second book, *Screen Door Jesus & Other Stories*, as a book club selection, and I

made yet another journey to Jefferson for a convivial evening with the original chapter of the Pulpwood Queens.

By then I'd moved on from the magazine. I'd headed back overseas to Prague, Czech Republic, where I live now with my artist wife Katerina Pinosova. Back in the States, Kathy has moved on, too. She no longer lives in Jefferson, and her vocational repertoire now includes yet another title, that of artist. That's her newest quest, and I enjoy watching from afar as she embraces it. I keep up with her and her lovely creations via Facebook.

Looking back, I suppose it's fair to say that I was there at the beginning of her first big adventure, or at least near it. So that was my good fortune, to watch it all happen. Along the way, Kathy and I became fast friends. More good fortune.

Actually, I don't even call her Kathy anymore. For years now, I've called her KitKat. I don't recall exactly when or how I started doing that. But I do recollect why. You know those little chocolate covered wafer bars called Kit Kats? She reminds me of those. They're multi-layered and complicated. Sweet, too. Full of energy. And always a delightful surprise. That's KitKat.

You could write a book about it.

The Ghosts of Jefferson

Michelle Cox

I had heard of the Pulpwood Queens Girlfriend Weekend, of course, but I never completely understood what it was. Phrases like "a wild ride" and "the most fun you'll ever have at a conference" often surfaced in conversations regarding it, which always made it more than a little intriguing. So when the Pulpwood Queen herself, Kathy L. Murphy, asked me to be a featured author at her annual event in Jefferson, Texas, I was thrilled and perhaps just a little apprehensive.

By the look of it on Google Maps, Jefferson appeared to be alarmingly small, however, and after entering seemingly endless variables into Expedia, I came to the conclusion that it was going to take two flights and two Uber rides to get there from Grayslake, Illinois. I assumed, given its size, that Jefferson would be lacking in hotel choices, so I was surprised to find an unusually high number of little inns, guest houses, and B&Bs pop up. Surely this was a good sign. Perhaps it was some sort of touristy getaway town?

The first hotel I clicked on, however, gave me a bit of a shock. It announced—right there on the home page for all to see—the fact that it was haunted. Haunted? Shouldn't that statement be safely tucked away somewhere in the legal disclaimers, I wondered, as I scrolled through the photos of this otherwise charm-

ing-looking hotel. Well, I wasn't going to take any chances, I decided, and clicked on the next hotel, which oddly proclaimed the very same thing! Perhaps this was a ghost hunters' destination town? For several seconds, I considered researching this theory but then decided that I didn't actually want to know. Finally, after four or five tries, I found the Excelsior Hotel, which made no mention of hauntings or ghostly presences of any kind on *any* part of its website, so I quickly booked it.

When I touched down in Dallas several months later, it marked my very first time in the Lone Star State, and I admit I felt a little flutter of excitement. I didn't have much time to look around, however, as I had to hurry to catch my connecting flight to Longview, which proved to be the smallest plane I'd ever been on. From there I snagged an Uber, the only one in Longview by the look of it. The driver said he hadn't been to Jefferson in years but he was willing to drive me the forty-four miles required. He tossed my case into his battered trunk, I slipped into the back, and off we went. Forty-five minutes later, as we rolled into town, I had a sudden vision of what it must have been like rolling in on a stagecoach, if such a thing had ever existed in Jefferson at all.

All small towns have a veneer of sameness to them, though I know from growing up in a town of just 1,100 people that a unique heart beats within each. Jefferson was no exception. In many ways it looked like any other small town, but the heart beating below struck me as being very southern—whatever that means, exactly. I have of course been to other cities in the South— Paducah, Orlando (is that really the South?), Myrtle Beach, New

Orleans—but those seemed pretenders in comparison. Jefferson seemed like the real thing, the *real* South—the sad South.

"The Union never made it to Jefferson," the Uber driver told me. "So none of its buildings were ever burned by the Yanks," he went on. (I wondered if he could somehow detect I was from Chicago, besides reading ORD on my suitcase label, of course.) Regardless, this lack of Union troops apparently left Jefferson with "the best collection of intact antebellum houses in Texas." That seemed like an almost unbelievable boast, but I decided to go along with it. After all, who was I to argue?

As we inched down the main street, I spotted all the hotels and inns I had seen online, hunched up together, one after another. This was more than a little worrisome, and it suddenly occurred to me: what was to stop a sad spirit from floating from one hotel into the next? Surely brick walls wouldn't stop them? Fortunately, the hotel I had booked was a little further down the street, and I hoped this was a good thing.

The lobby of the Excelsior was wide and genteel in a shabby sort of way, instantly endearing it to me. Historical memorabilia hung everywhere and spilled over into display cases along the walls, documenting not only the inn's storied life but the town's as well and begged to be read. I checked in without issue and climbed the stairs (no elevator), suitcase bumping behind me and large old-fashioned key in hand, trying to ignore the fact that the floors were slightly slanted, which I hoped was the result of age and not something else altogether, say, some sort of paranormal activity.

Normally, I like to unpack and organize myself when check-

ing into a hotel, but I barely had time to open my suitcase before I had to rush out to meet a fellow author for dinner at one of the local establishments. I didn't even have time to change clothes and instead dashed down the street to the restaurant.

As I hurried along, I got a closer look at Jefferson and quickly observed what seemed to be a plethora of antique stores. There were so many, in fact, that I began to wonder if this was perhaps *not* a touristy getaway town, nor a ghost hunters' destination town, as I had originally suspected, but rather a destination for antique hunters. But as I continued along, I noticed that there was more to Jefferson than haunted inns and antique stores. There were several quaint shops, restaurants, salons— many of them with signs taped in the windows reading "Welcome, Queens!" There was even a homemade ice cream stand. I could feel Jefferson's own particular remnant of southern sadness, but everywhere I saw evidence of people trying very hard to shrug it off—to be warm and welcoming.

I stood outside the pre-arranged restaurant, checking my watch and anxiously looking up and down the street, every few minutes stepping inside to check again to see if I had somehow missed my friend. The interior was positively humming, almost all of the tables full, but two women eventually managed to get my attention. They called to me and suggested that I join them instead of standing there at the door by myself. I was amazed. It wasn't hard to guess they were fellow conference attendees, of course, but still, we were strangers, and I was touched by their welcome.

Welcome, it turns out, was to be the theme of the Pulp-

wood Queens weekend. When I finally arrived at the conference center itself, Kathy herself greeted me *by name*, though we had never met in person. She was warm and welcoming and absolutely larger than life with a heart that seemed as big as her persona. Or what I thought was a persona. It didn't take me long to realize that Kathy had not wrapped herself in a shroud of anything, but was, in fact *is,* one hundred percent genuine. Her enthusiasm for connecting authors to readers and for literature and art is very real. And if the antique stores down the street were selling off bits of the town to keep it alive, Kathy was filling the resultant wounds with her enthusiasm and her love.

But it wasn't just Kathy who was warm and welcoming, it was all of the authors who were there, not just to promote themselves, but to really connect with readers and each other. And not just in the conference center, but in all of the shops and bars and salons where we happened to find each other. So many authors took the time to answer questions and to give me the advice I asked for, and I am particularly indebted to Ann Wertz Garvin, Barbara Claypole White, and Camille Di Maio, who generously shared their experiences with me.

But it was a moment shared at the Excelsior Hotel that particularly stood out for me. It happened early Saturday morning when I crept down the creaky stairs in search of some coffee. There in the shabby, genteel lobby, I bumped into another coffee scavenger and quickly assumed that she must also be here for the conference—either as a reader or a writer. We introduced ourselves—sans makeup or nametags or appropriate clothing, real-

ly—and began talking. She was Claire Fullerton, she told me, and proceeded to tell me a story about her house narrowly escaping the recent wild fires in California.

Eventually discovering that we were both writers, however, our conversation naturally turned then to books and writing and the business of writing, and soon we had taken up residence on an antiquated sofa in a little parlor. And as we did so, I couldn't help but think that the inn was somehow glad that someone was actually using one of its rooms for what it had originally be designed for, for sitting and talking and sharing. And if I didn't hear an audible sigh of contentment from the inn, I certainly felt it.

At the end of the weekend when I was sadly checking out, I attempted a moment of levity by commenting to the clerk that I had originally chosen their fine hotel because it wasn't haunted. "Oh, it's haunted," the girl said, not even looking up from what she was doing. "They all are. We just don't mention it." Well, I thought, perhaps. But Jefferson is *not* a ghost town, I concluded. It is indeed alive and well, especially as long as it remains the destination of Queens.

Mod Barbie, Elphaba, and the Yellow Rose of Texas

Susan Cushman

My friend and fellow Tennessee author River Jordan called me up one day in 2009 to ask, "Hey, Susan, do you want to go on a road trip with me to Jefferson, Texas next January?" I thought, "What the heck is in Jefferson, Texas, and why would we want to go there?" River proceeded to describe in colorful detail the annual book convention hosted by Kathy L. Murphy for her 750+ book clubs, known as the Pulpwood Queens. The event was called Girlfriend Weekend.

"What do we do there?" I asked River.

"We dress up in crazy costumes. The authors speak on panels and visit with the book club members, then we all go and eat barbeque."

What's not to love about that? And to top it all off, my favorite author of all time, Pat Conroy, was going to be there! And Elizabeth Berg! This was pushing all my buttons.

There's an annual theme for the event, and for the January 2010 Girlfriend Weekend, there were two themes. On that Friday night we would be celebrating the 50th anniversary of Barbie and on Saturday night there would be a commemorative ball for the 70th anniversary of *The Wizard of Oz*. During the rest of the week-

end, many of the authors and readers would dress in traditional Pulpwood Queens attire: tiaras (yes) and anything leopard print and hot pink.

It was January of 2010—exactly ten years ago—when I found myself tagging along with River to my first ever Girlfriend Weekend. I say "tagging along" because I really didn't fit into either of the categories to which the rest of the two hundred or more people belonged. I wasn't a published author yet (I had essays published in journals and magazines, but no book out) and I wasn't a member of one of the Pulpwood Queens Book Clubs. But I was an avid reader, and I was writing a book, so the weekend was truly a feast for my literary soul.

One of the highlights, of course, was meeting my literary idol, Pat Conroy. *The Prince of Tides* is my all-time favorite book (and movie). When I saw Pat wearing an apron and serving barbeque to a room full of book club members, I loved him even more. But when I saw him standing in line to get several new authors to sign their books for him—books he purchased—I was speechless. All the authors were like this—there weren't dividing lines between the *New York Times* best-selling authors and the first-time authors and the readers. Everyone joined together to celebrate books. To celebrate stories.

On Friday night when I saw Nicole Seitz dressed as "Cicada Barbie" with giant insect wings, in honor of her newly published novel *Saving Cicadas*, I had to have my picture taken with her. (I was "Mod Barbie.") We bonded over conversations about writing and our shared Christian faith, and ever since, Nicole has been a

mentor to me, encouraging and guiding me through the publication of five books—six, including this one. Our relationship is symbiotic, as Nicole contributed essays to two of my anthologies, and she crafted the original artwork for the cover for this one.

Since Saturday evening was the Great Big Ball of Hair Ball, with *The Wizard of Oz* as its theme, I went as the Wicked Witch, wearing a black hat and wig, and a green T-shirt that read, "The Flying Monkeys scarred me for life." This was before the musical *Wicked*, but I already had a love for Elphaba, and similar wounds from childhood. The weekend was fun, but it left me wanting more. I wanted to come back as a Pulpwood Queens author. It took eight years for that dream to come true.

In January of 2018 I returned to Girlfriend Weekend, dressing as an artsy hippie for the "Bohemian Rhapsody" theme. Two of my books were official Pulpwood Queens Book Club selections: *A Second Blooming: Becoming the Women We Are Meant to Be* was the February selection that year. It is an anthology I edited with essays by twenty women, several of whom were already Pulpwood Queen authors. My novel *Cherry Bomb* was a bonus book for March. It was surreal being on two panels that weekend, and later Skyping with several book clubs, some as far away as Las Vegas, Nevada! Another highlight of the 2018 weekend for me was the keynote speech by author Lisa Wingate, who wrote my favorite book of the year, *Before We Were Yours*.

And what a joy to return in 2019 for the "How the West Was Won" weekend. My second anthology, *Southern Writers on Writing*, was the January official book selection, and our panel of

contributing authors kicked off the weekend's celebration. I loved meeting Paula McLain and hearing her keynote. I had read and loved all of her novels, and when I got home, I read her memoir, *Like Family: Growing Up in Other People's Houses,* about her experiences as a foster child, which endeared her to me even more. It was equally fun to reunite with fellow authors I don't see in person frequently and to visit with book club members from all over the country. Although the Pulpwood Queens are an international group and not primarily southern, I loved being with fellow Mississippi authors such as Michael Farris Smith, Johnnie Bernhard, and Julie Cantrell, who isn't really from Mississippi but had lived in Oxford quite a few years. And my fellow Tennessee authors, River Jordan (who also gave a great keynote) and newcomer and fellow Memphian, Claire Fullerton, who was on a panel for her excellent novel *Mourning Dove.*

There is a large Pulpwood Queens Book Club in my hometown of Jackson, Mississippi, and they always show up in spades. Groups from many other states came to the 2019 event, and a great time was had by all, especially at the ball on Saturday night. Line dancing in costumes as hilarious as cows with protruding udders, a woman dressed as an oil well, and quite a few courageous women who represented the music, literature, and history of the west. I went as the Yellow Rose of Texas. We celebrated our love for each other and our shared love for books at the best literary event in the country.

As editor of this book, I'm honored to call Kathy L. Murphy my friend and to celebrate the 20th anniversary of the amazing Pulpwood Queens!

Finding Pulpwood Queen Friends on the First Day

Sara Dahmen

"There are no strangers here; only friends you haven't met yet."
—William Butler Yeats

The first day I traveled from Wisconsin to attend the Pulpwood Queens Girlfriend Weekend 2017 in Nacogdoches, Texas, I had no friends in Dallas, and I knew about five people total in the state of Texas. It was night when I landed in Love Field, and I'd booked a hotel room so I could sleep before driving halfway across the state.

Trouble was, I didn't know two Dallas airports existed. So when the taxi driver picked me up and took the address, he drove me miles away to the *other* airport hotel!

Which meant the next morning, I needed *another* taxi to drive me back to Love Field to pick up my rental car.

Luckily, I don't believe in signs.

Driving to Nacogdoches without tolls meant I meandered through a rainy Thursday morning and country roads, hoping I wouldn't run out of gas before I discovered a town big enough to have a gas station.

It was lovely countryside, and I kept awake by having pretend conversations between myself and whatever *Game of Thrones*

character I was crushing on at the time. (Don't tell my husband otherwise he'll tease me every time we watch an episode!)

I arrived in Nacogdoches with my giant suitcase full of costumes and copper, and the poor gentleman who owned the B&B nearly fainted lugging it up the stairs in a grand gesture of southern hospitality. It was my first taste of that. As a northern girl who is used to pulling her own weight in a metal shop and then some, it felt odd. I wondered what people would think about the crazy story I brought: I was a coppersmith as well as an author, and my novels and my cookware were deeply intertwined. Would I be able to explain myself when it was my turn on the stage?

Do I tip the guy who owns the B&B? Probably poor form?

I was supposed to pick up the lovely author Alyson Richman from her hotel and give her a ride to the first meeting.

But there was road construction and traffic. Alyson's hotel driveway was blocked, so I went through the backroads to see if there was another entrance. I considered taking a trail. I mentioned she could hike through the brush to get to my car. It was likely a short distance and the brush was mostly dead.

No, she didn't think that would work. Looking back, I don't blame her that. It was an insane, desperate idea.

She was able to swing a ride, and the first author meeting was wonderful. The only person I knew was Kathy L. Murphy herself, and she was exactly as she always is: welcoming, enthusiastic, and warm. It is no wonder people flock to her joy.

That night I trekked through the rain alone.

Not knowing anyone in town, and never one to shy away

from dining by myself, I slipped into a restaurant to grab a bite. I mean, eating alone has perks. You can order without judgment. You can work and eat at the same time, being doubly efficient (the best thing!).

And sometimes, you get to meet fascinating people.

I had barely sat down before I struck up a conversation with the couple sitting next to me, which led me to change my seat and eat dinner with two lovely, wonderful souls who have become "Mom" and "Dad" to me and "Grandpa Betty" and "Grandpa Bill" to my children. Betty Hunt Koval is a member of the Pulpwood Queens Book Club of Decatur, Alabama. As I settled myself into the chair next to her and explained who I was, she exclaimed with delight: she'd read my bio and was hoping to chat with me, the metalsmith author. Well. That was a good sign, if I believed in signs. The Kovals have since become part of our family, visiting us in Wisconsin and spending time with the kids. It was a sign of what was to come the entire weekend, but I didn't know that at the time.

It was clear I was a bit of a fish out of water. There wasn't anyone at the event from Wisconsin. I know, because my friends and I are the only Pulpwood Queens Chapter in the state. (Yes, authors can be readers, too!) But the weather showed my otherness. Everyone was in five sweaters, coats, boots and pants, whereas I was happy in a dress and sandals, regardless of the rain.

I mean, it was 60 degrees outside! That's positively balmy.

No one seemed to care about my bare legs in winter, though. All—from authors to readers—welcomed me with wide open arms and delightful conversation. Every. Single. Person. Tex-

as was warm. And, it became clear, so was everyone at the Pulp-wood Queens Girlfriend Weekend.

Maybe it's Kathy's infectious, glorious joy. Maybe it's southern hospitality. Maybe it was the 1:00 a.m. conversations at the B&B with authors Kathryn Casey and Karen Harrington. Maybe it's because there are costumes.

No matter the reason, I left Nacogdoches knowing I'd be back. I'd made far too many dear friends, whom I needed to see in person, even if it was just this one time every year.

I left Texas (using the correct airport), about 500 friends richer.

And isn't that the point of it all?

If There Were only One Space Left in Heaven and Kathy L. Murphy Were next in Line behind Me, I'd Give It to Her

Patricia V. Davis

Let me tell you why.

I was an adult before I read Roald Dahl's *Matilda*, but that children's tale certainly hit a nerve. Growing up, Matilda's life was my life. Apart from the telekinesis and the sweet, tragic figure of Miss Honey who rescued her from the Wormwoods, that is.

For me, there was no liberation from a mother and father who believed that allowing a female offspring an education was not only useless, but dangerous. My parents lived in a world of fear, superstition, and repressive boundaries. To my parents, sending a girl off to college would "ruin her chances for marriage," and that was a tragedy for me, because marriage was the last thing on my mind when I graduated from high school. I wanted to be a writer and a teacher, both dreams I'd held since for as far back as I can remember. I felt as though I'd been born for these purposes—to learn, to teach, and to write.

I remember going home from school with all my college applications, excited because my guidance counselor had told me my grade point average and test scores were high enough that I could apply for some wonderful schools and even some scholarships. I got the shock of my life when I saw my mother's horrified

face, heard her say, "*You're* not going to college."

It didn't seem as though it could be real. I knew my parents were strict, wildly so, by the standards of the parents of my high school friends. No babysitting as a teen, no sleepovers at friends' houses, no parties, no dating until I was sixteen, and even then, the most casual boyfriend had to sit and be grilled by my parents, so needless to say, there wasn't much dating for me, either. I suffered through all that, and lived, but if I was not able to go to college, I knew it would kill me.

I argued. I begged. I cried. And then, on the advice of a friend, I asserted myself. "When I'm eighteen, I can go. I'll be an adult," I told my mother.

"If you do, you will never be welcome in this house again," was my mother's response, and to a daughter such as me, one who'd always sought her parents' approval, that prospect was even worse than not going to college. It was years before I could accept and live with the knowledge that my mother simply was not able to love me, was incapable of seeing the detriment she was to my welfare. There are parents who regard their own children as a commodity at best, and an excuse for their own misery at worst. My mother was one of those parents. She was looking for reasons to dislike me as much as she did. This college impasse would be one of many.

My father intervened. Marginally, as was his way in so many other face-offs between my mother and me. It was suggested that I could go to a local, two-year college, one where I could live at home, as good girls do until they marry. My mother finally

agreed to this, on the condition that I pay the tuition myself, pay for my own car, and all my other expenses.

By choosing the path my mother wished for me, I made my life so much harder for myself than it had to be. I had to take a smaller course load so I could hold down two jobs, and my two-year college degree took two and a half years to complete. And I did something else to please my mother: I got married to someone she liked, someone who promised me that if I married him, he would "let me" finish my four-year degree. I was more excited about getting that diploma than I was about that marriage certificate. But, as for the boy I married, he had his own hidden reason for wanting the marriage, and that reason was just one more tragedy for me.

Despite what he'd promised, I did not attend school during that marriage. Thirteen months later, just around the time most of my high school friends were graduating from universities I'd qualified for, I still had no diploma, and, at twenty-one years old, I now carried the added "disgrace" to my family of being a divorcee.

Fast-forward thirty-four years—years that included therapy, weight loss, and a long, drawn-out severing of ties with my birth family. In that time period, I obtained a bachelor's degree in creative writing and a master's degree in education. I taught in the New York City public schools and overseas. I lived seven of those years in Greece, working there for Scholastic International as their exclusive representative in Greece and Cyprus, and owning an English-language bookstore. I had another marriage that, this time, lasted almost twenty years. I came back to the United States, got

divorced again.

I was over fifty years old before I wrote and published my first two books. Both were non-fiction aimed at women. The first was the memoir, *Harlot's Sauce*, which in part details my travels, but mostly details what a mess I was and how badly I'd screwed up. In that book, I made screwing-up sound humorous and fun, even though it most certainly wasn't. The second, *The Diva Doctrine*, was a treatise for young women on how *not* to screw up, written by an older woman who had screwed up, and badly.

I also founded The Women's PowerStrategy™ Conference, which was a conference aimed at those who came from backgrounds like mine—women and girls raised in exploitive, authoritarian environments who'd been brought up to believe they shouldn't and couldn't dare to be anything more than they were told to be. Those in need could attend the conference for free. It was funded by donations and by individuals in every area of expertise from technology to literature to science, who volunteered their time to speak.

Anyway, it was through this conference that I learned of Kathy L. Murphy. Always on the lookout for new, inspiring speakers, I heard of Kathy through Sam Barry, who was married to Kathi Kamen Goldmark, whose novel, *And My Shoes Keep Walking Back to You*, was published posthumously. Sam had been on a mission to make sure his wife's novel was published after she lost her life to breast cancer, and he made it happen. But it was Kathy who made that novel a Pulpwood Queens selection.

This alone put me in awe of Kathy—that she would do

such a thing to remember an author who'd been lost too soon. Kathi Goldmark was no longer here to come to Pulpwood Queens weekends or speak at book clubs, but that didn't deter Kathy from honoring her wonderful novel. Let me tell you, in the life I'd lived, it was rare to see that kind of sincere generosity.

Apart from that, I was awed by Kathy's accomplishments. Through her support of literacy and her myriad of other projects, she was making the world a better place, and that was something I wanted to do. As much as I wanted to catch up on my writing career, after all the years I'd wasted on trying to be the good daughter, the good girl, the good wife, I also wanted to help other women, as Kathy was doing.

Kathy was a role model for me, and it took only our first telephone conversation for me to see the incredible human being behind the hard work and achievements. We spoke for over two hours. She was warm, down-to-earth, compassionate, funny. And like me, she was dealing with her own heartaches. They hadn't made her bitter, something I was in danger of becoming. They'd just made her more determined. And that was a vital life lesson for me.

By the time I'd written my first novel, *Cooking for Ghosts*, I so badly wanted her to notice it. I've grown a thick outer skin over the years, but even so, at my core, I've never completely lost that need for approval that had been bred into me from childhood. I was in my late fifties, and I knew that I was way behind the curve when it came to achieving any kind of recognition for my writing.

Thank heaven readers seldom care about any of that. What

a reader wants is a good book, and I do my utmost to make sure I give them one. That's what truly matters, and that's all that should matter. But I confess, I so, so, *so* badly wanted Kathy to choose my novel as a Pulpwood Queens selection.

Why would I want that validation from the Pulpwood Queens, and not some other award or accolade? That's easy to answer—it's because the Pulpwood Queens are run by Kathy, and when I grow up, I want to be Kathy. I want to be creative and full of joy, I want my heartbreak to make me not bitter, but compassionate, I want to keep the world literate, I want to let everyone know that they're welcome to be in my circle no matter who they voted for, what color skin they have, or what god they worship. And I want to be surrounded by women who have my back, because they know damn well I have theirs.

That's who Kathy is, and if she were to pick my book as a Pulpwood Queens selection, well, then, honestly? You'd think, since this was so important to me, I'd have mentioned to her that I had a novel I wanted her to read. But of course I didn't. What if she didn't want to read it? Or worse, what if she read it—a book I'd put my soul into—and she said, "Meh."

I can take a "meh" from many people. I had less than a "meh" from my own mother and survived. But if Kathy said she didn't like my book, well I don't know how I would have felt. It might hurt too much.

So, I didn't ask.

Don't get me wrong—it's not like I didn't hint. Kind of. We were on social media together, and I was posting about my upcom-

ing novel everywhere, as they tell you to do. I thought—hoped—she might notice. And if she didn't say anything, then I could say to myself, "It's not that she doesn't want to read it. It's just that she didn't notice." This, as opposed to asking, and, "Just let me die right now—she said 'no.'"

As it happened, one day I got on Facebook, and there was a notification from Kathy L. Murphy. It read, "Patricia, I hope I get to read your book."

The minute I read it, I could feel all the blood rush to my head. Right away, I sent an email to my agent: "Kathy Murphy. Pulpwood Queens. She wants to read my book! What should I do?"

He wrote back with this wise advice: "Send it to her."

I sent it to her and didn't hear back for months. For all those months, I fretted. The reason being was that I genuinely liked her, and now I had the new concern that if she just didn't find the story to her liking, maybe she wouldn't be able to tell me. Maybe she'd "ghost" on me, and I'd lose the presence of someone in my life that I truly admired.

To prevent that from happening, I contemplated sending a follow-up note:

"Hi, Kathy. Just wanted to say hello, and listen—if you don't like the book, no hard feelings, because I'm not that way. I understand we all have different taste in books, and I hope you and I can still be in each other's lives."

But, no—that would just sound desperate, wouldn't it? I shouldn't send the note.

I sent the note.

She still didn't write back to me.

Another month went by. Then came the message, "I'm sorry I haven't been in touch. It's been so busy. I can't put you on the roster for this year—"

Oh, no. Oh, no, no.

"—but I'd love to put you on for next. Let me know if that works. Kathy."

That's when I started to cry.

And this is why, if there were only one space left in heaven, and Kathy L. Murphy were behind me in line, I'd give it to her. She deserves heaven more than anyone I know. She validated me and my work, when I so badly needed it.

Kathy, I hope this painfully honest essay demonstrates to you how much your influence means, not only to me, but to so many others. Thank you for shining a light on my writing, thank you for being a light in so many lives. Thank you for being you.

Long Live the Queens!

Jessica Brooks Dougherty

Moving to the small town of Jefferson was a bit intimidating in that so many people are related and already have close-knit social circles. A few months after moving to the area, I read about Kathy's Girlfriend Weekend in an area publication. I stopped by her then salon / beauty shop and knew I wanted to be involved. An avid reader, I knew I had nothing to lose by joining the Pulpwood Queens of Jefferson, Texas.

The first meeting I attended was a swim party! Nothing like discussing books in swimsuits and in a pool to break the ice. We were discussing *The J.M. Barrie Ladies' Swimming Society* by Barbara J. Zitwer and the publisher sent Kathy swim caps featuring the title. What a fun night! I knew then I had found a great group of ladies. We all have different backgrounds and beliefs, different religions and political leanings, but books tie us together. I've loved being a Pulpwood Queen and discovering so many amazing books I never would have heard about or chosen to read on my own.

And Girlfriend Weekend is the biggest jewel in our tiaras. What an amazing thing to be surrounded by book lovers and to have access to so many talented authors! Long live the Queens!

Intentional Literacy: Doing It On Purpose

Sharon Feldt

I met Kathy L. Murphy in January of 2018 when my book club friend, Jan Doerr, called about going to an event in Nacogdoches. She told me it was a gathering of writers, and even though it lasted all weekend, we could just go for one day. She emailed me the website for the Pulpwood Queens Girlfriend Weekend. After looking at the activities, I signed up for the entire conference and the Friday night dinner. Jan had known Kathy from her Longview days, and when we entered the conference Kathy bear-hugged both of us like we were *all* best friends! I felt an immediate connection with this smiling, wildly-dressed, big-haired woman! We went to the Friday night dinner. What a hoot—best time ever, *I thought*—but still ahead was the Great Big Ball of Hair Ball. The Pulpwood Queens and Timber Guys *do* know how to party—and honor authors, readers, and writers! The weekend was fabulous—meeting authors, listening to their stories, connecting with other readers and writers, and dressing up. We must have bought out Walmart's entire stock of leopard print fabric and all accessories pink and/or leopard print!

Kathy and I managed to chat a bit between panels and I realized she lived just down the road from me, about an hour away (that's *just down the road* in Texas). I invited her to our book

club—the Bright Star Literary Society of Sulphur Springs (the Literary Lovelies). Kathy and her friend Tiajuana Neel came to the very next meeting and we joined each other's book clubs! The rest is history. I cannot imagine my life without books, and can't imagine a January without the Girlfriend Weekend, the connections, the celebrations of literacy, the encouragement of writers, and the fun it involves. This past year five Literary Lovelies attended the Girlfriend weekend. I'm sure more will be going next year—it's just too much of a good thing, in so many ways, to miss.

Kathy's first book, *The Pulpwood Queen' Tiara Wearing, Book Sharings Guide to Life,* is not just a fabulously fun book to read. It is a serious encouragement to finding one›s inner strength and one›s passion and going after it! Kathy, tiara-wearing, big hair, wild hats and all, gives solid advice about the importance of God, friends, books, and the power of literacy in regrouping after a hard blow, and moving forward, onward and upward. We all have difficulties at some point in life. What we do about them, the choices we make concerning those very difficulties, determine our next path! There are hundreds of notable quotes from spiritual and government leaders, authors, poets, and friends that strike home, encouraging us all to be courageous, resilient, and determined. Kathy also revels in the glorious beauty of life— the wonders and the opportunities we are given—urging us to recognize them with an attitude of gratitude.

Kathy hasn't started just another book club with the Pulpwood Queens and Timber Guys. She has started a movement celebrating our Creator, celebrating literacy, celebrating our passions,

celebrating discovery—of ourselves, of inner strength, of resiliency. She's all about connections: to one another, to great literature, to God, to creativity. And she makes those connections work not only in her own life, but she makes them possible for others with the events, the gatherings, the books, the authors, the readers she brings together. She's all about helping one another, too. We all have different gifts, and combining and using those gifts for good can make miracles happen. Good literature itself is a gift. We can't help but become a little bit better inside when we read good books, because each one has a message. Maybe the message is *for* us, or maybe it's *about* us, or about someone we know. Each book can transport us to a new awareness, a new perspective, a new path or a new world. Perhaps one of my favorite quotes from her book is by Dolly Parton: "Find out who you are and do it on purpose." But do it with kindness and you will go far. And that's what the Pulpwood Queens Book Club is all about.

What Happens in East Texas Stays in East Texas

Jamie Ford

2018 marked the fifth time I've attended the annual Pulpwood Queens Girlfriend Weekend, which for authors is sort of like Coachella meets Burning Man with a little bit of Elvis thrown in for a hunka-hunka good measure. (And twice they've had world-class Elvis impersonators, so I'm not even kidding.)

In other words, you have to be there to fully understand this phenomenon.

The Pulpwood Queens began as one humble little book club founded in Jefferson, Texas (Pop. 1967), by Kathy L. Murphy, who owned Beauty and the Book, a salon/bookstore where you could read *Cutting for Stone* while Kathy cut your bangs.

Now they number over 750 affiliated book clubs all over the world. Their book-loving members wear tiaras, leopard print everything, and a lot of pink! (I tried writing that sentence without an exclamation mark, but it just *needed* to be there.)

Once a year, scores of these book club members make the pilgrimage to East Texas for a book love explosion of author panels, keynotes, dancing, and costumes galore.

A few years ago, the theme was "Around the World with Books" so I went as a steampunked Phileas Fogg, complete with a wearable hot air balloon. That was my fourth year, and I'd learned

that you can't overdo it when it comes to costuming. These ladies go all out. I was also honored to be co-hosting, which meant I got to do a lot of the interviewing, instead of being the interviewee, which was exhausting, exhilarating, and an all-round good time.

Plus, it's always nice to meet other authors, make new friends, spend time with fellow travelers on this weird, magical writing journey. I got to rub elbows with a Pulitzer Prize winner (Bill Dedman), a Nobel Prize finalist (Pan Montandon), and one of the ghostwriters for the Hardy Boys (Joe Holley).

Last, but not least, I was gobsmacked to learn that my novel, *Songs of Willow Frost*, had been voted the Pulpwood Queens Fiction Book of the Year. You'd think those highlights would be enough to sum it all up, but no, there's so much more.

So with that in mind, here are my Top-10 Pulpwood Queens moments:

10) Going to the exquisitely-named, Cooters, the only liquor store in town, to grab copious amounts of booze for the evening's festivities and running into a who's who of bestselling authors all doing the same. I'd tell you their names, but what happens in East Texas stays in East Texas. Except for photos. Those get shared on Facebook.

9) Watching the great Marshall Chapman play an electric guitar slung so low it almost graced her ankles. Marshall, in her youth, had been told by Jerry Lee Louis to "slow down." At nearly seventy years old, Marshall still wasn't listening.

8) Dressing up as the White Rabbit from Alice in Wonderland (my wife, Leesha, was the Dormouse). As I donned my ears and bowtie, fellow author, Mark Childress, said, "There will be photos of you in that outfit for the rest of your life." I'm totally okay with that.

7) Joseph's Riverport Bar-B-Que. I've woken up in the middle of the night craving their brisket and ribs. Oh, and one year all the cookbook authors prepared dinner, which was equally amazing. I still long for that bread pudding made with Krispy Kreme Doughnuts.

6) Gloria Loring speaking candidly about her successes and struggles in Hollywood as an actress, singer, wife, and mother. I cried. Gloria cried. Everyone cried. Her story was so moving I'm sure there are people out there still crying.

5) Meeting my hero, Pat Conroy, who was kind, funny, charming, and had a generosity of spirit that seemed to change anyone he came in contact with for the better.

4) Having some ladies point out that one of their book club members wasn't dancing because she was too busy reading my first book at their table. I asked her to dance and she happily joined me for a few songs, before excusing herself to finish the last thirty pages.

3) Sharing an Airbnb with the Hepinstalls: Kathy, Becky, and Polly, who insisted on warming up my coffee cup with boiling water and feeding me as though I were going off to war. Also, there was a boarded-up building across the street that we still refer to this day as "The Murder Shack."

2) The Sexy Reading Contest. This is where the few guys in attendance get up for a friendly reading competition as they read a random page from a random book in their "sexy voice." I've never felt so objectified and exploited. I sure miss those times.

1) The friendships. With readers, writers, B&B owners, and Kathy herself. I remember going to my first Girlfriend Weekend, alone, and leaving a few days later with lifelong friends. Good people are the real riches in this life and with the Pulpwood Queens I've struck gold. I love you all.

Most Definitely Not in Kansas Anymore

Joe Formichella

Back in the summer of 2005, Suzanne Hudson and I were on book tour together, she with her second novel, *In The Dark of the Moon*, and me with *Here's to You, Jackie Robinson*. Suzanne dubbed it the "Sex and Diamonds Tour," as she is fearlessly wont to do. Halfway to our first stop, to speak before Anita Paddock's library group in Fort Smith, Arkansas, we found out our publicist had quit not long before and that other than a few book festivals, nothing else had been scheduled by the publishing house, despite the repeated conference phone calls. We were either too naïve, too excited, or having too much fun to be distracted by the news. Suzanne, at least, didn't miss a beat, while I admit I did have some palpitations. In other words, left to my own devices, I can be a worrying Tin Man, stuck on *what-ifs* and *buts*. Hudson, of course, is the always optimistic Dorothy, oil can at the ready. I'd used all my allotted vacation days so we could tour during Suzanne's summer break from teaching. Did it still make sense to devote so much to a "tour" that had been reduced to a handful of events we'd pre-arranged ourselves, spread out over the ten weeks and scattered across Dixie? "Of course," she answered before I could even think of rusting myself again. "Keep going."

She, road maps at the ready, was going to start calling ahead

to bookstores in our meandering way, and said we'd just stop at any others we saw along that path. "Besides," she said more seriously, "we've got to find the perfect enchilada!" So we did, and it turned out to be the very best thing we could have ever done for ourselves as authors, and then some. Not for the Mexican cuisine—we're still on that quest (I'm told there's a candidate in Indiana, of all places). For it was at the end of that *ad hoc* tour that we chanced to meet the "book-sharing" queen wizard herself, Kathy L. Murphy (then Kathy Patrick).

From Fort Smith to Blytheville, to Kansas City, then Charlotte, Beaufort, down the Georgia coast through the Velvet Corridor, up to the book impresario of Birmingham, Jake Reiss, down the literary pipeline from Oxford to Jackson and Hattiesburg, eventually to Ponchatoula and then New Orleans, Bay St. Louis, and Bienville Books, stopping at every bookstore and library that would have us, and even those that wouldn't. Don't even ask me how many books we sold on the "Sex and Diamonds" tour. Haven't a clue. What I remember is getting to meet the legendary Buck O'Neill at the Negro League Baseball Museum in what turned out to be the last year of his life; the fire evacuation from the top of the Bank of America building; being treated like rock stars thanks to our dear friend, the late Carl T. Smith and Bay Street Trading Co. book store; tracing and retracing the short stretch of Highway 25 that is Eulonia, Georgia, trying to find the mythical Virginia and Howard Hicks and their Books on the Bluff; stopping at every single little town in southwest Georgia—because that's where *Moon* is set and where both Jackie Robinson and the hero of my book, Jesse Norwood,

were born—and leaving copies at either the bookstore or library: the places were so small, I don't remember any of them having both; Tom Franklin's raucous birthday party and having a chat with Barry Hannah; Suzanne's Mississippi Public Broadcasting television gig with Ellen Douglas and Tayari Jones; and our surreptitious disappearance for a weekend off the radar at the Horse Creek Marina that turned into three days, and then four.... (I'll only tell you that it's somewhere in Tennessee. It's our secret. Stay away!) But none of that, none of it—not the *Book TV* appearance or the salsa in an Albany, Georgia mall that liquidated Suzanne's sinuses (there happened to be a traveling semi-pro baseball team in the food court at the same time, Hudson prompting me, "Give them your book," to which they responded, "No thanks, we don't read." Sigh.)—prepared us for our visit to Jefferson, Texas.

All along the trek we kept hearing from different authors, "You have to go to Beauty and the Book." We called Kathy, and without hesitation she invited us. When we arrived she was in the midst of promoting that month's Pulpwood Queen selection, *Saints at the River*. Ron Rash was in town, as well as a whole bunch of tiara-wearing book club members, but she folded us right into the mix, introducing us around, giving us the obligatory haircut-and-style makeovers, the author photos, sharing the radio microphone with Ron over in Shreveport. It was dizzying, and magical. That old clunker she was driving that she toted us around in could have been a state fair hot-air balloon, I swear it. And before we left, she insisted that we had to come back for Girlfriend Weekend in January. We did, and it was non-stop authors and readers and panels

and books. It was outrageous and exhilarating and more than a little exhausting. So we went back again the following year.

Not long after that all hell broke loose in the book industry, as well as the rest of the economy, and everyone, it seemed, "went to the mattresses," as some of my extended Italian family say (I'm told). Little by little we climbed our way out of that mire, through feckless publishers, witless bean counters, demonic publicists, and a host of other peripheral tribulations, and there she was, none the worse for wear, as far as I could tell—though, as she says, "We all added on a little bit more life,"—the Pulpwood Queen, still at it, still as enthusiastic and infectious as always. We returned to Girlfriend Weekend in 2019 after a dozen years' absence, but not a whole lot had changed in the interim. The wizard, Kathy Murphy now, still presides over the whole delightfully crazy event, and all the authors, all the readers, all the help—which has grown to include family members, now that they're grown—the local judge, even the mayor himself, happily, giddily, go skipping down that yellow brick road, because Kathy knows where Oz is, and when she says click your heels three times and repeat, "There's no place like home in a good book," you do it.

As we look forward to the twentieth anniversary of Girlfriend Weekend, Hudson and I have our work cut out for us. See, the theme of this past year's "Big Ball of Hair Ball" was "How the West Was Won," and Suzanne dressed me up as *Gunsmoke*'s Miss Kitty to her Chester. (There's a picture somewhere of Tim Conroy wooing me, but we'll both deny it.) Reavis Wortham, Kathy's co-host, saw me in drag and made a beeline to our table as soon as

he entered the ballroom. Let me tell you, when a genuine, handlebar-mustachioed, Stetson-wearing, "this town ain't big enough for the two of us," Paris, Texas, cowboy shakes your hand and says, "You got bigger balls than I do," well, the bar can't get much higher. Not sure how we're going to top that one, but we're going to try.

Finding My Tribe

Claire Fullerton

I know a woman with her heart in the right place when I see one. This is what I kept thinking as I boarded the plane to Los Angeles after the Pulpwood Queens Girlfriend Weekend, my head still in a whirlwind, my feet yet to touch ground. Three action-packed days in Jefferson, Texas, and I settled into my Delta Airlines seat and leaned back, realizing that as I'd travelled to Texas, I knew I'd be involved in a book conference, but had no way of knowing Girlfriend Weekend would be way more than that.

As the plane reached its cruising altitude, I considered how to describe Girlfriend Weekend to my husband, who'd be picking me up at the airport. He'd want the details as clearly as I could cite them, but how to take the spirit of what I'd just witnessed and distill it to brass tacks? I wouldn't say Girlfriend Weekend was a book conference, though we were all there for the love of books. I wouldn't say it was a literary conference, though everyone there was certainly literary. It would be misleading to tell him that Girlfriend Weekend was a festival, though the combined energy of everyone there exceeded all definitions of festive. Two hundred attendees in tiaras and costumes fits the bill for a party, but I wouldn't cheapen three days of informative author panels by calling it that. I examined my powers of articulation. I'm a writer,

I thought, I should be able to say this succinctly. It seemed ridiculous to qualify Girlfriend Weekend as it was by putting into the equation what it was not. But how to put into words that it was the spirit of the weekend that impressed me most? That the pitch, roll, and tenor combined into a celebration that went beyond books
. The Pulpwood Queens Girlfriend Weekend transcended even its own description. It took a celebration of books and turned it into a celebration of life.

As the plane eased through the sky, my thoughts returned to the woman with her heart in the right place, and I considered regaling my husband about the weekend by beginning with her. Every fulcrum of activity has its rallying point, and in my experience of Girlfriend Weekend, Kathy L. Murphy was it.

Have you ever stood on a beach and watched a flock of seagulls flying overhead? It's hard for the observer to discern the leader, but it's clear one exerts their influence through telepathic will. Kathy was like that lead seagull at Girlfriend Weekend. Her steady enthusiasm was infectious, and throughout the weekend, I believe most of us felt we were in Kathy's house. Hers is a maternal kind of attraction—the kind where everyone in her sphere wants to put their best foot forward. I don't believe her charisma is anything conscious. She's simply one of those book-loving people that encourages authors and readers to step up.

And we stepped up collectively. What set Girlfriend Weekend apart from any other book-focused assembly was nobody took themselves too seriously. There were no illusions of hierarchy of importance, no line of demarcation between authors and readers,

and no suggestion whatsoever of egos involved. And the thing of it was, though I knew precious few before the weekend started, there was little need for introduction. There was no scrambling for common ground between authors and readers because we knew very well, we were standing on it. We each played our part in a unified front geared toward love of the written word, and I could feel it. The love of books may be esoteric to some, but for all of us at Girlfriend Weekend, it was a touchstone.

It's not often enough one is graced with the opportunity to meet one's own breed of cat dressed in costume. That tiaras and costumes were required at Girlfriend Weekend was a big help, of course, in fact, it was a stroke of genius. Costumes are a tremendous equalizer in any assembly, and word was, the more outrageous the better. Readers and writers are thought to be the erudite sort, but 2019 Girlfriend Weekend's display of creative costumes, culled from its theme, "How the West Was Won," ranged from the sublime to the gloriously silly.

By touchdown at LAX, I'd arrived at a succinct description for my husband. I'd found the words to parlay the weekend's unique spirit. I'd begin with Kathy Murphy's heart being in the right place and tell him, in a confluence of costumed book lovers, I believe I'd just found my tribe.

The Butterfly Effect and the Power of a Visionary

Connor Judson Garrett

The culture of a business or an organization is a direct reflection of its founders and leadership. It's not a coincidence that the Pulpwood Queens' culture is warm, welcoming, colorful, passion-driven, and a bit eccentric—all characteristics shared by its vivacious creator Kathy L. Murphy.

Before I met Kathy, my mom, author Echo Montgomery Garrett, had raved about her for years. Mom told me that nobody is doing more as an advocate for writers and books than Kathy. My first encounter with her came when the Pulpwood Queens founder took the time to read my debut poetry collection and gave me the opportunity to come to Girlfriend Weekend to speak on the author panels.

Even though my mom had been to Girlfriend Weekend before and had given me an idea of what to expect, I don't think I had grasped how much it would change my life. I went in with an open mind and an open heart. My first impression was of the host city itself—Jefferson, Texas—a small town, quiet outside of the occasional train passing through the night, idyllic, somehow kept pure and untainted. I felt like Edward Bloom from Daniel Wallace's novel *Big Fish* when he stumbled into the fictional town of Specter. I wouldn't have been shocked if the townsfolk all stood in rows

along main street waving just as they did in Tim Burton's hit movie adaptation. At night, the storefronts appeared to be lit by lamps and candles. There was no neon or spotlights, just lights strung over porches and around the bridge. You wouldn't find Jefferson unless you were meant to. It is a place for writers, a place for clear heads and soft hearts. A place that no matter how brief your stay, could create the illusion of home. Kathy knew this when she chose Jefferson to host us.

That next day we got ready to speak. I didn't know what to say or how everything was going to play out. In fact, I was arguably the least seasoned author in the room. At least half of my fellow speakers on the panel had written *New York Times* best-sellers. But when it all began, nobody held themselves in higher esteem than the others or with any sort of air of superiority (in fact, the most successful writers like Julie Cantrell and River Jordan also happened to be some of the kindest). The crowd of devoted readers, authors, and everyone who had traveled from far and wide to be there, was kind. The saying, "your vibe attracts your tribe" was once again reflected by Kathy herself. Each and every person I met was loving and gentle and as free of judgment as anyone I've encountered in the age of comparison culture. The audience asked questions, they were engaged, and most of all, it was clear that they were passionate about what we do as writers. It's said that without the reader's imagination, however, the writer can only develop a half-formed world. I was inspired to see the faces of people so deeply, madly in love with words, all there to support us in our craft and to enjoy each other's company. I burned to give them

more words, more ideas to devour. I understood why it is necessary that we engage with the world, and why we need to ensure that thoughts don't stagnate in our minds or fade into oblivion. The readers themselves were evidence of how words shape thoughts and how thoughts shape people. They were pure love, their glow warm enough to bask in. I imagined how beautiful the world would be if this culture of empathy and embraces was spread through the power of language.

The last night of Girlfriend Weekend was perhaps the most revelatory, fun, and quintessential to the spirit of Kathy and the Pulpwood Queens. We were all asked to dress up in western-themed costumes for the big dance. The costumes everyone had pieced together were flamboyant, bold, and of course, creative even when you consider we were in a room of artists. They played everything from "Come on Eileen" to "Thriller," and everyone danced. There was no hesitation to move and celebrate on the dancefloor. The Pulpwood Queens undulated in unison like flames, dancing dervishes.

What Kathy has built is a home for ideas, dreams, wordsmiths, and those who dare to be a little different. Empathy is the hallmark of a reader; heart is the shared gift of the Pulpwood Queens. I do believe in the butterfly effect—that one action as seemingly small and insignificant as the flap of a butterfly wing can trigger a monsoon on the other side of the world. Words and the people who read and share them have that same cause and effect on humanity. The Pulpwood Queens is a way of channeling that strength and reminding us of the power we yield in our writing.

Enveloped by Love

Echo Montgomery Garrett

After going through two literary agents and being rejected by more than sixty publishers over a two-year period, I faced the fact that I wasn't going to get a book deal for my project of the heart *My Orange Duffel Bag: A Journey to Radical Change.* My co-author Sam Bracken and I decided to self-publish, because we had a mission: to launch a nonprofit that would offer life plan coaching with teens and young adults experiencing poverty, homelessness, or aging out of foster care.

We started the Orange Duffel Bag Initiative in 2010 and launched our book the weekend I celebrated my fiftieth birthday. I never dreamed that God was about to give me the best gift ever.

When Monday came after our action-packed launch, I got the mail and then tucked in to take a nap. In one of the many book marketing newsletters I subscribed to, I read a feature story about Kathy L. Murphy, founder of the Pulpwood Queens, the largest "meeting and discussing" book club in the world. She described what she looked for in books. Kathy said that she didn't care whether a book was self-published or from a major publisher. She just wanted a great story to recommend to her thousands of book club members. This lady sounded like my kind of people.

I jumped out of bed and ran to my computer. I wrote her

an email explaining a little about our book and our cause, and then took a copy to FedEx. I was shocked to find a warm, lengthy response by the time I got back from dropping off the package. She promised to read it right away.

The next day I jumped each time the phone rang. While I was fixing dinner, I decided that maybe it didn't hit with her. Then she called, practically shrieking into the phone about how much she loved our book. She announced that she was making it her November 2010 book of the month pick.

Once she learned all that we'd been through along our self-publishing journey, Kathy made a promise. "If you sell 1,000 books this first month, I will dye my hair orange to match your book cover," she said. Our bright orange, canvas zippered cover was designed to look like the orange duffel bag in which Sam kept all his belongings as a homeless teenager.

I laughed out loud and accepted her challenge. Since she owned Beauty and the Book, a combination bookstore/hair salon, I thought it was a brilliant idea. When we hit the 500-mark she dyed a wide swath of her hair bright orange and chronicled our progress on her Facebook page. In a little more than two weeks, true to her word, her hair was bright orange. Her stunt got our book mentioned in "Shelf Awareness."

Sam and I experienced a little slice of the heaven that awaited us at the 2011 Girlfriend Weekend, and we were featured speakers at a faith-based book event that Kathy hosted that November. I've attended writers' conferences, but I was still unprepared for the Pulpwood Queens Girlfriend Weekend—the party

that Kathy presides over for authors and booklovers. I didn't expect to find my tribe in Jefferson, Texas. From the moment I was greeted by Tiajuana Neel, I immediately felt so at home and enveloped in love by this community of bibliophiles.

At the airport I met Diana Black, an invited author who also happened to be from Marietta, Georgia. She contacted me a month after we got back from that magical weekend in the storybook town of Jefferson. "I'm interested in doing some volunteer work with Orange Duffel Bag," she said.

I invited her over to my house, which was serving as headquarters for the nonprofit at the time. Within the month, she was the vice-president, a position she retains today. We never would have met if it hadn't been for Kathy inviting us both to Jefferson.

After some posts about the Pulpwood Queens and Girlfriend Weekend, I also reconnected on Facebook with Kimberley Cetron, a friend I had not seen since I'd lived in New York City and worked as an editor and freelancer. Two years later we were invited back to Girlfriend Weekend when *My Orange Duffel Bag* was picked up as the first self-published book ever acquired by Random House. Kimberley and I saw each other in person for the first time in more than twenty years and were roommates. Kimberley started a PQ chapter in northern Virginia, and we formed a tight bond. She's become one of my trusted readers for any project I'm working on, and I'm helping her with a book project she has in the works.

I devoured books and especially loved biographies and historical fiction when I was growing up. My dad Bob Montgom-

ery was a songwriter. The walls in our basement were covered with his framed sheet music and photos of the artists who had recorded his songs, from Patsy Cline, Eddie Arnold, Buddy Holly (my dad's best friend and partner in a rockabilly duo when they were teens), Herman's Hermits, and many more. From a young age, I understood that you could make a living with words.

I was a word nerd and kept running lists of words that I thought were cool and which I might use in my articles or books someday. At one of the first Girlfriend Weekends I attended I discovered that Pat Conroy did the same thing. At another, when John Berendt read a few descriptions of the quirky characters populating *Midnight in the Garden of Good and Evil*, he said, "Always write down your first impression of a place. You never get that chance again."

That comment stuck with me, and I've tried to put it into practice.

Authors like Shellie Tomlinson (*Suck Your Stomach in and Put Some Color On*) and Stephanie McAfee (*Diary of a Mad Fat Girl*) made me laugh out loud. River Jordan (*Praying for Strangers* and most recently *Confessions of a Christian Mystic*) made me weep and helped me reconnect with my spirituality at a time when personal tragedies and traumas had dinged my soul like a beat-up pickup truck.

The consistent success and persistence of Lisa Wingate (*Before We Were Yours*) and Patti Callahan Henry (*Becoming Mrs. Lewis*) reminded me to keep going and continue to tell my stories. You never know which of your darlings will captivate readers.

The lyricism and lush language in the work of Julie Perkins Cantrell, who won major awards at age forty for her first novel *Into the Free*, and artist/writer Nicole Seitz (*The Cage-Maker*) spoke to my heart. Julie sharing her story of letting a teacher's cutting words when she was in high school dissuade her from pursuing her heart's desire of being a writer reminded me of my own story. While my high school English teacher was key in helping me have the courage to write, my first college professor in advanced English hated everything I wrote. I didn't write anything of substance for a year. By sophomore year this first-generation college student decided that one person's opinion shouldn't block me from what I'd dreamed of since I was a child: to be a writer.

Julie's story reminded me that I needed to say thank you. I went home from that Girlfriend Weekend and wrote a long over-due love and gratitude note along with signed copies of some of my books and sent the package to Miss Sharon Tracey at David Lipscomb High School in Nashville, Tennessee. When I was in her class as a sophomore and again as a senior, Miss Tracey secretly entered my poems and short stories in contests. I won. Those affirmations fueled the literary aspirations of this shy, insecure girl. She called to tell me that I was one of the only students to ever write a letter about the impact she'd had on my life.

Over and over again I heard inspiring stories from authors, who had overcome all kinds of obstacles to get their books published. Fannie Flagg, one of my favorite authors ever, discussed her dyslexia and how winning a contest forced her to pen *Fried Green Tomatoes*. Many, many of my favorite books like Jeannette

Walls' *The Glass Castle* took years to write. Rejection was a common theme.

The one that hit me the hardest was Robert Hicks' story. He'd been a music business executive and was on the board of Carnton Plantation in Franklin, Tennessee. He tried for several years to persuade a writer to take on the incredible story of what happened there during the Battle of Franklin, where 10,000 men died in one day during the Civil War.

Finally, approaching age fifty, he decided to write the book himself. The result was the stunning, historical novel *The Widow of the South*, which became an international bestseller. I had heard the story of Carrie McGavock, the heroine in his novel, many years earlier when my husband Kevin and I had come home from New York City to visit family in my hometown. "This would make a great book," I said, but at the time I was chasing a book about Calumet Farms and the scandal of the suspected murder of the racehorse Alydar.

I was thrilled that someone had given life to the untold story of the woman who tended the graves of the fallen and spent the rest of her life writing letters to the families of the soldiers who died on her property. *The New York Times* gave Carrie her moniker "The Widow of the South."

Robert is a crusader—a believer that a book could keep history alive. His enormous success helped fund the restoration of Carnton, the battle ground, and breathe new life into the city of Franklin.

When we first met, Robert was the keynoter and had his

second novel out—*A Separate Country*. This raconteur's style reminded me of the wonderful storytelling that went on whenever I visited our relatives in the Texas Hill Country. I grew up listening to a mix of hilarious and heartwarming tales on front porches, down by the Lampasas River at our family reunions, or over a game of checkers or 42 dominoes. Robert, who had been orphaned many years before, spoke about the themes in his novels—grief and dealing with deep loss.

Late that night, he and I sat up at the bed and breakfast where we were staying, talking into the wee hours. In my work with so many traumatized teens, I'd dealt with deep grief as well as in my own life. Robert's books sparked many widows, orphans, and others to share their stories with him. We wept together as we spoke about some of the stories that had pierced our hearts and remained there. That night a connection was forged.

When I got an assignment from a national magazine to write about the music scene in my hometown of Nashville, Robert invited me to stay at his folk art-filled cabin. He graciously hosted me for a four-day romp through the art, music, and food scene. Robert starred in my story "Nashville Now," which was published in the award-winning magazine *Private Clubs*, and won an international award for best lifestyle piece from the North American Travel Journalists Association.

My husband Kevin photographed Robert and the gardens at Carnton for a story. My son Connor and I stayed with Robert on another trip back to Nashville. He has mentored Connor since that time, encouraging him with phone calls and feedback on his

writing.

Connor submitted his poetry book *Life in Lyrics* to Kathy, and she invited him to attend the 2019 Girlfriend Weekend. Like me, my son was immediately taken by the warmth and acceptance of the community Kathy has woven together. Julie Perkins Cantrell, Nicole Seitz, River Jordan, and, of course, Tiajuana and Kathy all made a special effort to be sure Connor felt at home.

A true artist whose gifts appear to be endless, Kathy sees the beauty in words, in people, in nature and music. Tenderhearted and kind, Kathy gives until it hurts—her time, her energy, her compassion, her encouragement, and her whole heart to support others, especially those who paint with words.

She has created a place where readers and authors can come together and celebrate the joy, comfort, and inspiration that books bring. Each time I've attended Girlfriend Weekend, I have loved hearing what drove those authors to write their stories.

Kathy and Girlfriend Weekend put the wind beneath my wings and remind me of the mission statement I wrote for myself in 2004: I write stories that inspire people to greatness.

I owe a big debt of gratitude to the woman with a heart as big as Texas and a vision to match: Kathy L. Murphy. Thank you for helping readers discover stories that they might not have otherwise seen and for giving authors a place to connect and find encouragement and build great friendships. Bring your daughters, your sons, your best friend, your neighbor to Jefferson for this wild and wonderful weekend. I promise you'll come away the better for it.

What Exactly Are the Pulpwood Queens?

Peter Golden

Nine years ago, when my first novel, *Comeback Love*, was about to be published, I was talking to Robert Gray, a columnist for *Shelf Awareness*, who lives not far from my home outside Albany, New York. I had been writing biographies and histories and knew little about the fiction market. Robert seemed to know everything, so I listened for quite a while, saying little, until he finished up by recommending that I send the novel to Kathy L. Murphy at the Pulpwood Queens.

"What exactly are the Pulpwood Queens?" I asked.

Robert smiled and gave me the short answer. "A group of book clubs. But trust me. Get in touch with Kathy."

Robert is eminently trustworthy, so I got in touch with Kathy and mailed her an ARC of *Comeback Love*. Eventually, we spoke on the phone, and she told me some of the Pulpwood Queens would be in New York City in May for BookExpo. Would I like to join them for dinner?

Yes, I would, and dinner, at a bright, crowded restaurant off Times Square, was a cheerful affair with Kathy, the energetic Pied Piper of the written word, and a group of equally passionate Pulpwood Queens.

Kathy selected *Comeback Love* for her book club, and I

thought it would be interesting to attend the January weekend.

"What's it called?" my wife asked me when I got home.

"Girlfriend Weekend."

"Oh?" she said, with an inflection that a husband, if he's smart, learns to dread.

We checked the Internet for pictures of Weekends past. My wife observed, with a sly chuckle, that at the Saturday party people were in costume, primarily dresses.

"I'm open-minded," I said, though I was happy to see that the men in the pictures—the Timber Guys—were wearing trousers.

I made my reservations, but as departure day approached, I was not that enthusiastic about going. First off all, to imagine Albany in winter, think Alaska with snow tires instead of dog sleds, and I avoided the outdoors. Then, to reach the event required two plane rides, frequently delayed in January, and a three-hour car ride. And finally, people like me, who have chosen to spend their adult lives in a room with only a cat and a computer, are not in a hurry to attend a Mardi Gras—even if it's in celebration of books instead of the last day before Lent.

"It's flu season," I said to my wife. "I could call and say I'm sick."

"What a nice thing to do," she replied with one of those tones that husbands discover it is best not to ignore.

So off I went, and following a trip that would have exhausted Jason and his Argonauts, I arrived. Shortly, I found myself sitting at a table by myself, watching the Pulpwood Queens and Tim-

ber Guys talking and laughing.

A writer, a woman, sat across from me, and before I knew it, we were talking about our sons going off to college and the assorted horrors of the empty nest.

Another writer sat down, and the conversation widened, and then another and—well, you get the picture—a bunch of writers talking, each one as friendly and interesting as the next.

Then I began to meet the readers, the sort of impassioned readers who make you believe that you haven't wasted your life by sitting alone with your imagination.

As of this date, I have attended three Weekends, all of them wonderful. Yet, what stays with me are those readers and writers I met.

Many of us keep in touch after those weekends. I don't find myself doing the things with them that writers are reportedly fond of doing—smoking opium or chasing big game across the Serengeti Plain. But they have remained a constant source of encouragement and help in a trade that does not always attract people with such a glimmering spirit of generosity.

So Happy Anniversary, Kathy, to you and your Pulpwood Queens.

For me, the reluctant traveler, your creation has been a joy. And a blessing.

The Morning Everything Changed

Mark Green

One morning, I'm having my coffee when all of a sudden I get a call from Echo Garrett, co-author of our book *Step Out, Step Up: Lessons from a Lifetime of Transitions and Military Service*. I can hear a little excitement in her voice. She says, "Mark, I just found out we're invited authors for the 2018 Pulpwood Queens event in Jefferson, Texas!"

I say, "That's pretty cool." Then she goes on to share with me that it is called "Girlfriend Weekend" and I respond, "Oh, um, I'm not a girl!"

She laughs and says, "That's okay, there are other guys there. They're called Timber Guys."

I am still uncomfortable. but I say, "I guess that would be okay," and then she says, "Oh, and there's one more thing. You have to dress up."

I'm like, "Dress up like what?"

She says, "The theme this year is Bohemian Rhapsody."

"What the heck is that?" I'm starting to rethink my decision on this entire venture. But I also feel that in order to support my book, I need to be out there doing things like this, so I thank her for calling and hang up the phone.

After I got off the phone, I Googled "Bohemian Rhapsody"

and a bunch of pictures of Johnny Depp popped up! Hats, scarves, bracelets, and v-neck white t-shirts, acid washed jeans, and black boots. I was way out of my comfort zone, being a rigid field grade officer. I decided, *what the hell*, so I went to the local Goodwill and looked for things that would work for the outfit. I bought a pair of old jeans, a scarf, a hat, leather bracelets, and a v-neck shirt. I figured if I was going to look silly I might as well look silly all the way.

I couldn't believe what that last year had been like, going from wearing a military uniform every day to writing books, posting on social media, and creating events for veterans across our country. I spent some time looking at Kathy L. Murphy's website, with more interest once I realized that hers is the largest book club in the world, and seeing what she has built with her incredible chapters of readers. I got to thinking about doing something for this incredible woman who has had such an impact on the literary world. I thought about titles for women like queen, goddess, and other titles given to magical women with incredible hearts, strong business skills, and golden pens in their hands. I realized that she probably is a goddess, so I had an idea.

I looked up an English proclamation and changed the wording to proclaim Kathy Murphy as a Pulpwood Queen goddess. When I told my son Adam about it, we came up with the idea to do a video with him reading the proclamation. We placed it inside a jeweled message tube I bought at an Afghan bazaar. The tube had been used to pass messages between different cities in Afghanistan. Adam pulled out the proclamation, put on his best English accent, and read it aloud as I recorded. Adam is quite creative and

finished the proclamation with, "from a budding author."

When I got to Jefferson, the weekend was an experience I'll never forget. I was on a panel looking out over a room mostly full of women from the southeast, with some of the best authors in the country. I was blessed and overwhelmed with their knowledge, their southern ways, and their kind and beautiful hearts. They taught me more about books in one weekend than I'd known in my entire life.

The authors were powerful and multi-talented. They not only love to write books but also love to get together and have a great time. They definitely got me outside of my comfort zone. Simon & Schuster gave out scores of books and the panels were incredibly informational. I was especially interested in real-life experiences that were written as novels. The book that I shared was a memoir about my life. It's scary to find the courage to write about your life, and the flood of emotion that comes from doing so changes you. It takes you back in time to relive the moments, but it's encouraging to realize that those moments are no longer affecting your life if you choose to see them as your past. My whole life has changed because I chose to have different responses to what happened in my life, and now I'm not afraid to share it. I am the top resilience and transition mindset veteran in the country. I have proclaimed it and I own that space. And up until my weekend with the Pulpwood Queens, I was only interested in nonfiction.

I never realized what I was missing by not reading novels. I always thought that they were just stories for ladies, and that was my mistake. I now have decided to write a novel, about the

coal mines in Missouri in the depression era.

Knowing that 2020 marks the 20th anniversary of the Pulpwood Queens and that I am a part of a historical event together with some of the best authors in the world humbles me. I am grateful to Echo Garrett, Kathy Murphy, Tiajuana Neel, and all who have welcomed me into the circle as a Timber Guy. If you have never experienced the Pulpwood Queens event, you need to add that to your bucket list. You need to come to Texas and kick up the dust, eat some great barbecue, hang out with some amazing authors, learn the history behind the Pulpwood Queens, and become a reader. Bring your big hair, your dancing shoes, your positive attitude, and a willingness to hang out and lose a little ego.

Book Goddess

Jim Grimsley

When I was visiting New Orleans in March 2015, having been invited to the Tennessee Williams Festival and the Saints and Sinners Literary Festival, I was seated in the lobby of the Hotel Monteleone, awaiting my first event. I was scheduled to discuss the presentation of the self in memoir on a panel with a very fine moderator and some strong fellow writers. Since I had arrived at the hotel a bit early, I was attempting to contemplate what it meant to present the self, one of those terms that could be deadening if discussed in purely academic terms in front of an audience of general readers. Nevertheless I found the idea to be intriguing, since our life in this modern world of constant media is a performance in so many ways.

As I was seated in a nice stiff-backed armchair beside the entrance to the hotel restaurant, a group of women walked past me, decked out in a motif of beige fabrics and leopard prints—scarves, blouses, jackets. My impression of them was that they were very much connected to one another, maybe even family, similarly tall, blonde, with carefully done hair. They carried themselves with an air of the regal, so much so that one could see at a glance that they understood the idea of the presentation of the self, the performance of even so simple a matter as a walk across

the hotel lobby. One of them glanced at me and appeared to recognize me, though I decided quickly that I must be imagining this. The women processed into the restaurant and then out again, maintaining their stately grace, moving as if they were aware that people would probably watch them, as I was doing.

A few minutes later, as the panel discussion began, on the front row of the audience sat these singular women who made leopard look like exactly the thing to wear at a morning literary event, and who managed to sit with the same sense of purpose with which they had glided through the hotel. At that point I understood there was something special about these people, though soon enough the business of the conversation on the panel took over and I did what I was supposed to do. I talked about my book and stepped into the conversation with the other writers. From time to time during the hour that followed, I glanced at the row of women and wondered who they were.

Later when I was signing books in one of the side rooms on the Monteleone mezzanine, the leopard group swept into the room and asked me to sign one of my books, and at that point they introduced themselves as representatives of the Pulpwood Queens Book Club, with Kathy L. Murphy as the queen herself. As I would learn later, hers was the vision to found the book club group, which at present comprises over 700 chapters, adventure trips, international reach, good hair maintenance, and a movie deal. Kathy knew of my work from her days as a sales representative for Algonquin Books, my publisher. We chatted. She told me a bit of her story, which is extraordinary, including her career in the

book world, subsequent turbulence both professional and private, the founding of a salon called Beauty and the Book, and her book club empire. At the end of the conversation I was left with the feeling that she was the one who had been on stage that morning, and I was part of her audience. I suspect this is a reaction that people often have when meeting her. She is one of those people who cannot help but change the world wherever she touches it.

So a few weeks later I heard from Kathy that she had chosen my memoir as an official bonus book for June 2016, putting me on the list of authors selected for the worldwide Pulpwood Queens to read, and therefore eligible to attend the Girlfriend Weekend in January. The notion that I am affiliated with the Pulpwood Queens movement is a real highlight, and I am grateful to have been taught a lesson in the presentation of the self by one of the masters of the art, Kathy Murphy, book goddess.

The Gift of Girlfriend Weekend 2009

Jennie Helderman

Sometimes we aren't aware of the effect we have on others. That was certainly true of Kathy L. Murphy in this story from my first Girlfriend Weekend.

"You'll need a costume," I said, having just arm-twisted Ginger into being my travel buddy to Jefferson, Texas, for something called Girlfriend Weekend. "I'm going as Cleopatra."

Ginger's face went blank.

I'd spent four years with Ginger McNeil, writing her story in what would become *As the Sycamore Grows*. Seldom had I seen her at a loss for words. Ordinarily, she was confidant, poised and mischievous. In fact, she earned her living now speaking in court as the voice for women who couldn't speak for themselves. Abused women who were afraid, as she had been before she escaped from a padlocked cabin hidden in the woods, no phone, no electricity, and a chain-smoking husband whose beard reached the .38 strapped to his belt.

"Tell me again where we're going," she said.

"Kathy Murphy's Girlfriend Weekend. Remember I told you about Kathy? The big book dynamo who gave me the hair-do-to-heaven?"

I had won a hair makeover from Kathy when she stormed

Atlanta.

Kathy had combed, teased, bouffed, and pinned hairpieces into my bob until my head could hardly fit into the car on the way home. While Kathy backcombed, she told tales about a gathering in Texas she called Girlfriend Weekend.

"I hear it's like a big house party with books and authors," I said.

Ginger nodded.

A month later Ginger and I sat in Jefferson's Convention and Visitors Center, clad in hot pink t-shirts like everybody around us, enthralled by the authors on stage talking about their books. The authors were old friends by now, having visited with us while they served our supper the night before. The same for the tiara-wearing readers. We were learning names and faces.

Back at our B&B, our costumes hung in the closet, both Cleopatra outfits. I had been surprised when Ginger told me what she'd selected at the costume shop, but it didn't matter.

After supper that Friday night, a band played music that brought people to their feet. I poured a glass of wine and held out the bottle to Ginger. She shook her head. All around us, people danced, arms over their heads, no partners, just women and a handful of men. I can't clap to a beat but I joined in, whirling, laughing, letting go.

Ginger sat at a table smiling, swaying to the music. I waved to her. "Come on," but she shook her head.

The next day, more authors. Ginger introduced me to people she'd met.

At our B&B after supper on the final night, we dressed in our costumes, each helping the other apply black and blue eye makeup.

That night I poured the wine and Ginger held out her glass. When the band played, she beat me to the dance floor. We waved our arms, swayed, joined the conga line, laughed, had fun.

We had a long drive home the next day, a lot of time to talk.

"I wanted to join in Friday night. Everybody was having such a good time, and I wanted to be part of it, but I didn't know how," she said. "I've never done anything like this before. I wasn't allowed."

I knew her family's religious views were stricter even than their church required. Her brother said breathing was a sin. Like leading cheers.

As a child, Ginger sat on her concrete stoop hugging her knees to her chin while her next door neighbor practiced her sixth grade cheerleading moves in the front yard. Ginger couldn't be a cheerleader. She couldn't even pretend to lead cheers.

"I wasn't allowed to go to slumber parties, or twirl a baton, or take a role in the class play. No Scouts or proms." Her eyes filled with tears. "Until last night, I'd never worn a costume. Never even played dress-up as a little girl. Pretending was a sin."

"And what happened last night?"

"Not just last night. It was this whole big happy family weekend. I can go home now and play with my friends. I learned how."

Ginger and I have traveled together many times since that

Girlfriend Weekend. She hasn't stopped playing.

Thank you, Kathy Murphy, for Girlfriend Weekend and its gift to Ginger and so many others.

It's Good To Be Queen

Mary Ann Henry

Being a queen had never appealed to me. A princess? That looked like fun.

But I was neither. I was an unknown writer whose short story collection had earned positive reviews that caught the attention of a few awards committees. Which is how I ended up on a long bus ride from Seattle to Bellingham, Washington, with Kathy L. Murphy and eventually learned what queenship is all about.

For some reason the city of Seattle had closed one of its main highways at five o'clock on a Friday. Chaos reigned. Traffic snarls and long lines created gridlock while Ms. Murphy and I sat across from each other, strangers on a bus heading to the same writers' conference. Then, we started talking. And talking. Hours passed while we traded stories about growing up with critical mothers who shaped our characters in ways we might never understand. Hers used to say she was "almost pretty." Mine called me Plain Jane, and with five other sisters that was a singular honor. We talked about the pain of our divorces and how much we loved our daughters, nature, and solitude. As we peeled away the layers, we discovered not only a love of writing but a foundation for a lasting friendship.

This might be a good time to introduce an intriguing aspect

about Ms. Murphy, A.K.A. *The* Pulpwood Queen, who is without a doubt the most generous person I know in the world of books, of writing, of publishing, of marketing. The day after our bus ride, she stopped me between conference sessions to invite me to be a featured author at the upcoming Pulpwood Queens extravaganza in Texas. I had no idea what I was in for.

If you took a high school girls' slumber party, an upscale literary salon, an old-time camp meeting, and a book fair and rolled them into an event that attracts both famous and emerging authors, along with some of the most avid readers of fiction and non-fiction on the planet, you would have the Pulpwood Queens Girlfriend Weekend. For good measure throw in an Elvis impersonator, a Pat Conroy Lookalike Dinner, and a contest that somehow landed me on the front page of the local newspaper dressed as a "fancy lady" to a group of diamond miners.

And that was just the beginning. Because the essence of the event is ultimately about the power of words and the thrilling connection between author and reader.

Not only was it an honor to meet such dedicated *readers*, I was in the exalted company of some of the most brilliant *writers* in the country. So, what did I do when it was my turn to introduce myself? I started speaking—horror of horrors—the truth! I spilled my guts about why I wrote the collection, how I had experienced a terrible betrayal and the only way out of the emotional devastation was to write about fictional women who faced down adversity and found some aspect of their authentic selves. I told the audience that each of the female characters haunted me; that

I wrote the book in the middle of the night when I could not sleep.

I was positive it was too much information. Later, I made an apologetic remark to Kathy Murphy about the outpouring of my soul. She gave me a quizzical look and said, 'That's why we call it Girlfriend Weekend'. I *got it.* Like that long bus ride that stripped away pretense, the weekend is about being who we really are, authors and readers alike.

The Pulpwood Queens weekend may look free-form, but it is calculated for the best possible reasons, as Kathy craftily removes the barriers that keep the famous writers from talking to newbies (like myself); as she knocks down the walls between readers and authors; as she encourages freedom of expression in even the shyest of attendees. Because these events are as free and unrestrained as Kathy herself.

Books are how readers understand their world. Writing books is a way for authors to understand our own worlds. Girlfriend Weekend de-mystifies the roles, bringing together the best of both and empowering us each to be the Queen of Whatever World we inhabit.

I finally understand. It's good to be queen. Long live Kathy L. Murphy.

That's What It's All About

Kathy Hepinstall and Becky Hepinstall

Pulpwood Queens Girlfriend Weekend means many things to different people. To the Hepinstalls, it's all about family—our own delightfully dysfunctional nuclear group, and our new, larger, wonderfully kooky, book-loving Queens.

Kathy: Wait. I thought it was about booze.

Becky: No, you lush. It's about family. And reading.

Kathy: And booze.

Becky: OK. So maybe a little booze. Stop interrupting me or I'll talk about the time you brought a handsome gigolo to Girlfriend Weekend.

Kathy: That was my husband.

Becky: Suuuuure he was. Like anyone believes that.

Kathy: It's not like I pay him by the hour. He's on retainer. Besides, I tried to hire Jamie Ford. He was way too expensive.

Becky: Can I get back to talking about Girlfriend Weekend now? Kathy Murphy has been our biggest cheerleader, inviting us back year after year, no matter how badly we make asses of ourselves.

Kathy: She is historically the only cheerleader who didn't shun us.

Becky: And she's given us a whole new tribe. An amazing

group of women (and men!) who lift up each other, champion diversity, and celebrate the written word.

Kathy: And they can dance too.

Becky: Can they ever! Some of our best Girlfriend Weekend memories involve getting down on the dance floor with those dancing Queens and our mom, Polly.

Kathy: Why is it all of my memories of Mom at Girlfriend Weekend seem to involve margaritas?

Becky: For once, your memories are accurate. Especially that time we got her tipsy and she dressed up like Cruella DeVille. She gleefully yanked us about the room by gold leashes around our necks. I couldn't turn my head for weeks.

Kathy: She would have done that sober. That's how she potty-trained us.

Becky: True. But she definitely wouldn't have danced to "All the Single Ladies" while dressed as Liberace without a little "helper" at dinner.

Kathy: Also true.

Becky: At any rate, we'll forever cherish the times we've spent with Kathy Murphy and her Pulpwood Queens. And the best is yet to come!

Kathy: All hail the Queens!

How I Became a Pulpwood Queen

Betty Herndon

I moved from Dallas to Linden, Texas in the summer of 2013. I belonged to two book clubs in the Dallas area and wanted to find one to join in East Texas. Since my new house was in Cass County, I went to the library in Atlanta and the librarian gave me the phone number for a woman who was a member of a book club there, and I called about the possibility of joining. The lady very haughtily said in no uncertain terms, "Honey, we already have ten members and we try to keep it at that number."

I told my husband how I had been "snubbed," and we had a good laugh about it. He then repeated the story to our realtor, who told him about a woman who owned a combination beauty shop/book store across the street and gave him her phone number. I called Kathy Murphy and made an appointment for a haircut. I came out with a great haircut and color job, a Pulpwood Queen membership, a book about the Pulpwood Queens and a new friend! How cool is that??

Since then I have attended every Girlfriend Weekend, made many book-loving friends, met loads of great authors, and had a few haircuts as well!

I love the Pulpwood Queens!

Bohemian Rhapsody and How the West Was Won

Laurel Davis Huber

The First Year

1.

The Email

I get an email from Caitlin, my publicist. *Congratulations*, she says, *you have been invited to the Pulpwood Queens Girlfriend Weekend!*

Oh, wow, I type in my reply email, *that's great!*

I leave a space.

Um, what is the Pulpwood Queens Girlfriend Weekend?

2.

It's a Big Deal

Caitlin explains that it is a very big deal, but I still don't really understand, so of course I Google it. I am immediately impressed. The keynote speaker is Jamie Ford, author of one of my favorite books, *The Hotel on the Corner of Bitter and Sweet.* I am already hooked. I scroll down the list of attending authors. Wow— this really is a big deal. And hundreds of readers from 750 book

clubs will be there. And my book will be on sale! But there is a catch.

3.

The Catch

There is a theme to the weekend. "Bohemian Rhapsody." Which means authors must dress in bohemian mode for several days, culminating in a Great Big Ball of Hair Ball on Saturday night. Not only that, but apparently wearing a tiara is mandatory. This sets me back. I am not a costume-party sort of woman. I definitely don't have a tiara in the back—or front—of my closet. I will be a fish out of water. I will not be able to breathe. This is not my world. I've got to tell my Caitlin I can't go.

4.

Buck Up

Buck up, I tell myself. This is a big opportunity. Just because you are an introvert squared doesn't mean you shouldn't just go ahead and do this thing. Hey, you can always leave, no one is going to arrest you. Besides, there is no way that lots of other attendees aren't introverts, too, right?

Okay, okay. I am going to the Pulpwood Queens Girlfriend Weekend.

At some point I have a question about dinner tickets and email the administrator, Tiajuana Neel. She answers right away,

and ends her response with: "You will have the time of your life."

5.

Getting Ready

I have a few months to get ready. But still, it seems like there's so much to do, and I am confused about almost everything. First, what to wear.... Let's see, I have a sort of Mexican blouse that could pass for bohemian. And some harem pants that I got off an outdoor sales rack in Florida for about $6.00. I find a crystal-studded tiara on Amazon. It's a start.

But then there's also a tiara *contest*—you have to make a special tiara that reflects the theme of the weekend. Then I see on the Pulpwood Queen website that for the ball you can dress up as your favorite character from a book. *Then* I see that all the invited authors are supposed come up with something creative to donate to an auction to benefit the Pat Conroy Literary Center. Well, I am all for that! But, gosh darn it—there is just so much to think about, so many decisions to make, so much to organize....

Help!

6.

What I Am Thinking

Here is what I am thinking—I have imagined that being invited to the weekend means this: that I will attend the event, contribute my auction item, mingle with authors and readers, and

have the opportunity to sell my books. I will soon find out that what I am thinking is not quite all there is to it.

7.

The Event Begins

I fly from Newark to Houston, and arrive too late to attend the opening ceremonies on Thursday evening. But I show up early on Friday and find the long table where the auction items are on display. The table is crowded and I can't find a place to put the little Velveteen Rabbit box that I made. I set my bag down and carefully move a couple of things to make some space. I am just putting out my box when a voice behind me says, "Which author are you?" I turn and see two women who look rather alike. Turns out they are sisters. We chat a bit and they say they come every year and like to meet new authors.

"When are you speaking?" one sister asked.

"Oh, I'm not speaking, I'm just attending."

The woman laughed. "Well, if you were invited, you're speaking."

"Oh, no, I don't think so—" I was saying as she pulled out her program.

"Here you are—you're on a panel on Saturday at 10:00."

"Oh, wow," I said, flushing. "I had no idea."

They thought it was very funny and I laughed too, because it *was* funny. Could I be a bigger idiot? And the weekend is just beginning. *Plenty of time for more idiocy*, I think.

8.

The Rest of the Day

It occurs to me that it's probably good I was so ignorant because I had no time to get nervous. Okay, I can handle this.

I take a look around. A large room, filling up with people sitting at long tables in the back and in rows of chairs in front. *Don't just sit down and try to be invisible, Laurel, that's not why you're here.* I spy a woman with raven hair. She wears a tiara of book covers with ships on them, and awesome boots. I walk over. "Hi, I like your boots!" I say, meaning it. The chic woman is Patricia Davis. We seem to hit it off. Phew.

And then the show begins. There she is, up at the podium, Kathy L. Murphy, the Pulpwood Queen in person! Looking fabulously, beautifully, bohemian. She introduces her co-host, Jamie Ford. I am utterly thrilled to see the famous author walk up from the back of the room. And when he speaks, he is so genuine. Engaging, funny, and warm. *This is good,* I think.

At the author dinner that night, I get a plate that's piled high with beans and barbeque and look for a place to sit. *"Is this seat taken?"* I ask. The woman I've addressed smiles a huge smile and says, *"No, sit right down!"* and we talk throughout dinner. This is the author Susan Cushman. We share some details of our lives. Turns out we both graduated from high school the same year. *Well, dang, looks like I've made another friend. Not to mention I am saying "dang"— is that a Texas thing?*

9.

Saturday

I do fine on my panel. The day flies by. I am so entranced with the talks by well-known authors—Randy Susan Meyers (whom I had seen at a conference years earlier when her first book had just come out); Alice Hoffman (whom I have always admired); and Lisa Wingate (whom I do not know, but she has written tons of books and is clearly beloved by the audience).

That night I attend the ball. I wear my harem pants, a gypsy-like silk blouse with a sash, and my crystal-studded tiara. I'm rather pleased with my "look." Then I see Judithe Little. She's one of those people who'd look pretty dang beautiful even wrapped in a car tarp, but then you put a "tiara" on her head that looks like she stole the butterfly room from the local botanical garden and well, you just know who's going to be voted queen of the ball. (She is.) I have a vodka or two. And I look around—they we all are, a host of sparkling Christmas ornaments, and there is Kathy at the top—a glowing angel, resplendent. There is great music, a comedy act, and a room so full of gorgeous outrageousness that people who are attending a birding conference in the hall next door keep sneaking in to take pictures of the scene. They must be ecstatic—they've spotted the rarest birds on the planet!

10.

Then *This* Happens

It's all over. I am back home in New Jersey. Kathy Murphy

is posting maybe 10,000 times a day on Facebook and I'm trying my best to keep up. Then one day she posts a photo of a painting she's done. I think it's about the most stunning thing I've seen. It is a very big painting. And it is for sale. I message Kathy and say I'd love to have it. Well, she's pretty doggoned (trying not to say *dang* here) excited. Only problem, she says, is how to ship it since it's so big. She says she'll figure it out.

She figures it out, all right.

Next thing I know—and it couldn't have been more than a few days later—she tells me that she and Tiajuana are *driving from Texas to New Jersey to deliver the painting in person!* Now the story of that trip can only be told by Kathy, but I can tell you it was a wild ride. And before I know it, I am welcoming Kathy and Tiajuana into my home.

I am bonding with the Pulpwood Queen!

And I have a spectacular painting hanging on my dining room wall.

Wow.

The Second Year

11.

What It's All About

I return. The theme for the second year is "How the West Was Won." Things are different this time around. I have learned a thing or two. I don't even fret. Well, I don't fret too much. I go online, find some deals on eBay and boom! I have two cowboy hats

(one leopard-printed!), one tiara, one fringed leather jacket, and cowboy boots with a blue flower design.

At the conference center, I feel at home. And I am thrilled to find that Kathy has included my novel in her newly-formed venture with my friend Patricia Davis (the one with the cool boots) and author Rebecca Rosenberg—"Breathless Bubbles and Books," which pairs books with wine. Now I will be on the "Breathless Bubbles and Books" panel.

And Lisa Wingate? The author I hadn't really known about the year before? After 30 books, her latest, *Before We Were Yours*, has hit the *New York Times* bestseller list and it is just staying there like it's stuck with Gorilla Glue and she has sold over a million and a half copies! Everyone is so cheered and inspired by her remarkable success.

I meet some great local people in the town of Jefferson—shop owners, restaurant workers, women from the Garden Club. I have a new appreciation for the legions of Pulpwood Queens Book Club members, readers who travel from all over to hear about books and meet authors. The authors who speak and read from their work touch my heart.

I reconnect with Patricia Davis, Susan Cushman, and Judithe Little. I meet lots and lots of new friends.

Authors. Readers. Talking about writing. Telling the stories of our lives. Friendship. The people who make all this happen. That's what it's all about. The costumes and craziness? All a very clever guise. *Well done, Kathy.*

12.

For Everything There Is A Season

Now, for me, there will be a time each year—round about the middle of January—when it is time to come out of my shell. A time for all of us author-introverts to come out of our shells. A time of community that we can be sure will be touching, uplifting, and totally nutty all at once.

It's called The Pulpwood Queens Girlfriend Weekend.

Thank you, Kathy, for envisioning such an extraordinary event.

(And, for the record, Tiajuana was right. I had the time of my life.)

Go Ask Kathy

Suzanne Hudson

I've always been ridiculously naïve about business, about the roles of folks betwixt and between the creation of art and the wider world of appreciation /consumption thereof, and about those rare birds (vultures) that might be in it for a totally different reason than one would hope. I'm just not hard-wired to think about profit margins, product placement, networking, or sycophants. Numbers give me anxiety fits and cause hyperventilation; dickering over fees and such makes me want to take a shower. Try this: Imagine our heroine, Alice, lazing on a riverbank, gazing over her sister's shoulder, losing herself, drowsing, in a book that takes her down a crazy, cluttered rabbit hole and into meandering unrealities. Yes, she's falling down and down and down, but what does the bottom line have to do with *that*?

Case in point: My first foray into this . . . *habit* was back in the 1970s, when I found a home in a college creative writing class of a dozen or so students sitting around a conference table, reading aloud, offering constructive criticisms . . . and chain-smoking cigarettes. It *was* the 70s, after all, so we might have even gone to class ganja-stoned a time or two—or, as with Alice, might there have been mushrooms? I'll never tell.

Our professor encouraged us to enter all the contests we

could manage, but I never did take a stab at *Redbook* or *McCall's* and their two hundred dollar prizes—not because I sneered at the money, which was quite a bit of moolah at the time, but because of my self-defeating lazy streak. However, when my classmate Sonny Brewer waved a *Penthouse* magazine in our faces, pointing to the National Endowment for the Arts-sponsored fiction writing contest with a payout of over five thousand dollars, well, my interest perked up. I was pregnant, after all (never fear, no illicit substances went into my vessel of gestation, the bod), and that kind of dinero would fund all manner of infant needs, starting with a washer and dryer for Mom. When I actually won first prize and the validation of judges like Kurt Vonnegut, Jr. and a relatively little-known new voice named Toni Morrison, the agents, publishers and editors came down on the New York winds like a swarm of locusts. Who *were* these people?

"You simply can't do anything without an agent," I was told, so I secured one who had big city cred and a stellar clientele. When an independent film director called and asked if he could do a screenplay based on the winning short story I had written, I was at a loss. "That's what your agent is for, you doofus," I was told. Who knew? And when said agent reported to me about her chat with Hollywood Guy, she remarked, "I think we can get more." As in, money. What did I know? I was a rube, an impostor, a lower Alabama literary poser, a bibliophilic bumpkin, who dared not differ with the Manhattan madam whom I did not recognize as a garden variety pimp. That is exactly how naïve I was: It never occurred to me that the agent was not representing me merely out of the

goodness of her heart. I know, it was monumentally and flat-out ignorant of me, but, in fact, it didn't dawn on me that she was in it for money, and rightly so, I reckon, until months and months later, after the potential movie deal had evaporated, after I turned that remark over and over in my mind: "I think *we* can get more." The truth was, I realized, that I would have loved seeing my imaginings up on the silver screen for, well, zero dollars. I would happily *give away* my work if someone would actually take a look at it.

Overwhelmed, I walked away from writing, away from the business, away from the habit, for over two decades, dusting myself off after an early 80s divorce before embarking on a twenty-year disaster of a relationship that left me in a heap around the turn of the twenty-first century. And that, of course, along with the coaxing of my old pal Sonny Brewer, brought me back to the pen and paper. Nothing like personal disaster to light a fire under the desire to write, huh? This time around, though, after a few initially distasteful experiences, I stayed independent, worked with small houses or university presses and gravitated toward the colleagues I actually, well, *liked*, as people. And that good energy, that positive parlay, the wisdom born of devastation and the need to waltz with the karma that would buffet me—that, I maintain, is what spat me out into Beauty and the Book in Jefferson, Texas, around 2005, with a truly crazy book lady (note: there is crazy-good and crazy-bad; this lady was/is crazy-good) named Kathy Patrick. She gave me the coolest, edgiest, chicest haircut and style I ever had and took my husband, author Joe Formichella, and me on a summertime romp across the east Texas and west Louisiana land-

scapes, book clubs, and air waves with one Ron Rash, whom we had known from being included in an anthology or two with him. They were both a delight. And Kathy was insistent, *adamant*, that we *had* to attend Girlfriends' Weekend in January.

I wasn't about to jinx that juju. And that's how we found ourselves gloved, capped, and bundled up in woolen layers against a bone-freezing winter wind, marching, parading up and down the streets of Jefferson with a new-found longtime friend-to-be, Karen Spears Zacharias, with drum major Kathy pied-piping us along. We donned our over-the-top outfits for the Great Big Ball of Hair Ball. We hobnobbed with best-selling authors and small-selling ones, because there was no exclusive lunchroom table for the "popular kids" at this wonderfully outrageous "conference." Egos were parked elsewhere; collegiality ruled. The readers/book lovers were not segregated as "audience" but were integral to the totality of the experience. The weekend was whimsical, organic, without a scintilla of pretense or self-consciousness because it all came from that spiritual place of generosity and the desire to uplift. It's a feeling, a gut grab, the truth of being in the presence of a big-hearted, big-hugging earth mother. You can't help but give yourself over to Kathy's exuberance, trusting in the honesty of it all.

Still, after a couple of years of east Texas boot-scooting, Joe and I began to drift back to our own corner of the southeast. We fell in with a couple of publishers who wooed us with their hookah-pipe dreams for us, inevitably falling short. Another couple of houses seemed like tax write-offs for rich folks and we often felt

like hired friends for wealthy misfits. Another began with noble intentions but gave in to a dearth of interpersonal skills that enabled the kind of toxic energy invasion that spells ultimate doom for any who attempt to grapple with it. We got ourselves immersed in crazy-bad, found ourselves at the Mad Hatter's tea party sharing crumpets with dormice and white rabbits, being mocked by a Cheshire cat's ghostly grin. In short, we had ceased to bathe in the light of genuine collaboration, mutual support, and true good will. Through the looking glass, darkly.

Was it serendipity, salvation, or delightful irony (all of the above?) that we ran into Kathy—now Kathy L. Murphy, just in the nick of time, at the Louisiana Book Festival? There she was, with her *own* book now, *The Pulpwood Queens' Tiara Wearing, Book Sharing Guide to Life*. And she embraced us immediately, with that earthly mother hug, that aura of a fortune-telling free spirited gypsy moth on Jackson Square, and took us right back into her magical wonderland. She bade us introduce her, for her presentation, as we had a history with her and a story to tell, as did she, all of us rising from the ash heap of the old Phoenix.

Who among us has never been spirit-shattered? Show me that one-dimensional, never-lived person, with an enchanted life, cherubic children, and a career that is all crème brulee with no curdled lumps in sight, and I'll show you one of two things: a liar or a bore. Certainly not an author—well, maybe the author of fairy tales or sugary confections that appeal to our sweet tooth—but best not to eat too much of that refined white stuff. No question, Kathy has been spirit-shattered; just go ask her. If she had never

walked the walk she would not have a blessed thing to teach us, and because of her I have learned a thing or two about a thing or three or four.

First of all, given her recognition by "Oprah's world", "Good Morning America," and network television, film, hundreds of book clubs worldwide, and much, much, more, Kathy could easily be an overbearing diva or a demanding general or a controlling monarch, a red Queen of Hearts, barking orders and "off with his head!" at those who fail to toe the line or to bow and scrape in her presence. But, no, she is easy and kind and a flow-goer, who rolls with whatever presents itself; no histrionics in sight. Oh, Joe missed his Girlfriends' Weekend panel? Well, come on up here, Joe, and join *this* panel! It's not the End of the World, is it?

Secondly, I know that the Pulpwood Queen could demand quite a princely profit from product placement, as so many do, both above and beneath the already-set table—or charge out the wazoo for Girlfriends Weekend events. Yet the powers that be learned quickly that this royal raconteur was absolutely *not* going to be a sellout; greed is not her engine. And she works hard to keep her insanely wonderful January weekend affordable for those who look forward to it, year after year—enough to bring it to this moment, the twentieth anniversary. All she asks of the authors is that they bring a willing spirit and an auction item to support Kathy's pet non-profit, the Pat Conroy Literary Center. She's not a taker; she's a *giver*.

Finally, and most personally, I know that Kathy could cave in and sacrifice her riskier choices of "reads," like my novel, a

2005 pick, *In the Dark of the Moon*, which is pitch-black, indeed, and violent, and disturbing, and cringe-worthy . . . but, then, so are racism and lynching and abuse and manic hyper-sexuality. She took a stone cold, sure-enough chance by selecting *that* book, but she sticks by her choices, and if a few of her book club members squirmed and complained as a result, well then . . . so be it.

Thank you, Kathy L. Murphy, for not going all "Queen of Hearts" on me or any of your authors. And thank you for being bold enough, for going so far as to select the book of my alter-ego, R.P. Saffire, as a current "pick"—*Shoe Burnin' Season: A Womani-festo*. It's a much safer choice than *Moon*, though it certainly has its own sharp edges, its envelope poking, its political incorrect-ness, and its decidedly bawdy bent. Thank you for not being a wuss about going into unconventional territory, grabbing others by the hand, and pulling them along with you, whether it's down the rabbit hole of Girlfriends Weekend, or the undertaking of a trek through the pages of a current bestseller, or on a pilgrimage to bear witness to the resurrection of a years-ago published tale that was never *really* promoted. You, Your Highness, are merely the champion of second chances, the facilitator of redemption, the guru of the Wonderland of the Girlfriends, the Cheshire cat's meow.

You are ten feet tall.

My Experience with the Pulpwood Queens

Alexandra Jenkins

To be honest, I had never heard of the Pulpwood Queens Book Club or their annual Girlfriend Weekend extravaganza before I became involved as a personal assistant for the founder and creator, Kathy L. Murphy, almost two years ago. I can say that since first learning about the Pulpwood Queens, I have become whole-heartedly and completely immersed in everything Pulpwood Queens, and I look forward to Girlfriend Weekend every year.

I first learned of the Pulpwood Queens from Tina Boitnott, career development director at my university at the time, Texas A&M, Texarkana. We had developed a friendship after I became involved in several internships I found through the Career Development website. It was during one of our conversations that we discovered we both had a passion for books and reading. I told her I was an avid reader and aspiring author. Tina asked if I had heard of Kathy L. Murphy or the Pulpwood Queens; I had not. As they say, from that moment on it was history. Tina contacted Kathy to see if she needed a personal assistant for the upcoming Girlfriend Weekend; she did. To my utter amazement, without any prior knowledge of me or meeting me, Kathy agreed to let this complete stranger shadow her and help her with the event. I can only say that I am so glad that she did.

When I arrived that weekend, I had no clue what to expect or what exactly I would be doing. I learned very quickly that nothing could prepare me because Girlfriend Weekend was so much more. I became a small part of something incredible. Kathy, her family, and the Pulpwood Queen's executive director and Kathy's right-hand woman, Tiajuana Anderson Neel, put together a beautiful blending of authors and readers in a space where they could truly mingle and discuss their love of the written word. It was mesmerizing to watch. I was in awe of how personal and approachable the authors where. They were excited to talk to the attendees, not just seclude themselves until their panel or time to present. They sat with the attendees, talked with them, and served them at the Authors' Dinner. Having gone to many conventions over the years I had never seen anything quite like it before.

Though nervous at first, I began to approach the authors—not just as someone who was working and seeing if they needed anything. I approached them as a reader and an aspiring writer. I asked them questions and got to know them. I learned a lot and met some spectacular people. I will never forget meeting Alice Hoffman, Carolyn Turgeon, M.J. Rose, and Randy Susan Meyers, just to name a few. Getting to talk to them and pick their brains is something I will carry with me always. They are not only phenomenal authors but wonderful people as well. Many were even open to the possibility of reading over some of the things I had written. This made my inner child and fangirl heart giddy with delight.

However, it is not just these connections and relationships I am thankful for; it is the relationships I built with Kathy and her

crew that are truly unforgettable to me. Kathy, her daughters, Tia-juana, and the various other new friends I made along the way are my greatest takeaways from my experience with the Pulpwood Queens. They became more than people I was working for during Girlfriend Weekend; they became my friends, people I keep in contact with throughout the year, people whose achievements I celebrate, and people I feel I could call to hang out with whenever we are in the same city. It is these relationships that are most precious to me.

The 20th year celebration of the Pulpwood Queens Book Club and Girlfriend Weekend will be the third weekend I have participated in, and I cannot wait to see what's in store. It is going to big; it is going to be bold; and it is going to be unforgettable. I am so thankful for this experience and everything the Pulpwood Queens have brought me. I have seen women and men who have been a part of the Pulpwood Queens since the beginning, and it is incredible to not only witness that history but to now be a part of it as well.

The Motown Experiment
Year 2059

River Jordan

Somewhere along the border of the New Mexican desert at the Holy Chapel of the Lonesome Highway a strange gathering begins to form. The occasion—the last story rites service of the author River Jordan whose Motown Sundown 50 location chip went off-line six months ago.

River Jordan's last projected hologram testimony requested that the test group known as the Pulpwood Queens road-trip down to this remote highway chapel either bodily, by hologram projection, or genetic teleportation, to join her on this Lonesome Highway one last time on this side of the eternal border.

My name is Sunday Catcher. I am officially contracted by Motown Experimental Pharmaceuticals Laboratories as a Story Engineer, Class Three. In wake of the sudden retirement of Clyde Catcher, Story Engineer, Class Five, I've been re-assigned to the test case group Motown Sundown 50, otherwise known as The Pulpwood Queens.

At the specific instructions of my employer I have physically traveled by archaic methods to reach this remote destination. The purpose of my report is to observe and document this cult of women known as the Pulpwood Queens and to try to further

ongoing studies to ascertain why the experimental elixir known as Motown Sundown 50 has reacted differently on the members of this test group not foreseen in its creation. Over seven hundred of the Pulpwood Queens have physically traveled to the Central District of the State of Detroit to receive a transfusion of Elixir 50, then be chipped for tracking as the Pulpwood Motown Sundown 50 or the more common acronym, PMS-50.

The original chipping of these women and their enrollment in the program began in 2025. At that point in the history of Motown Pharmaceuticals, Sundown 50 was in the early stages. Little was known other than the fact that laboratory tests had shown improvement in the concessions that once had to be taken for granted as given—bone loss, developments of lesions, onset of organ demise, and the expected onset of a host of other genetic diseases. A twenty percent improvement in life quality and an increase of physical activity was fully expected.

Kathy Murphy was the first person to respond to the Motown advertisement for willing participants. Let the report show that the visuals of Kathy Murphy, who is referred to under the cult tribal name, Queen Kat, arrived at the laboratory with rose colored hair, wearing an ensemble of extinct mammal prints in blush rose and a headdress of feathers and jeweled stones. She emitted a strange power some refer to as an aura, which accompanied her throughout her tests and transfusion. Sparkled dust fell from her steps and left a trail across the medical facility. Rumors are that it can be seen to this day regardless of multiple sterilization attempts. This has resulted in numerous laboratory workers join-

ing this cult, which continues to see surges in growth rates to this day. I have never traveled to the Motherlode Laboratory in Detroit, therefore I cannot verify or deny these rumors.

Scientists wanted to know whether the elixir did indeed turn back the clock as it had intended. Were organs and joints somehow being renewed? Did brain activity increase? Old, dying synapses come to life?

The historical records of report show that this particular group, PMS-50, has exhibited tribal group dynamics from the beginning of the study of their control group. The following examples demonstrate that these behaviors are *not* side effects of the enhanced life modality of the nutritional effects of Motown Sundown 50. These women brought these qualities with them.

They are determined to reenact their tribal rituals each year in the sub-district of Jefferson, Texas. Again, I repeat for the purpose of this report on the record, their activities are not a side effect of their transfusions. The wearing of feathers, animal prints, headdresses and so forth all started years ago and continues to this day.

There seems to be nothing that stops them from gathering in body. Some actually use the teleport, which I believe is a much safer form of travel. Others utilize the significant advances of the genetic hologram system. Some will still only travel by stagecoach. (That is this story engineer's attempt at humor, regarding all physical transportation devices as outdated.)

This control group of PMS-50 exhibits every aspect of the tribal code of Planet Selection Code 684229A: The instinct to gath-

er. The dedication to tribal dress. The incorporation of elder talks. The breaking of bread, carnivorous consumption, and unlimited portals of wine. These rituals are magnified by the further practices of multiple storytelling sessions, even more elaborate tribal dressing, and native dancing.

The Motown Sundown creators had one initial goal—to improve the quality of those approaching the "sundown years" of their lives. To, in effect, turn back the clock to the age where many women were completely fulfilled, content, powerful, and at the height of being contributing factors to society, which was the perfect age of fifty.

Queen Kat became the first test subject. Her reports of increased physical vitality, mental acuity and creative output had an immediate wave of influential results. Pulpwood Queens and Timber Guys followed suit, fearlessly traveling to the Motherlode Motown Laboratories for the initial vibrational assessment, elixir infusion, and reader chip implant.

The record shows clearly that the Pulpwood Queen control group shattered all scientific explanation or expectations and upset the universal medical community at large when it was discovered that the PMS-50 group were experiencing "the uncommon longevity factor." Although MS-50 worked exactly as early laboratory results predicted with other control groups, the Pulpwood Queens exhibited inexplicable extended life-spans.

Motown Sundown 50 was created to instill fearlessness, curiosity, creativity, playfulness, passion, and continued relational equations. Unknown to Motown Laboratories at the time was

the fact that the Pulpwood Queens already possessed all of these qualities. At some point during their continued gatherings these qualities had grown and been passed on between them and had become an ingrained part of their DNA. As such, the Pulpwood Queens brought these qualities to the table, and what happened instead was that the Motown Sundown 50 elixer infusion introduced the eternal life quotient. While not becoming immortal, they exhibited agelessness. Their life spans increased by forty, fifty, possibly even sixty years so that those who might have passed beyond this planetary existence remain active to this day in 2059. Since they have also been able therefore to take advantage of other, new technological and medical advancements they seem unstoppable.

Motown has tried to keep the results in these reports classified as top secret so as not to incite riots by the many other participants who have not experienced the same results. In addition, corporate spies from all planetary sectors have tried to steal the formula for Motown Sundown 50. Security factors have become paramount but more than that, the creators of Motown Sundown 50 are determined to document the activities of the 700 PMS50 test subjects. This poses a wide variety of impossibilities.

There are twenty-seven Motown Story Engineers assigned to study test group PMS-50. That borders on cruelty for those of us assigned to this sub-group.

Fifty-two women have cruised to Bali. They all purposely chose the long way. A hundred women have hiked seven different mountain chains. Sixty-four have gone on remote meditation

mountain retreats. Eighty-five embarked on a motorcycle race through Central America to excavate the ruins of some newly discovered archeological find. Two have taken up sailing. Their own ships. As captains. Seven have gone into space. And that's just this week.

I have sent a formal request asking for re-enforcements but to date have not received a response. No one can humanly cover this many women being this active. Their passionate curiosities may actually be killing me, and some of them are in their 90s now and four of them are over 103.

But back to the situation at hand. The gathering has continued. The pews are hard wood, gathered from old churches in the New Mexico Desert that were salvaged from the flood of 2033. While the pews are quaint, I am uncomfortable. A cross hangs in the chapel behind the glass podium and just now the light shifts behind the stained-glass windows casting colors that catch and hold in the headdresses of the PWQ-50 participants. The light softens and this tired Story Engineer will now rest during this part of the reporting and simply observe.

The gathering grows in size and scope. Some, who have chosen teleportation or hologram projection simply materialize. There are groups in full dress, feathers about them, wearing those reflective headdresses that seem to be required. Others have traveled as I did in overland process by rail and skybus. They come in and take their seats among the early arrivals.

I am here to watch, listen, record. That's my purpose. Catch

the story. Deliver it to Motown Laboratories. Tonight I will file my report via hologram file enclosures.

Two women walk in and choose seats just behind me, bringing an ancient, loud rustle and breath.

"She ain't gonna be here, I told you." She drops some kind of bag, opens some bottle with a scent that floats forward. "It's her funeral."

She says the last word with a stress.

"I'm not hard of hearing," her friend responds. "You don't have to shout it."

"I know you can hear me, I just don't think you're understanding me."

There is the opening of a bottle. A scent like nectar rises behind me.

"We should have teleport-ta-ted ourselves here. Skybus is a waste of time."

"I still don't trust them teleports. I might do it sometimes but I don't like it. Besides, we might meet someone on a skybus. You never know."

"I'm 99 and you are 102. What are we gonna do with somebody if we meet them?"

"Things can happen." She laughs and it elicits a smile from me in spite of my being an impassive observer. "You don't never know."

There is the clink of—what I'm not sure—I turn around to see, curious in spite of myself. After all, it's my job.

"Well, hello there."

They take in my dress. Black shirt, Motown Lab Logo on the pocket. Black pants. Black boots. Standard issue.

"Let me guess," the dark headed one says.

"Motown Laboratory reporter," the redhead says.

"Story Engineer, Class Three," I report.

"Well, hello, Story."

The tinkling of the glass continues. Suddenly they pass me a tiny glass, fill it with a liquid like burgundy fire.

"Oh, I'm on duty and . . ."

"Story, we won't tell if you won't," says one.

"Besides," says the other leaning in to whisper, "if you look around, you're in good company. No spies be we."

As they fill their glasses I take the time to look around at the chapel which has begun to fill with all those feathers and finery. There's that stained-glass light. And something, I can't finger just what it is, causes my throat to catch with the sight.

The women watch me for a moment, their eyes deep and reflective. Knowing. And for a minute I see them as something beyond test subjects, results, experiments. More like wisdom bottled up in human skin.

"Here's to us," one says.

And I tap my glass with them and drink the wine of my assigned cases. It's a smooth warm taste against the sand held in my throat. Sharing food and drink—it's against the rules. I offer them the glass.

"Oh, keep that." That's from both of them. Protests. Looks pass between them.

"It ain't over yet."

"Might come in handy. Can't never tell."

"Nope," says the other, "can't never."

"Hey Story, let me ask you something," says the dark haired one.

My stomach is warming, my hands, my face feel a little flush.

"What's that?"

"So, they say River Jordan's chip went offline."

"That's what I heard," said the redhead, "but I don't believe it."

"The offline chip has been verified." I said. I realized it came out matter of fact.

"They found it?"

This from the both of them in unison.

"Not physically found and verified. The reader went offline. It has been verified not to be an electrical surge." I drank the last of my glass." "Not a glitch," I said, then realized my speech patterns had relaxed considerably.

"I think she turned it off," said one.

"Can't be turned off," I said. "Only removed."

'I think she removed it," said the other.

"I heard she ran off with a Nu-man."

"A Nu-man?" This question popped up from me. My brain calculating the odds. "But Nu-men don't run off. I mean, they're programmed. To . . ." I couldn't figure out the word, "perform." I searched for other words but ended up repeating myself. "Pro-

grammed."

"Well, what we heard was she run off with a Nu-man that went rogue."

I looked at them. Speechless. I had heard a few rumors of this, too, of course but it was rare if it was true. I focused on the facts. Tried to stay away from the flush of what might be fiction.

"Yep, she has turned a Nu-man. Caused him to go rogue. I bet he could take that chip out of her."

"So, if that happened,"—again the bottle, the refilling of glasses. I was a part of their group now. My glass was refilled along with theirs.—"she went rogue with him. They've both gone off-line." I offered this assessment on my own accord.

"Well, that clan up there in Jackson, where are they now?" She looks around the room and there in the corner is a wild assorted group, most of them wearing fur lined shades currently all the rage. "Look, there they are—the BB Queens of Jackson. That one there, red like me, she told me River Jordan was last seen in Belize passing out books to poor kids. "They call her Gringo Libro loco," she said.

"What does that mean?" I asked trying to translate in my mind. White? American? Book? Crazy? Crazy white book lady. "Well, that could be true," I said. "Everybody's gotta be something." The women looked at me and I realized that burgundy sauce might be getting to me.

"She could have taken that Nu-man to Belize and still be passing out books," said one.

"You never know," said the other.

"I heard tell she'd gone up to a hill in what's left of France, to a monastery to become a nun."

"Well, that won't work out if she's got a Nu-man." I said. And the women laughed and I laughed and they refilled my glass. When I wasn't looking, someone had slipped a feather boa around my neck. A pink one. I had to admire the way it flashed against the black. I could roll with that. I flipped my ID badge where they could see my picture. "That's me, right there," I said. "Sunday Catcher, Story Engineer, Class Three."

"We got you, Story, we got you."

They refilled my glass.

"If you don't have a place to stay we'll put up an extra cot. Not a good night maybe for skybus and you."

There's a rush of energy in the room. Someone is talking as she comes through the door and there she is. The leader of the PQ cult, Queen Kat herself.

"I did it!" she is saying. "HEY, Hey, EVERYONE! Touch me! I'm really here! Not a hologram. I was in Egypt just a minute ago on a camel and now—TADA! I'm here! That teleportation thing is the way to do it. Now, I'm going EVERYWHERE!"

I'm sitting backwards, outright staring. I am vaguely aware that I'm no longer reporting. Not recording anything. There she is. The Motown Sundown 50 Elixir first test subject of all time. It's true. Sparkle dust is flying, falling everywhere. She is talking but I don't hear her. The women behind me refill the glass I didn't realize I was holding out.

"I told you we should have teleport-ta-ted."

"It's teleported," says the other one, "And I still don't trust it. Just keep watching. Her arm might fall off. You don't know."

"No, that's true, you don't never know." She refills their glasses, "But then I guess now they could just grow you another arm and attach it."

"That's artificial limb genetic resurfacing," I offer.

They both look at me a little surprised at my contribution.

"See there, Story here knows the deal."

I take a sip of the red stuff. "It's really quite successful. There have been no reports of genetic rejection in the early trials or later applications."

"I have a feeling, Story girl," one of them says, winking at the other, "that you might need to get out more often."

I couldn't argue that. I did most of my research from my cube. All of my needs were air-vac'd directly to me. I had little need for the world beyond my realm. My life was very sterile.

For the first time the Queen goes from one group of PQs to another, clusters of them scattered in numbers everywhere. Accents from the southern regions, western shores, even the far, far northern border woods beyond the Motherlode of Detroit. Some speak foreign languages and the Queen speaks with them fluently. At first, I think she has used these years to master other languages but then I realize she wears the new translation device.

They are not archaic, these women. What had I thought? There is the sound of glass clinking and drinking and I see that a host of other beverages have surfaced. That someone bears a platter, correct that—people have platters. Food is being offered,

passed, served, shared.

This is all happening. This is different than I imagined. And what exactly did I imagine? Reports. Numbers. Results. Reviews. Facts. Figures.

The PQ jeweled headdresses catch the light cast from the chapel windows and for a moment I see all of them as light bearers.

Then Queen Kat is at the podium. I hear, "Gathered today. Remembrance. Life. Passion. But I think someone has a few words left to say."

Queen Kat steps away from the podium and there is a dimming of lights, an electric rush, a blue flush of electrons, neurons, and there at the podium is a hologram sequencer. It's the kind of thing you can tell. The blue shade that comes from the crystalized forbearance. Like a living photograph moving through water. In short effect, it's a recording of a hologram projection which is not to be confused with live genetic holograms.

Dear Pulpwood Queens.

If I stand before you in a flash of a neon light then I have indeed exited stage right. The play has run its course, all the acts be done and the curtain dropped. Then so be it. Time to end and to begin again in some new way. To enter into some deep waters beyond my current comprehension, to discover exactly how complicated or how simple the fathomless waters at the end of time. But don't cry for me Argentina, my Gypsy Soul doesn't mind unchartered waters

or some stellar road trip without an end. The borders fall away now for me. The limits have lifted off.

What lies beyond is mystery still to me but this life—you have made it something certain. Sometimes in this life we get knocked down, the undertow of loss tries to pull us under. The jolts on this precarious journey sometimes take us by surprise. But in equal measure there has been this—the pleasure of the outstretched hand, the understanding words from friends that heal our hearts and mend our wounds and both challenge and inspire us to laugh and love again. Those who hear the music are full of dance and incite the spirit of celebration.

My friends, you have indeed been my inspiration. A thousand mirrors held before my soul because I have looked into your eyes and seen myself resting there. Like the surface of a thousand wells, deep and deeper still. It is within our friendship that I have rested. Leaned into your embrace, your smiles, and bowed with all due reference to the many miles you covered in pilgrimage all for the love of story. If we could do it all again, I'd say not one of us would miss the party or change our journey, laid storied brick upon storied brick.

From somewhere music begins to play, soft at first, something I can't recognize. But I can tell some of these women know it well, their heads begin to move, and their feet tap out the beat of this ancient melody.

Now it is time to dance. Let us dance until the cows come home. Until the roosters crow and the life of a new day has begun. Let us dance for all the stories of the past and for the millions of stories still left untold. Let us dance for the love of good friends, in

celebration of this good life and memories made. And just remember, Pulpwood Queens never die. We simply join the eternal story, and roll into the star filled sky.

The music grows loud and louder still. The drums beat, feathers fly, light catches from all those headdresses shattered, dropped and beamed across the room. And the hologram that was River Jordan begins to dance, continues dancing until molecule by molecule, there is nothing but a blue shadow, particles and neurons of memory that dance, lift, shift, and dissipate into the light.

Postscript 2063

I've just boarded an Ocean navigator with fifty-two women currently destined for a new Island just discovered off the hemisphere of Brazil. We're traveling in the method of the ancient mariners, one salty wave at a time. These women swear that getting there together is half the fun. I can't argue that fact as we plunge into the aqua waters off the coast of Belize. One woman whispers, "I think I saw her and that Nu-man drinking under a cabana," and the other says, "Your eyes are playing tricks is all. It couldn't be."

They open a bottle, fill tiny glasses, pass them around.

The pink coral stretches out before us for what seems like a moon of many miles. I press my face against the observation portal, my eyes searching for what mysteries might be revealed, lying just beyond the next sandy reef. Caught against the glass for just a moment is the reflection of the women but by some trick of light and shadow, they appear to be every woman past and present, sailing bravely out into the deep, blue sea. They raise their glasses

in a toast. The reflection shifts, narrows to the group behind me, to my own image, headdress glittering, pink feathers flying, my glass raised high, "Here's to us," I whisper.

My name is Sunday Catcher. I've been promoted to the post of senior reporting engineer for Motown Experimental Pharmaceuticals Laboratories, exclusively assigned to cover the activities of the test case group PMS-50, otherwise known as the Pulpwood Queens.

They just call me Story.

Beauty and the Book

Cassandra King

My first novel, *Making Waves in Zion* (published in 1995 and later re-released as *Making Waves*) is set in a beauty shop in a small town in west Alabama. It's the kind of book that's referred to as "small," which puts it somewhere below mid-list. (Actually, *way* below mid-list.) The truth is, *Making Waves* made few waves in Zion or anywhere else. Because it was released by a local press and had a minuscule first printing, I was grateful when it got any attention at all. I had to restrain myself from tracking down every reviewer and grovel at her or his feet. (Trust me, it wouldn't have taken me long.) Every time someone bought a copy, I wanted to grab that person in a big bear hug—which would've been fine, considering the purchaser was usually either family or friend. Pathetic as that sounds, I have a feeling that a lot of writers know what I'm saying. We never, ever forget our first readers.

With that scenario as backdrop, imagine my surprise when I was contacted by someone in east Texas who had not only read my book but wanted me to come do a signing in her bookstore. After introducing herself as Kathy, she told me why she'd called. My little book had struck a chord with her, she said, and then went on to explain why. What she said blew me away: Kathy was the proud owner of the only bookstore/beauty shop in the nation. (Maybe

even the world!) That such a place existed not only enchanted me, it filled me with such delight and amazement that Kathy L. Murphy immediately became my new hero. Anyone who loves getting all dolled up to read a book is a lifelong friend of mine.

That initial reaction only intensified when I traveled to Jefferson, Texas, to meet Kathy and see her bookstore for myself. The shop was every bit as unique and charming as I'd imagined it to be, but Kathy herself was more than I expected. Straight out of central casting (if there'd ever been a call for a bookstore-owning beautician), she bubbled over with charm and vitality. Vivid, colorful, enthusiastic, and pretty as a Texas beauty queen, Kathy wowed me from the first moment we met and instantly became my new best girlfriend. And could that girl talk books! I've known a few beauticians in my life and talked books with them quite a few times, but our conversations had never gone to the depths of those Kathy and I shared. She was better read than me, and I was a college English teacher who read like a fiend. I loved this woman! Icing on the cake, she fixed my hair in a French braid and showed me some tricks for applying makeup. She was too sweet a person to point out that putting on makeup in my usual way made me look like Tammy Faye Baker. Leaving her shop, I was transformed from Tammy Faye to Meryl Streep (if you squinted and had a few drinks.)

It got even better. Kathy was launching a book club to share her love of reading with others. Being from east Texas, what could she call it but the Pulpwood Queens? The first Girlfriend Weekend that I attended can best be described as indescribable, but I'll give

it a stab: Think having the Mardi Gras parade in a library with the Grand Old Opry on acid. Think the Miss Texas pageant in drag cavorting with a three-ring circus of bookworms. And that's just the Great Big Ball of Hair Ball. Words fail me, but I've never, ever had such a good time at a book event, before or since. Kathy and her staff did everyone's hair, the only time in my life I've ever had big hair, even though I was raised in Alabama, the heart of the big-haired South (men and women both.)

Since that first fabulous Girlfriend Weekend, I've returned many times. It's the highlight of every book tour. I've met the most wonderful sister writers, the sweetest Timber Guys, the coolest booksellers, a few actors, and even some famous musicians like Marshall Chapman. Marshall gave a one-woman concert that had a bunch of middle-aged women (led by me) yelling and clapping and singing along like a bunch of teenagers. I've met iconic authors, agents, publishers, and media, but mostly, I've made dear and cherished friends. One time when I was scheduled to present, I developed a sudden bout of vertigo from an inner ear infection. When my doctor said flying was out of the question, I came home sad and angry. How could I miss Girlfriend Weekend? It was supposed to be my reward for surviving a grueling book tour. When I called Kathy with the news, she was gracious and understanding, the way she always is, but before hanging up, she lit a fire under me. "Now get off your butt and write a new book so you can come again soon!" It was the perfect incentive.

After I married Pat Conroy, I was determined to get him to Girlfriend Weekend. Kathy had told me many times how much she

revered him and his writing, so I knew she'd be thrilled if I could talk him into it. And I knew he'd love it if he'd just give it a try. Just once, and he'd be hooked. But Pat wasn't having it. "Have you lost your mind?" he said when I begged yet again. "Can you see my fat ass dancing around in a cowboy hat with a bunch of wild women? Not going to happen. You go and have fun, but leave me out of it."

I gave in but not up. I knew I was closer to making it happen when I returned and told him about an adventure Kathy and I'd had visiting an old Citadel classmate of his. He listened with interest when I described his colorful classmate, who was right out of a Larry McMurtry novel; the very historic and haunted gothic mansion he lived in; and the fascinating family stories we heard there. Pat loved a good story more than anybody, and he soon had me telling guests about my trip to Texas and the characters I'd run into there. That's when I knew it was only a matter of time.

Sure enough, the irrepressible Kathy Murphy got hold of Pat and talked him into coming to the next Girlfriend Weekend and bringing a couple of his buddies with him. By then Kathy had another way of swaying Pat: his daughter Melissa had published her first children's book and won a coveted Pulpwood Queens Book Club award. Pat agreed to come to see Melissa, albeit reluctantly. (Or so he claimed. He was only doing it for his daughter and buddies, he insisted). Finally, he made it to Jefferson and the Girlfriend Weekend. I refrained from gloating when he told me on his return home that he'd had the time of his life. Not once did I say told you so. He must've had a real blast—at one point he'd taken off his britches and donated them to the auction. I dared not ask

for details, even when I saw pictures of him and his friend Bernie Schein posted on social media, surrounded by a bevy of big-haired babes dressed up like angels, with wings and halos. There are some things a wife is better off not knowing.

My last time at Girlfriend Weekend, in 2017, was bitter-sweet. Pat had died the year before, in March of 2016, and I'd re-treated into a shell of grief. Kathy Murphy, also grieving the loss of a beloved friend and fellow writer, was dedicating the weekend to Pat. Melissa and her daughter Lila were going as well as my dear friend Janis Owens, who had been with me at Pat's bedside when he crossed over to a better world. How could I not go, despite my intense longing to curl up in a dark room and never venture out again? Pat was gone from my life, and he'd taken light and laughter with him.

On a whim, I took a few items of Pat's with me for the auc-tion, thinking of the contribution he'd made last time he was there, which folks still talked about. I smiled through tears when Jamie Ford proudly held Pat's shirt aloft on hearing that he'd been the highest bidder. Pat would've loved that his shirt went to a young writer he'd admired so much. Melissa, Lila, Janis, and I dared not look at each other whenever another one of Pat's items was claimed, fearing that seeing their joy might bring us to our knees. The money raised that night was donated to the Pat Conroy Liter-ary Center to sponsor a book club convention. Again, Pat would've been pleased, but he would've been even more moved by the way the Pulpwood Queens had chosen to honor him.

Gamely, we dolled ourselves up for the Great Big Ball of

Hair Ball— or rather, the others did. I just didn't have the heart to. From the sidelines I watched as the lights dimmed and the music took hold of the dancers—writers and readers and good-time girls and guys from all over this great country of ours, united by a love of books. Feet started moving, hips twitching, and arms waving. I forced a smile and a little wave when Melissa, her precious daughter, and our dear friend Janis swirled past me, but I refused to join them.

To this day I don't know how it happened but somehow, and before I really realized what was going on, Bren McClain had pulled me to the dance floor. All I remember was shaking my head and holding up my hands in protest, sure she'd understand. I was a new widow wrapped up in my grief who had no desire to even be there, if the truth be told, much less on the dance floor. But Bren paid no attention to my protests. Next thing I knew, I was dancing. There I was, dancing like a fool with a bunch of wild, crazy, wonderful, big-haired people under sparkling lights, kicking up our feet, hooting and hollering, and getting down to the music. Through the makeup and the big hair and the flashy costumes, we looked at each other and laughed. When we joined hands and formed a circle, it was a glorious, dizzy circle of love. It was Girlfriend Weekend.

Good Books and Great Times at PQ Girlfriend Weekend

Bobbi Kornblit

Why do I love glittery headpieces, shocking pink, and leopard print? The answer is simple: Kathy L. Murphy. The Pulpwood Queen introduced me to her world of "tiara-wearing, book-sharing" women (and Timber Guys) who continue to touch my heart and stimulate my mind.

In 2012, shortly after the release of my debut novel, *Shelter from the Texas Heat*, I ran into fellow journalist Echo Garrett at the Atlanta Press Club. She was overjoyed at the publishing deal she had landed with an imprint of Penguin Random House. She credited much of her success to the support of a national book club leader who was based in a small town in Texas. Echo encouraged me to contact Kathy L. [Patrick] Murphy to submit my book for consideration at her annual book club convention, the Pulpwood Queen's Girlfriend Weekend. I was intrigued and was on a mission!

It sounded like a natural connection, with my novel being set in Texas. I was told that Kathy liked *The Divine Secrets of the Ya-Ya Sisterhood*, and my book had been compared in reviews to the popular tale about keeping secrets and the power of friendship. I contacted her and asked to visit Jefferson, Texas—hoping

she would offer to do my hair while interviewing me on her cable book show. I submitted my novel and crossed my fingers.

Kathy suggested a better fit would be to join her book excursion to New York City with PQ readers and authors. She graciously promoted my novel on her website when advertising the weekend trip to the Big Apple, which included entry to BookExpo, an elegant tea with author and soap opera star Tina Sloan, a tour of the Metropolitan Museum of Art led by Melissa Conroy, and a cocktail party hosted by Robert Leleux. Other well-known authors were on the schedule . . . and me!

Kathy ushered her group of literary pilgrims with enthusiasm and joy. We celebrated all of the senses by viewing art, dining, and sharing ideas. Friendships were formed with club members from chapters across the country, including Kathy's trusty sidekick, Tiajuana Anderson Neel. Although I loved the excursion, in the back of my mind I hoped Kathy would invite me to be a presenter at the upcoming book convention. I told myself to have patience! I savored every minute of the trip, including the farewell dinner where Kathy and I proudly wore our tiaras.

When I returned home to Atlanta, I couldn't believe my computer screen with the post from Kathy that listed me in the line-up of the 2013 Girlfriend Weekend. My dream had come true. And this was just the beginning!

The opening night theme was silent movie stars. Hollywood was a world I knew well, as my late husband, Simon, had been a top movie studio executive. I gathered my costume—a hot pink boa, a flapper headband, and the ultimate accessory: a

replica of an Oscar® statuette. Kathy and Echo greeted me in their glamorous finery.

At the dinner, authors served the book club members iced tea, tasty Texas barbecue, and loads of pickles, in a chaotic dance of trying to deliver the meals to each table in a timely manner. I enjoyed a reunion with people from the New York City excursion and met readers from many other chapters.

The ringleader of this camaraderie was Kathy L. Murphy. With a hearty laugh and often a tear collecting in her eye when she talks about her peeps, she's the mother hen of her band of reading revelers. Her personal story is inspirational, and she strives to help others by supporting literacy programs.

I connected with fellow writers. Their encouragement was also expressed throughout the year. Bestselling authors Lisa Wingate and Julie Cantrell featured my novel in their column in *Southern Writers*, a generous endorsement. Pulpwood authors often exchange "likes" and comments as Facebook friends, and we have also become *real* friends.

I returned the following year to talk about my journey with *Shelter from the Texas Heat*. The support of the Pulpwood Queens had been a big part of it.

Kathy invited me to Girlfriend Weekend when my second novel, *Red Carpet Rivals*, was released a month before the convention. She and Jamie Ford moderated the panel on which I discussed my book that revealed the "reel" story about stars, studios, and scandals—the first Hollywood #MeToo novel of 2018. What timing! Kathy had added me to the program at the last minute be-

cause of the late publication date that overshot her deadline, once again being supportive and loyal to one of her PQ authors.

I attended the convention again in 2019. Having grown up in Texas, I couldn't resist the theme of "How the West Was Won." As one reader stated, it should have been called "How the Best Was Won."

I packed my rhinestone cowboy boots, jacket with sequin buckaroos, and glitzy tiara. My sentiments echoed the comment of club member Marie Christopher when she won the bid for the silent auction package with my two novels and jewelry: "I'm all about books and bling!"

With boundless warmth and generosity of spirit, Kathy urged me to attend the 20th anniversary event in Jefferson in 2020. I'm honored to participate in this tribute to the Pulpwood Queen and her one-of-a-kind book convention.

A strong bond was formed at my first Pulpwood Queens Girlfriend Weekend. Here's to many more years of book talks, friendship, and outrageous fun!

A Lifetime of Books and Reading

Betty Koval
Doug Marlette Award Winner, 2019 Pulpwood Queens
Girlfriend Weekend

I do not remember a time in my life when I did not have a book or access to one. The first books I remember are collections of Mother Goose nursery rhymes, Bible stories, and Little Golden books. Once I could read, I was allowed to go to the local library and check out books. This was the ultimate privilege. I felt as grown up as my older sister. Did I ever think I was special! A whole new world opened to me, not only new places but other time periods as well. Anything historical has always been my favorite genre to read, whether fiction or non-fiction.

I met Nancy Drew, those cute Hardy Boys, Sherlock Holmes and Dr. Watson, and then on to Perry Mason. I loved trying to solve the mystery before the end of the book. I admit a good mystery or spy thriller is my not-so-guilty pleasure. Who doesn't like a good puzzle to solve?

I was fortunate to have two wonderful English and literature teachers who suggested—well, required—the classics. I loved *Moby Dick* and *Silas Marner;* even though most of the other students groaned, I devoured the classics. I thought myself to be the fourth Musketeer or the servant to help both *The Man in the Iron Mask* and *The Count of Monte Cristo.* My all-time favorite

was Hugo's *Les Misérables*. I will admit I did actually "get it" after I was grown and read it a second time. Love will lead us to make sacrifices for another beyond what we believe ourselves capable of enduring. Love gives one the tenacity to keep going against all odds. The performances of *Les Mis* just cannot give you what the descriptive words in the book convey. If you have never read this book, give it a try and see what I mean.

James Fenimore Cooper helped me learn what it was like to lose every member of one's family, a whole culture wiped out because of greed and war. We can learn a lesson from this, but it seems we are doomed to repeat history.

Jack London and Charles Dickens took me to places and times I could hardly imagine. Rudyard Kipling and Edgar Rice Burroughs dropped me in the deepest, darkest parts of Africa. Robert Louis Stevenson and Jules Verne had me going to an atlas to find places of unbelievable adventures. I went to war and ran with the bulls with Hemingway! Mark Twain introduced me to Tom and Huck and their mischievous activities.

Harper Lee and John Steinbeck taught me the lesson of doing what is right even when it is not the popular thing to do. C. S. Lewis had me first traveling to Narnia through a wardrobe for the same reason. Later, his *Screwtape Letters* led to deep discussions on religion in a class on the book.

Lest I forget Shakespeare? Never! I admit this was not a favorite until recently. The OLLI (Osher Lifelong Learning Institute) classes we take at the University of Alabama in Huntsville have led me to a wonderful instructor who taught Shakespeare for years. I

have a whole new and wonderful understanding and appreciation of the bard.

As I reached my twenties I had a shift into pure fluff as I call it. I admit Danielle Steel held my attention for about two years and then I became bored. It just seems all the storylines are the same, and only the names of the characters and places were different.

I have always loved a good western. Louis L'Amour and Zane Grey were favorites until I met Larry McMurtry! *Lonesome Dove* was an epic adventure of love, loss, and what it was like to work an entire life to accomplish your dream. He touched me like Hugo's work.

Then I found the proverbial pot of gold at the end of the rainbow—Pat Conroy's books! Oh my goodness, I do not have adequate words to express how much I have loved the books he wrote. I own and have read almost all of them, some twice! I still have my paperbacks from way back when *The Water Is Wide* and *The Great Santini* first came out! I love them and would not part with them. My only regret is not having Pat sign them when I had a chance. I simply did not want to impose. I am sure he would have been happy to see I had kept them.

I still like a good mystery, and John Grisham and David Baldacci are two writers I favor. Both are attorneys, but I have to say Baldacci seems to put a little more into his storylines.

Other authors I have enjoyed are Diana Gabaldon, J. K. Rowling, and Jan Karon.

In 1999, two of my four grandsons were born and the first

thing they received from Grammy was a book—and books are still my favorite gifts for them. I hope it instills a lifetime love of reading!

I was introduced to the Pulpwood Queens and Kathy L. Murphy by a bookstore owner and friend of my boss. Mary Gay Shipley and Liz Smith went to a Girlfriend Weekend and came back to tell me about the experience. We all went the next year and I have only missed two years since 2009. We started a book club in Blytheville and the rest is history for me. I have moved away and live in another state now, where I am hoping to start a book club. I hope to garner enough interest to get a few ladies interested in having a club where someone else chooses the book. I have told them repeatedly they would not regret the decision. I am still trying!

The Ties That Bind

Kasey Kowars

I talked with Kathy L. Murphy for the first time in the spring of 2005. She sent me an email telling me how much she loved the interview I did with Horton Foote in December 2004 on my website. She wrote of her love of *To Kill A Mockingbird* and told me about the Pulpwood Queens. Her phone number was on the email, so I called her. She answered the phone and we talked for nearly 30 minutes. The only reason we ended our conversation was that she had a customer waiting at her hair salon/bookstore, "Beauty and the Book." Talking to Kathy that day was like looking in a mirror and talking to myself. That had never happened before. I love books in a way that few people love them; and I intuitively knew that I had just met a fellow book lover, and that we were both more interested in promoting the books of the authors we loved than we were about writing our own books. (That also puts us in a small pond.)

I researched Kathy and learned that she had the world's largest book club, the Pulpwood Queens, and I read about her annual Pulpwood Queens Girlfriend Weekend held in Jefferson. She was (and still is) brilliant at marketing books. More importantly, she made reading books look fun and glamorous.

We talked again a few weeks later and I told her that I had

done my homework and that I was impressed with what she was doing, and that I would love to join forces with her on a project if the opportunity ever presented itself. A few months went by and Kathy called to invite me to the Pulpwood Queen Girlfriend Weekend to interview Jeannette Walls. Ms. Walls had recently published *The Glass Castle* and was one of the keynote speakers at the 2006 weekend.

"Are men allowed at the weekend?" I asked Kathy.

"Absolutely, we call you guys the Timber Guys." She laughed and told me that I would not be the only man there.

"How many Timber Guys will be there?" I had seen pictures of events like The Big Ball of Hair Ball and the Tiara Competition in the program. Being a bald male would pose a challenge at these events.

"Not too many, but you'll fit right in." She allayed my fears and off I went to Jefferson for my first Girlfriend Weekend.

I had a great time. I had dinner with Jeannette Walls and set up a date and time to interview her for my website. She was on the cusp of being a superstar. Jeannette was delightful; she was full of stories and took a genuine interest in what had led me to pursue the concept of my website.

I was utterly amazed by the experience. Hundreds of women were having a great time attending the panels and listening to the keynote speakers. It was magical. These women were *readers,* and they read the books that Kathy recommended every month. I met retired educators, lawyers, successful businesswomen, housewives, and lots of authors. It was, quite simply, a celebration

of reading and writing. It was a celebration of words.

I broadcast the first interview on my website in July 2004. My first guest was Andre Dubus III. I filled my weekly live interviews with a combination of best-selling authors mixed with an eclectic roster of new authors, playwrights, editors, poets, and screenwriters. It was the interview I did with Jeannette Walls that put me on the map in March 2006. Meeting and talking with her at the Pulpwood Queens Girlfriend Weekend gave me the edge I needed to prepare for our interview. I read and re-read *The Glass Castle* until the day of the interview.

The interview went off without a hitch and it has been listened to thousands of times all over the world. It is used by websites for teachers and professors and is a recommended source for term papers.

I love the word *serendipity*. In 2004, when I started my website, I was nearing the end of a twenty-five year career as a stockbroker. I was still four years away from becoming a high school English teacher, but the seeds were being planted.

My interview with Horton Foote received a lot of attention. (It was the first time he had openly discussed certain elements that were crucial in the making of *To Kill A Mockingbird.*) One day in 2007 I received a call from R. Barton Palmer, a literature professor at Clemson University. He was working on a book titled *Screen Adaptations: To Kill A Mockingbird: A Close Study of the Relationship Between Text and Film.* He asked my permission to use quotes from my interview with Mr. Foote, which I gladly gave him. The book was published in 2008 and is a great read if you are a fan

of both the film and the novel. He sent me a copy of the finished book with a note attached asking me to please call him when he returned from France the following week.

He and his colleague, Robert Bray, were writing a book titled *Hollywood's Tennessee: The Williams Films and Postwar America.* The book was published by the University of Texas Press and was a textbook for theater students and serious Tennessee Williams fans. (The price was $60.) I called him and we had a pleasant conversation about his time in France, and then he asked me if I would be interested in interviewing him and Mr. Bray at the Tennessee Williams/New Orleans Literary Festival, which would be held in late March of 2009 in the French Quarter. The festival is a bi-annual affair and features a stellar roster of actors, authors, scholars, and Tennessee Williams fans. It was an incredible experience. All of the participants stayed at the same hotel. I ended up going to Mass at the St. Louis Cathedral with the actress Frances Sternhagen. I had breakfast one morning with Richard Ford at a greasy-spoon restaurant that was a favorite of his.

It was my first year in the classroom and I clearly remember going into my principal's office to ask him if I could take two days off to attend the conference. He thought it would be a great experience, since I taught *The Glass Menagerie.* He told me I would have to pay my own expenses, but that he could get me a substitute. I explained that I was going to be a panelist and that I would be interviewing two of the authors. They were paying my expenses and a small stipend for moderating the panel. He laughed and told me to go and have fun.

I walked into the lobby of the hotel for transportation to the opening festivities and I saw Kathy Murphy standing across the lobby talking with an author. I had not seen her since the 2006 weekend. I had interviewed her about her book *The Pulpwood Queens' Tiara Wearing, Book Sharing Guide to Life* earlier that year (which has recently been reissued). We had a great visit and it turned out that her presentation *Cat on a Hot Tin Roof* and my panel on Williams' movies were at the same time and the same day (at different locations). Serendipity.

Kathy and I have stayed in touch over the years; in fact she wrote the introduction to my second book, *Another Celebration of Words*. My wife, Sharon, has attended the last two Girlfriend Weekends with me and she is now an official Pulpwood Queen. It is an event that Sharon and I look forward to and we are making great friends every year.

I am now finishing up my eleventh year in the classroom. I teach AP English language and composition to high school juniors. My students love *The Glass Castle*. I have read the book over 100 times and I never tire of it. Serendipity. When the movie opened in theaters last year I met up with a group of my former students to watch the movie. We had coffee and discussed the movie afterwards. I use many of the things I have learned from being a part of Kathy's tribe in my classroom. The Pulpwood Queens are important to me. With the demise of the chain bookstores it is imperative that we develop new paths for new writers to follow.

The mission of the Pulpwood Queens and my "A Celebration of Words" series is to promote literature and encourage

writers. I thank God that I met Kathy in 2005. She has encouraged me to stay true to my vision and to never give up. Books are an important part of any civilized society, and I sleep better at night knowing that Kathy continues to be a force of nature doing what she does. She is one of my heroes, and we all need heroes in our lives. Long live the Queen!

The Pulpwood Queens Community

Caroline Leavitt

This story, which is all about community, actually begins
with me, alone, in a deserted airport in East Texas. It was my sec-
ond Pulpwood Queens Girlfriend Weekend, and the airport was
the size of a grocery store. When I arrived, the two people at the
main desk were packing up and going home for the evening, which
scared me just a little. Okay, it scared me a *lot.* There were only a
handful of people in the place, and when I looked outside, nothing
but miles of darkness and empty road.

"How do I get a Lyft?" I asked the person at the desk.

"No Lyfts here, honey," she said, buttoning up her jacket. "No
Uber, either."

"A cab?"

"No cabs, honey."

"Limos?"

"Well, you can try."

She looked at me with deep sympathy. "Listen, honey, we leave
the doors open all night. You can sleep here."

The airport emptied out even more and I was about to burst
into tears when someone touched my arm. I turned to see a smil-
ing face, so grateful I was about to throw myself in her arms. "Hi,
I'm Nicole Waggoner. Are you here for the Pulpwood Queens?" she

asked. "I want to make sure you're okay because you look at little distressed." I hugged her. She assured me that she had rented a car, which was a good thing because by then we were the only people in the place, and when she called the Avis Station, we heard the ring. We followed it to the Avis booth, which was locked up tight.

"Uh oh," I said.

We called everyone whose number we had—who were involved with the Pulpwood Queens—but no one answered. The night grew darker, and we were hungry, so we feasted on snacks from the vending machine. "I'm not sleeping here," Nicole said. "And neither are you."

Finally, I called a limo, and the driver told me he could be there in two hours and take us to our hotel. "One hundred and sixty dollars," he said. I didn't hesitate for a second.

"Done," I said.

In those two hours, Nicole and I sat and talked about writing and our families and airplanes, and we bonded so strongly, we might as well have been superglued together. By the time the limo driver came, we were best friends. I couldn't look at her without smiling.

The event, of course, was amazing. I hung out with Nicole, and Ann Hood, and all these amazing writers, and within minutes of meeting each one, we exchanged numbers and emails. One night, we all decided to hit a local bar. I am not a drinker or a bar person, but these were my friends now and I wanted to be with them!

The bar was lively, but the best part was the waitress, a hometown girl who peppered us with questions. "You all are writ-

ers?" she said. "I love to read. Tell me your books." She wrote all our book titles down and then she brought us fireballs. She was soon my best friend, too. She hung out with us, talking, telling us that her boyfriend was in town, but it wasn't all happy. Her voice trembled. She wanted more from him. She needed more. "He won't marry me," she said. "He won't even live with me."

"Well, why the heck not?" Nicole said.

"I don't know," the waitress said.

"Well, we like you," Nicole told her.

"Yeah," I said, woozy from the fireball, "And we're going to help." I felt brave!

"Where is this guy?" Nicole asked, and the waitress pointed him out, a guy with a long ponytail and lots of tattoos slouching by the bar. I grabbed Nicole. "Come on," I told her. "We're going to fix this for our friend." Nicole's eyes sparkled.

We approached the guy who seemed to sink down deeper in his seat. "Man up," Nicole told him. "You can't string along a wonderful woman like her." And that's when I felt my New York City coming out. I jabbed him. Really. I jabbed him. "Hey," I said, I'm from New York City and we don't like it when men lead women on." I have no idea why I said that or why he should care about New York or where I was from, but he actually looked scared, so I kept on. "You had better connect better to her, and if she wants to get married, then you had better do it. You hear us?"

Chastened, he nodded.

"Good," Nicole said, and she and I went back to our table, our arms around each other, both of us triumphant because we felt we had given love a nudge.

I don't know if the waitress married her boyfriend. But I bet she did, because that was the kind of electric atmosphere that was going on at Pulpwood that weekend. Anything could happen and everything did. I was inspired by all the people, all the support and camaraderie. I never laughed harder than with Ann Hood talking about whether or not the khaki pants costumes we had to wear (It was an event celebrating Pat Conroy so we were supposed to dress like he had) made our butts look big or not. Author Christa Allen and I gossiped and laughed. I will never forget that my novel *Cruel Beautiful World* was book of the year (amazing, right?!) and when I accepted the award, this magnificent clear globe that Kathy had chosen for me, my hand caught in Kathy's glorious hair, making her yelp, but we hugged anyway. Tiajuana Anderson Neel, Kathy's right-hand woman, showed me her home, invited me in, and made me feel as though we were always going to be related. And I swear that we are.

Yes, the Pulpwood Queens celebrate books and reading and writers and readers. They do so much for literacy, and they bring people together in a way that is unforgettable and fun. (I still remember Meg Waite Clayton using her eyebrow pencil to dot on freckles for my costume.) And who is more inspiring than founder Kathy L. Murphy, who went back to college and is now an artist? It's something, isn't it, to have a supportive group of thousands of people, readers and writers both, all across the country, and all of them are on your side?

And hey, Pulpwood Queens, I'm on all of your sides, too, with grateful thanks.

A Sports Journalist-Turned-Novelist Meets the Pulpwood Queens

Marjorie Herrera Lewis

Before becoming an author myself, I never gave thought to what my life might be like as a member of a community of authors. I suppose if pressed, I'd figure it was much the same as life among a community of journalists, at least, in the way I had experienced it. After all, we all are writers.

For most of my life, all I knew was journalism. I cut my writing teeth in journalism—sports journalism—and for years, my life was a race to the finish line. Life was hectic, exciting, and often, excruciatingly painful in the sense that each day—and days that bled into weeks, weeks into months—was one long competition.

My life was a daily deadline, dashing from one place to another, catching planes to both domestic and international destinations. I lived out of a suitcase for weeks at a time, often waking up and grabbing the local newspaper on my nightstand to remind myself of where I was.

That was the sports writing life, for me. One big hurry. One big competition. Journalists can be a supportive bunch, but competition was always foremost in our minds. Get the story first. That competition was an adrenaline rush, and I loved it. It was in-

tense, and the Dallas/Fort Worth area, at one time, had three major newspapers. Until the early 2000s, newspapers were to news what the internet is to news today.

I was the first woman named a Dallas Cowboys beat writer in February 1986, so the pressure was intense and the spotlight, immense—neither of which bothered me. I thrived on the pressure. But that is not to say I wasn't immune to its most powerful side effect: stress. I had trouble sleeping. I had trouble eating. I had trouble relaxing.

And then one day, everything changed.

On October 2, 2018, my debut novel, *When the Men Were Gone*, was published, and on that day, I became a different kind of writer. I became an author, a novelist. Shortly thereafter, I discovered life as an author was quite different from life as a journalist. The competition I thrived on was gone, and I discovered I didn't miss it.

In its place I have found a warm and embracing community, exemplified by the weekend I spent in Jefferson, Texas, in mid-January 2019, where I was warmly embraced by the literary community. I was introduced and immersed in the Pulpwood Queens Girlfriend Weekend, and I discovered competition was supplanted by support.

When I was first invited to participate in Girlfriend Weekend, I had no idea what that meant. My publisher was thrilled, so I was, too. And the title of Girlfriend Weekend, of course, did offer a clue: easy to surmise it would be a welcoming, fun experience. I began looking into it because, frankly, the reading world I had

lived in was quite different from the reading world I was walking into. Although I have always been a reader, I'd lived in a world of newspapers, magazines, online news sites, sports sites, *Sports Illustrated*, ESPN, and *Sporting News*. I'm embarrassed to admit, but I had no idea book clubs had become so ubiquitous in our culture.

So when I arrived in Jefferson for a three-day event, I feared I may not have much in common with the other writers and readers who, as I discovered within minutes of walking into the Jefferson Convention Center for the first time, could spew the names of authors I'd never heard of and talk of works I'd never read. While they spoke, my head was spinning with names like Melissa Isaacson, Cindy Shmerler, Peter Alfano, Kevin Sherrington—all award-winning, accomplished sports writers. I kept their names to myself while wondering: *Would we understand each other? Should I admit that everything I was stepping into was new to me? Would I stick out as a novice?*

Soon my fears dissipated when I found myself in a conversation with Beth Howard. She was talking about pies. Pies! A sweet treat I rarely eat and certainly have never baked. Then I realized the women I was about to spend the weekend with didn't have to love sports or competition or even journalism. Our common interest was the love of the written word. And so I spent the next few days in a warm, embracing community of readers and writers, and ultimately, of friends.

I Had a Dream

Judithe Little

I've read that if you want to be a good conversationalist, you should never talk about your dreams. I've also read that as a general rule, writers should avoid using dream sequences in novels. Dreams, to the person who didn't experience them, are generally considered boring.

So, going against all advice, I'm going to tell you about a dream I had. It happened in January 2018 at the Pulpwood Queens Girlfriend Weekend in Nacogdoches, Texas—which is also MLK weekend.

If you're not familiar with Pulpwood Queens and you love books, you're missing out. Founded by Kathy L. Murphy to promote books, authors and literacy, Pulpwood Queens now boasts over 750 book club chapters worldwide, and an annual get-together every January in either Jefferson or Nacogdoches featuring authors from all over the world, a tiara contest and a Great Big Ball of Hair Ball. An artist and visionary, Kathy also has a killer business sense (don't let the dreamy headscarves and bohemian garb fool you). How else could she get best-selling authors like the late Pat Conroy, Paula McLain, Jamie Ford, Alice Hoffman, Lisa Wingate, to name a few, to a small town in east Texas? And get Simon and Schuster to send 40 boxes of galleys and books to give away to

attendees? (Pack an extra suitcase!)

I was invited to talk about my historical novel, *Wickwythe Hall*. I had no idea what to expect, but I did not expect to make lifelong friends after just three days. I did not expect to laugh as hard as I did because so many authors can double as standup comedians. (Who knew?) I did not expect to meet so many members of book clubs who come to this event year after year after year. I did not expect to get so comfortable wearing a tiara that I almost forgot I had it on. I did not expect to become a member of a tribe. I did not expect to be inspired to be a better writer and a better reader and even a better person.

But all of that happened.

At Girlfriend Weekend, authors shared their stories, their advice, their struggles, and their successes. We laughed, we cried. There were what I used to call "Oprah Moments" that I will now call "Pulpwood Moments." Do you remember those old rock tumblers that you could get at Toys-R-Us and you might have coveted, as I did, when you were a kid? The ones that claim to turn rough rocks into semi-precious gems? That's what Girlfriend Weekend felt like. I went in a rough, unpolished stone, was spun around in a rock tumbler, and came out feeling like a semi-precious gem. Maybe it was all those tiaras...

Which leads me to the dream. Friday night, after we authors dressed in our best hippie outfits and served dinner to the readers, I literally dropped like a (rough) rock into bed in my fringe vest and love beads and fell fast asleep. And that night, I had a dream I've never had before, a very vivid dream, about the

moon. It was way up there in the night sky, all warm and white and glowing. And it was shaped like a heart.

I usually have dreams where I'm driving a car I can't control. The steering wheel won't steer, the brakes don't work and I'm veering all over the place, on the brink of disaster—the typical dreams of a person who feels like their life is out of control. But Saturday morning, I woke with a sense of serenity I don't usually have, of peace, and well-being.

A deep-thinking friend pointed out that the moon is a symbol of reflection as well as of the soul, which makes perfect sense. That heart-shaped moon was a reflection of the spirit of the Pulpwood Queens Girlfriend Weekend, the joy, the tears, the Pulpwood Moments, the tribe. As another author put it after Girlfriend Weekend 2018 came to close, "my soul needed this." So did mine.

Enter Kathy L. Murphy

Bren McClain

I can sum up my Pulpwood Queen experience this way: Be a debut novelist who is not a spring chicken—ha!—and be published by a small press. Try not to think about all those young writers, published by the biggies in New York.

Are you with me?

Enter Kathy L. Murphy and the Pulpwood Queens. Be in Nashville, Tennessee at the Southern Festival of Books in 2015, and have your dear friend, the extraordinary writer River Jordan, introduce you to Kathy.

WHOA.

Tell her that your novel, *One Good Mama Bone*, will published by Pat Conroy's imprint, Story River Books.

What, she says, *I love Pat Conroy. He's my favorite author. Send me your book.*

Pick yourself up off the floor, then send her your book when you get an advanced reader's copy.

Maybe you'd better sit down for this next part.

Because Kathy will make your book the May 2017 selection. And, because you told yourself that you would leave no stone uncovered *when* you got published, you decide to go to Texas for a few days that May. And that's when your friend, the amazing Pulp-

wood Queen writer Texan Kim Griffin offers to help set up events.

All right, so let's take this back now and get in real time, because, I want to sink into this week, because it'll tell you what it means to have a Pulpwood Queen community. I want to show you hearts so big, I wouldn't dare miss a single beat.

Kathy Murphy's original Pulpwood Queens chapter in Jefferson hosted the first event. Held at the Carnegie Library, I walked in to find the ladies dressed in cowgirl garb, the tables decorated with cow décor and a healing basket of biscuits in honor of my main character, Sarah Creamer, who dreamed of having enough money to make biscuits for her husband's illegitimate son, a little boy she is raising as her own. Honor is the word, isn't it? These ladies honored me and my book. They set themselves in the world I created and showered me with bits of its essence.

The next afternoon, at the Tyler Public Library, I sat at a table in the foyer with copies of my novel for sale. Mostly, I waited for folks to come by. One did. Kathy Murphy herself. Busy with her college studies and work at a retail clothing shop, she made time for me. Came by in all her magnificent glory and kept me company. She didn't have to do that. But she did. Replete with smile and humor and a heart that will not be contained.

On day three, Kim arranged a wonderful gathering at Dewberry Plantation in Bullard. Again, Pulpwood Queens in attendance. Yep, Kathy Murphy again. And Tiajuana Anderson Neel, who also was in attendance that first night.

It would be Tiajuana again on day four as I displayed books at the Longview Public Library that morning and then went on to

Books-A-Million that afternoon, where Kim joined me.

I closed out my visit with the Tyler Pulpwood Queens chapter, again with Kim.

But my story doesn't end there, because something even more humbling happened, an honor that I will take with me to my grave. My novel was voted 2017 Pulpwood Queens Book of the Year.

See what I mean about these hearts? Each of these kind gestures alone is soul-honoring, but, when accumulated, they are mind-blowing.

And that's why I'm a forever believer in the tribe that is Pulpwood Queens, a book-loving community that doesn't just read. No, this community nurtures us writers.

I'm talking *me*. Nurtures *me, Bren McClain*.

What You Get With the Pulpwood Queens

Fletcher McHale

When I dove off the deep end of the pool at fifty-five and decided to write a book, I had no idea what I was doing. And I don't mean I was a little green; I mean I had *no idea what I was doing.* In my mind this was to be the sequence of events: I wrote a book, it became an instant success, read and loved by millions, a successful movie was made right away, followed by a scorching and scandalous affair with Harrison Ford, and I retired after a string of late-night appearances and an Oscar for Best Screenplay.

What I learned was this: even though that scenario happens sometimes, it doesn't happen for most of us. But you actually get something pretty freaking cool. You get a tribe. After my first book, *The Secret to Hummingbird Cake*, was published by Harper Collins, my agent kept telling me we had to try to get into the Pulpwood Queens Book Club. I'm born and raised in Central Louisiana. Pulpwood Queens are the wives that get up at 3:30 a.m. and send their men off to the woods to cut trees. I couldn't understand how the hell some pulpwood wives from Texas were going to help me push a book.

But lo and behold, my publicist hooked me up and I was introduced to Kathy L. Murphy. I mean, *the* Kathy L. Murphy. If you want to meet an adventurer, an advocate, an ally, an encourager,

an organizer, and best of all, a friend, then you need to meet Kathy. She welcomed me into the fold immediately, made me feel like I belonged there, and continues to do so today. But I didn't just get Kathy. I got so much more.

Also, in my infinite wisdom and vast experience as a first time author at fifty-five, I had painted a picture in my mind of all these writers who would be at Girlfriend Weekend—all young, beautiful, vibrant women in their early twenties with the perfect glasses and perfect bodies who wrote masterpieces and who wouldn't speak to me or understand anything about me. But you know what I found? I found all these writers who were from eighteen to eighty, all beautiful in so many ways, all vibrant, all with stories they were eager to share, and full of advice for a newbie like me. I found readers anxious to hear me, and met other authors who were a delight to listen to. And I fell in love with all of them.

Long live Kathy L. Murphy and the Pulpwood Queens!

The Night of the Fairy

Laura Lane McNeal

Several years ago, Kathy L. Murphy asked me to participate in the Pulpwood Queens Girlfriend Weekend. My debut novel *Dollbaby* had just come out and I was still learning the ropes of being a new author, especially the part about speaking in front of audiences, which was terrifying to me. As I started my journey from New Orleans to Texas, a five-hour drive, I was more than a little anxious. To ease the stress, I brought along the essentials—an ice chest loaded with beer and wine, a bottle of scotch, and plenty of snacks. I took off having no idea what I was getting into, not knowing a soul who was going to be there, my nerves a little raw. I was driving a new car and was unsure of its many features, including one where a coffee cup appears on the dashboard telling me it's time to take a break. The icon covered the speedometer so I had no idea how fast I was going, plus I couldn't figure out how to get rid of it. This wasn't helping my apprehension.

About two hours into the trip, I got pulled over, my heart racing at the sight of the flashing blue lights. The policeman informed me I had yielded at the turn onto the highway when I shouldn't have and could have caused an accident. I thought he was being a little overzealous by stopping me. He didn't give me a ticket, just a warning, but the incident made me consider if I

should just throw in the towel and head home. I didn't; I drove on. Two hours later, as I was travelling through a small town just this side of the Texas border, I was pulled over again. When the officer asked me if I knew how fast I was going I pointed at the coffee cup icon on the dashboard and said I had no idea. I'm sure he thought I was being sarcastic.

He asked for my license and registration and then eyed the ice chest and the bottle of scotch on the back seat, making me wonder if he was not only going to give me a speeding ticket but lock me up for transporting liquor across state lines. When he came back to my car with the ticket book in his hand, I thought that's it, I'm heading home. Too many bad omens. He asked me where I was headed in such a hurry. When I explained I was an author and I was going to the Pulpwood Queens Girlfriend Weekend, the serious expression on his face relaxed.

He informed me his wife was a member of a Pulpwood Queen book club and asked if I had an extra copy of my novel. Normally I travel with a whole case of books, but not this time. I'd taken it out of my car to make room for the ice chest. No, I replied, but I'll be happy to send her one. He started scribbling. My heart fell. I was still getting a ticket. Then he handed me a piece of paper with his address and informed me his wife would love to read my book if I'd send her one. He patted the car and walked away. I took in a few breaths and drove on, rattled but relieved. The Pulpwood Queen had gotten me out of a jam and she didn't even know it. I would have to thank her.

These unexpected stops made my arrival in Texas later

than expected, so I hurriedly changed into my fairy costume complete with wings and a crown of flowers, the theme of the Girlfriend Weekend, and drove over to the meeting place. By the time I arrived the meeting hall was buzzing. I'd already missed the group picture, but Kathy Murphy came up and greeted me with a big smile and a warm hug, one that felt like she meant it. I relaxed a little and set about serving dinner to the guests, all the while chatting with other authors who also made me feel welcome—Mary Alice Monroe, Patti Callahan Henry, Paula McLain, Susan Crandall, Kristy Woodson Harvey, Peter Golden—just to name a few of the many that opened their arms to me. That night I invited anyone and everyone to come back to my hotel room to enjoy the libations I'd brought along. At the end of the evening, I packed my fairy wings and went to bed with a big smile on my face.

Over the course of the weekend I met many new friends. There was never a spare moment. We laughed, we joked, we traded stories. I found my tribe. There are few times in life when you meet people that change you, and for me that was Kathy Murphy. I have never known anyone quite like her, a dynamo so full of energy, so genuine and effervescent, it's contagious. She filled the room with sparkle, and in turn, made everyone else shine. Her own story is amazing—going back to school to earn not one but two degrees, an author herself who is now pursuing a new a career as an artist, the passionate leader of a worldwide book club willing to lend a helping hand when needed and never asking anything in return. Her dedication to both readers and authors knows no bounds. She deserves that tiara because she's a queen in so many extraordi-

nary ways! Meeting Kathy alone was worth the trip to the event.

By the end of the weekend I was exhausted, the apprehension I felt upon arrival replaced by a warmth I carried with me all the way home. I wanted to turn around and go back because I already missed all the people who'd made my experience at the Pulpwood Queen's Girlfriend Weekend so wonderful. My ice chest was empty, but my heart was full.

From a Chance Encounter to Finding My Tribe

Susan Marquez

It felt like the world was pressing down on me, and my life was not my own. For six months my life stood still as my daughter fought for hers. After she survived an unimaginable accident, I was by her side pretty much all the time, and there was no place else I would rather have been. But I was tired. I longed for normalcy. I needed to be around fun, intelligent girlfriends. I suppose it was no accident when I ran into Jonni Webb at the pharmacy one afternoon as I was picking up prescriptions for my daughter and Jonni was dropping off pottery to sell in the store's gift department.

Jonni and I had known each other in a former life, when we were both in the advertising world—she as an advertising manager of a successful weekly newspaper and me as a copywriter at a large ad agency, and later as marketing director of a regional shopping mall. Our lives changed when we changed careers. Jonni took up pottery, which she developed into a thriving business. I began writing feature articles for magazines, newspapers, business journals, and trade publications. Both of us worked from home, so we didn't see other people on a daily basis. Making connections and staying in the loop was important to both of us. Little did I know that the most important connections of my life would come from our chance meeting at the pharmacy.

We friended each other on Facebook. We were both new to the social media platform at the time. I saw a post she made about going to her book club. A book club! *I would love to be in a book club!* I love to read! I love intelligent discussion! And most of all, I love wine, which was the drink of choice at the book club meetings. I reached out to Jonni and asked about her book club. "You can be my guest at our meeting next month," she said. "Just bring an appetizer and five dollars for wine. Oh, and bring your own wine glass."

I bought the book and began reading. I'll never forget it: *Saints in Limbo* by River Jordan. I was absolutely immersed in her beautiful words. The story was unlike any I had ever read. Seductive, sensitive, southern, secretive. I can think of so many adjectives to describe that book and the experience I had reading it. If that's any indication of what kind of books we would be reading in the book club, I wanted to sign up right away!

The book club meeting went pretty much the way I had fantasized it would. A long table surrounded by women from all walks of life. Young and old, professionals and stay-at-home moms. The common denominator was the love of reading. After visiting and eating, the discussion began. One by one, each woman gave the book a rating of one to five, with five being the best. A short rationale for the score was given as well, as each person talked about what she liked or didn't like about the book. There was very little not to like. Then something magical happened. Jonni pulled out her phone and dialed a number. She put it on speaker and suddenly she said "Hey, River!" Then River Jordan herself

was talking to us about the book. She talked about what motivated her to write it, and she talked about the characters I had gotten to know. I could hardly contain my excitement to hear an author talking to us about her book, the book we had just read.

I went home feeling that a new world had been opened to me. I knew a few of the women in the club, but most were friends I had not yet made. Now I can't imagine my life without them.

At the next meeting, Jonni told us about Girlfriend Weekend, held each January in Jefferson, Texas. It was a gathering of Pulpwood Queens from across the country, complete with costumes and authors and fun. The whole shebang was headed up by THE Pulpwood Queen, Kathy L. Murphy. Jonni and her longtime friend, Brownie Shott had been attending for a few years, and now that Jonni was the head of an official Pulpwood Queens chapter—our book club—she was making sure we all knew about it. I'm pretty sure fellow member Leslie Puckett and I booked a bed-and-breakfast that very night for the conference that was still nine months away.

I attended my first Girlfriend Weekend in 2010, and I've been going ever since. That first one was a bit of a shock for me. Having come from the corporate world, where conferences were overly organized and often impersonal, Girlfriend Weekend was anything but. My first exposure to the annual affair was walking into the community center in downtown Jefferson for registration. It was a free-for-all with a couple of people in the middle of a fort of sorts, surrounded by folding tables with eager Pulpwood Queens on all four sides trying to get their registration packets. A

short woman with red spiky hair and long decorated fingernails (Tiajuana Neel) and a bleach-blonde man dressed in a suit with a shiny purple tie (Robert LeLeux) were doing their best to attend to the crowd. I wondered if the whole weekend would be as chaotic. "Don't worry," Jonni assured me. "It's always like this, and it always works. Just relax and roll with it." That was the best advice ever.

Still reeling from the registration melee, I settled in my seat for the opening of the conference. Music played loudly on the sound system as a tall woman with big hair strode confidently to the stage. "Welcome everyone, to Girlfriend Weekend!!!!" The crowd (most of whom were wearing tiaras and feather boas) cheered as Kathy Murphy paced the stage while introducing authors and telling us what we would experience over the weekend. Authors crossed the stage in elaborate costumes, as if it was just another day at the office.

Over the next couple of days, I listened to authors talk about their books and their writing lives and I stood in line to buy way more books than my budget would allow. I then stood in another line to have my books signed by the authors. All personalized to me.

I have been writing all my life. From term papers to press releases, ad copy to feature articles, I love using words to express thoughts. Feature writing gives my curious nature a free ticket to ask questions, to learn the backstory, to find commonalities and to celebrate the human spirit. Writing opens doors for me and gives me a glimpse into the lives of other people. I learn what they think,

hope, fear, and dream. Then I have the honor of telling their stories to others and getting paid for it. Writing, for me, is a privilege.

Writing is also a responsibility. When a story is so big, so powerful, so inspiring and so intriguing, it must be told. That's the boat I'm in. I have a big story. It began with my daughter, who I mentioned at the beginning of this essay. She experienced something not many people have. She fell six stories from the roof of her apartment building in New York and survived. Not only did she survive, she has thrived. She is an ambulatory incomplete quadriplegic (she walks!) and she is a motivational speaker. And her story is automatically my story, because as her mother, I lived through it as well. And now I'm writing a memoir about her accident and miraculous recovery, from a mother's point of view. It's been difficult to write, as it means revisiting some very dark times, but the rise from the ashes, so to speak, makes it all worth it.

It's been a learning process, and in doing the learning, I've met my writing tribe. I've gotten to know River Jordan, the author whose book is still so vivid in my mind. She has gone on to write more books, and I've loved each one. And best of all, I now call River a friend. In that magical space at Girlfriend Weekend, I have befriended other authors I admire including Susan Cushman, Julie Cantrell, Cassandra King Conroy, Bobbi Kornblit, Stephanie McAfee, Bill Torgerson, J.C. Sasser, Nicole Seitz, Jonathan Haupt, Pattie Welek Hall, and so many others.

Had I not been exposed to such amazing authors, both established and up-and-coming, at Girlfriend Weekend, I may not have gotten to know some of my favorite characters. I fell in love

with sweet Henry Lee in Jamie Ford's debut novel, *Hotel at the Corner of Bitter and Sweet*, which also educated me about Seattle and the internment of Japanese Americans during WWII. Lisa Wingate's novels took me to the outer banks of North Carolina and introduced me to strong female characters like Tandi Jo Reese in *The Prayer Box* and Whitney Monroe in *The Sea Keepers Daughter.* While reading Cassandra King Conroy's novel, *Moonrise*, I could visualize Helen Honeycutt walking among the white flowers of the nocturnal gardens of the Victorian mansion that once belonged to her husband's first wife. I followed Mare, the main character in Susan Cushman's debut novel *Cherry Bomb,* as her life took all sorts of unexpected twists and turns. I've laughed out loud at the antics of Graciela "Ace" Jones in Stephanie McAfee's *Diary of a Mad Fat Girl*. The pain, redemption and triumph in every one of Julie Cantrell's novels inspire me in ways that make me want to be a better person. And who knew I'd fall in love with a book about a cow? Kathy Murphy did, of course, and that's why she put *One Good Mama Bone* by Bren McClain on our reading list.

Creative non-fiction books have captured my imagination as well. *Empty Mansions* by Bill Dedman told the incredible story of the reclusive heiress Huguette Clark. NancyKay Wessman's *Katrina, Mississippi: Voices from Ground Zero* had my heart racing as I turned the pages. And *A Mother's Dance* by Pattie Welek Hall hit close to home for me as she lovingly and honestly chronicled her son's traumatic brain injury. And I still laugh when I think about Robert LeLeux's description of his mom's lip implant shooting across the women's lounge at Neiman-Marcus in *The Memoirs of*

a Beautiful Boy.

Kathy chooses twelve books a year for her book clubs to read, as well as bonus books for alternatives. I'm not going to say I love every one of them, because some subjects are just not my cup of tea. But I do appreciate the effort and talent that each author poured into their work. Reading books by people I've gotten to know makes them all the sweeter. I can now hear their voice in the words on the page. I feel more connected to the authors with each word I read.

Connections. There have been so many connections made through my association with the Pulpwood Queens. My book club friends who love reading as much as I do. The women from other book clubs who faithfully attend Girlfriend Weekend each year. The authors who not only want to promote their books, but who connect with the readers in a magical way. And the connection with Kathy Murphy, who has created something bigger than her already larger-than-life persona, which connects authors and readers, but most of all, friends. I have found my tribe.

Dolly and the Queens

Michael Morris

I first learned of the Pulpwood Queens the same way many others did. When producers of "Good Morning America" asked the Pulpwood Queens to pick a book for their show's book club, my mama called and said, "You ought to send these women your book. They seem like your kind of readers."

My first novel, *A Place Called Wiregrass*, had just been released and I was trying to get anyone and everyone to read it. My living room had become a makeshift mailroom with books and packing envelopes stacked everywhere. Basically, I spent a lot of money on postage and heard few responses. But Kathy L. Murphy did respond. In fact, we started an email exchange that launched our friendship. It was an old-fashioned pen pal relationship, straight out of the old kids' show of my day, *Big Blue Marble*. She had already picked her books for the upcoming year, but she asked me to let her know as soon as my second novel was published.

When *Slow Way Home* was released, Kathy made it an official selection and worked with my publisher to set up a weeklong traveling tour of the Pulpwood Queens chapters in Texas and Louisiana. She not only set it all up, she picked me up and hauled me around in her minivan.

I still remember that first visit to Jefferson, Texas. I arrived

in the dead of night, a bit disoriented and trying to figure out exactly where I was on a Texas map. At the House of Seasons bed and breakfast tour home I was assigned a room that was called the Laura Bush suite because when she visited as Texas' First Lady, the book lover had stayed there. It was the typical first-class treatment I've found Kathy extends to everyone.

The next morning Kathy greeted me with a big wave from the driver's seat of her van. Then she jumped out and welcomed me with a hug. Her spirit was as big as the hairstyle she was wearing. My only surprise was that she didn't have a Southern accent. "I'm a Kansas girl," she told me and launched into a story about her family. We've been swapping stories ever since.

During that week, while traveling in Kathy's van down a Texas interstate, I had a phone interview with the *South Florida Sun Sentinel*. When the book editor heard I was with the Pulpwood Queen, he was intrigued. His only disappointment was that we were driving around in a van. He said he expected a Pulpwood Queen to be in a red convertible Mustang! Later, Kathy called to let me know the article was reprinted in the *New York Post*. Only the Pulpwood Queen can bring forth that sort of attention.

Visiting Pulpwood Queens chapters that week was not only fun but also inspiring. Instead of talking about my novel, I found myself spending more time getting to know these women and their stories. Their love of reading is only second to their love of adventure. All the Pulpwood Queens I met know how to enjoy life.

Many of the women come from small towns like where

I grew up and others from big cities like Dallas and Houston. At their annual Girlfriend Weekend, I am always amazed at the level of creativity they bring to their costumes for the "Great Big Ball of Hair Ball." Book club members and authors dress as their favorite characters—everyone from Harry Potter and Anna Karenina to characters from *Sex and the City*. These are women who I have come to know as friends and even as first readers for manuscripts.

When a novella I wrote, *Live Like You Were Dying*, based on the Tim McGraw song, was released, the Pulpwood Queens helped to organize a launch party at a casino in Shreveport. Songwriters who wrote the McGraw song, Tim Nichols and Craig Wiseman, came and performed.

One Pulpwood Queen told me her own *Live Like You Were Dying* story. When her husband died, she decided that every month for the rest of her life she would do something she'd never done before. One month it was donating blood, the next it was jumping from a plane and skydiving. I've never forgotten that conversation. It is typical of the determined spirit and love of life that I've found within this group of women who come together for their love of the written word. They are proof that words can change lives.

Through Kathy and her Girlfriend Weekend, I have met not only wonderful members of the Pulpwood Queens but many writer friends from far and wide. For me, friendship is at its core what the Pulpwood Queens are all about. These women not only share their thoughts on books with one another but also their triumphs and challenges in life.

I'm honored to call many of the Pulpwood Queens good

friends—friendships forged not only at their Girlfriend Weekend convention but also on trips with them to New York and Nashville. (I mentioned they know how to live life in a big way.) A highlight of one trip was being with some of the book club members and seeing Dolly Parton perform at the Grand Ole Opry. It was particularly fitting because the book club has long raised money for many causes, including Dolly's Imagination Library, which provides free books to children.

Social outreach is important to all the Pulpwood Queens I know. One of my favorite memories involves the head of the Anchorage, Alaska, Pulpwood Queens. She formed a chapter at a women's prison. The women ended up reading *A Place Called Wiregrass*, which deals with a woman leaving an abusive marriage and raising a granddaughter because her daughter is incarcerated. According to the National Coalition Against Domestic Violence, as many as ninety percent of women incarcerated as violent offenders are in prison because they killed men who had battered them. The letters I received from these readers remain treasured possessions. Moments like these are why I keep writing.

The Pulpwood Queens are still going strong, making an impact on their communities and having fun along the way. And while they have been a force for two decades they might be just beginning. In fact, if the enthusiastic and vibrant women I know in this book club are any indication, the Pulpwood Queens might one day find themselves with their own network series. Long live the Pulpwood Queens!

Two Women From Forty-Seven Miles Apart

Jennifer Mueller

Flint Hills rolling undulating

Without trees

So close yet never meeting

Jennifer from Emporia

Kathy from Eureka

47 miles apart

Pacific northwest

Ocean, islands and mountains with trees

So far apart yet meeting

Man bun, big hair, value village!

Girlfriend weekend

You want me to go out in what?

Do you want sweet or unsweet tea with that?

Hot pink and leopard print

Tiaras for queens and the queen

Books, books, and more books

World with books, bright and shining

Travel the world without ever leaving your chair

So many worlds so little time

Readers writers and friends

So many friends so little time

New friends, old friends, and all friends in between

Fruit loops and cigars and the Poltergeist room

Big ball of hair ball

What a wild ride

Diamonds are a girl's best friend

Bohemian Rhapsody

How the west was won

Shimmering vodka bottle

When two women from 47 miles apart get together

Great Love!

Glamping and Adventuring with the Pulpwood Queens

Tiajuana Anderson Neel
The Pulpwood Queens Executive Director

[Editor's Note: Tiajuana Anderson Neel died on April 19, just twelve days after she wrote this essay. I am so grateful to have her words here as part of this celebration of the Pulpwood Queens and Kathy L. Murphy, who loved her dearly.]

I first heard about the Pulpwood Queens Book Club in a *Longview News-Journal* feature article. It made me very excited and I said to myself, *this is me!* I want to be a Pulpwood Queen. I had a customer come into my job, and in casual conversation the topic of reading came up. He said, "My mother is in a book club."

I said, "Which one?"

Low and behold, it was the Pulpwood Queens. He said "Let me talk to her to get you some information." I was so excited. The next day he came back with a handful of books from his mom, Kay Brookshire, who has since become a very good friend. That's all it took; I've been hooked ever since.

I owe my life to the book club. I have made some of the best friends in the world through this group. I've seen these ladies dig deep in their pockets to help a member in need or a stranger on the street. This is what our group is all about. Helping one an-

other and promoting our love of books.

The first Girlfriend Weekend I attended was like I had died and gone to heaven. I didn't know what to expect and I was pleasantly surprised. Costumes were over-the-top beautiful. I hadn't been in the club long and I asked Kathy L. Murphy if she needed any help. She was so welcoming and said sure come on. That was so many years ago now I can't remember, but I have been helping every year since. I look forward to Girlfriend Weekend like a child waits on Christmas. It's like a big family reunion. I keep up with several of the members through Facebook all year, and then we get to share our lives and stories in person when we come together for the weekend.

A Pulpwood Queen is more than just a reader. We give service to our communities. Many groups go out of their way to help others. Some help raise money. Others give books to people that would not have access to them. My daughter, Amanda Markham, has a friend from our hometown who moved to Mississippi. Her sister was involved in a bad car accident with her daughter that resulted in paralysis of the child. My daughter and her friend headed to Mississippi with no place to stay and not a lot of money. The BB Queens of Jackson, Mississippi, took them in, brought them snacks to the hospital, offered them a place to stay in their homes, and gave them money and moral support. This is what a true Pulpwood Queen does. They went out of their way to help them. I appreciate everything they did in this terrible time.

Kathy and I travel together a lot. We have had many adventures that have made us laugh and cry. Our trip to New Jersey to

deliver a piece of her artwork to Laurel Davis Huber was quite an adventure. We had never tackled such a trip. Kathy called and said, "I think I'm going to drive this painting to New Jersey because it will cost about the same price to ship."

I said, "When do we leave?" I'm the navigator on these trips. We drove through New York on our way and, with all the traffic, we missed the turn. It was no big deal but Kathy was almost in a panic. We did a little loop-the-loop and we were back on track in a flash, all the while she was freaking out. When she realized she was driving in New York City she was so proud of herself. You have to understand we are from a very small town in East Texas that doesn't have much traffic at all. I'm amazed at all the traveling we have done with no major mishaps.

We started looking at campers to transform into a "glamper," and we wanted to join a women's camper group called Sisters on the Fly. They go camping, fishing, and just have good clean fun. The first camper we looked at was a great price. We couldn't get there fast enough to buy it. We had big dreams for this little jewel. The pictures were deceiving. It was a total mess. We were trying to see the top of it because there were signs of leakage on the inside. The guy showing it to us climbed up on a car that was sitting nearby. He slid off the roof and fell into the windshield. His whole rear end went through it and broke it into a million pieces. Amazingly he didn't have a scratch. We left there and went to Camper World and Kathy bought a brand new camper and named it "Mark."

We took Mark to Tyler State Park for Kathy's birthday weekend. I had not been camping in many years. This was Kathy's

first experience in her own camper. Helaina, Kathy's oldest daughter, made plans to meet us there and camp with us. She had brought a birthday cake and we had tons of food we were going to cook. Well, of course, we would pick a day to camp when there's a burn ban, so that changed our menu up since we were prepared to grill out. Helaina got to the campsite and had a present for Kathy. Kathy had said no presents but Helaina said, "it's just a little something." She told us Madeleine, Kathy's youngest daughter, wanted to do FaceTime while she opened her gift. Hmmm, that's strange, but oh well. In the woods we didn't have very good reception so I took a video on my phone to share with Madeleine. Kathy opened her gift and pulled out a bag of coffee and a coffee cup that has "Mama Kat" on it. If anyone knows Kathy, you know she's a big coffee drinker. Ok, cool. Helaina says "Open the cup for a surprise inside." Out pops a onesie that says "Mama Kat's Little Camper." This took Kathy by such a surprise, as we didn't suspect it at all. We both screamed in delight. This topped off our birthday camping trip. I've been around these girls through ups and downs most of their lives. I love these girls like my family. Now we have just welcomed Kathy's first grandchild, Hawthorne Wolfe Wilkerson, to our tribe.

Girlfriend Weekend 2019 was also an adventure. We decided we would bring the glamper for the weekend. We could stay across the street from the venue and Kathy could bring her cats so she wouldn't have to get a cat sitter. We would be close to the events, and if we had down time we could relax a bit. This camper is new to us and we have only camped in the summertime. Well, we didn't know how to turn the heat on. I did everything I knew but was afraid I was going to break something. It just wouldn't

budge. We got there that night and were advised not to hook up the water to the camper because the weather was expected to be freezing. So, here we are with no water, no potty, and no heat. We decided to try it anyway. I got into my bed and wrapped up my head and ears. Nothing peeking out but my eyeballs. I was still cold. Kathy said, "I can fix you up." She grabbed a fur rug she purchased for the camper and threw it over me. I was warm, all but my hands now. She then chuckled and handed me the oven mitt to put on my hands. We laughed and took pictures. Now, who does such crazy things? The next morning, I tried to get up and the bed was rocking. I think it must have slipped off the platform. No, it was broken. I guess the weight of me, the rug, a cat or two, and all the blankets was all it could take. We got our wonderful security person Mark Perkins to check our heat and with a minor adjustment he got it to work.

Since becoming executive director of the Pulpwood Queens, I have been blessed to travel throughout the U.S. with Kathy, visiting authors and Pulpwood Queens. They have opened their homes to us and shared their lives with us. It has truly been the most fun I've had in my entire life. It has opened doors that would have never been available to me. We post on Facebook the news that we are headed in a certain direction and these wonderful people reach out and say, "I've got an extra room, come stay with us." Now, where else do you get such hospitality?

I'm very proud to be a Pulpwood Queen. The love of books and the love of people is what we're all about. You get to meet some of the best authors in the world and make lifelong friends.

Ruined by Books

Janet Oakley

I was ruined by books at an early age. Snuggled close to my mother, I learned the secrets of the One Hundred Acre Woods, its Heffalumps and honey pots; of McElligot's Pool and Horton's Who. Red lights stopped. Green lights made everything go. At night, I dreamed in Technicolor.

I was a quick learner. By the time I was seven, I was reading on my own, expanding my vocabulary and finding new worlds. Even Jane and Dick appealed, though their language was wanting. I read on box tops; found learning on trolley car ads and yellow cabs. And books. I had armfuls of books. Shy and hesitant, books gave me courage. I became brazen in speech and asserted myself with expressions such as "I'm as hungry as *all get out*." Or, "I'm *busy* getting dizzy." I spoke in the tongues of many.

I began to imagine.

In the comfortable corners of Carnegie's house in Pittsburgh, I found Dorothy and Oz, Black Knights and Narnia. I brought home what I wanted and assembled their worlds on a shelf by my bed. By daylight or flashlight, they waited for me, each holding a promise. A wardrobe and lamp post beckoned me often. I explored the prairies. Found Laura and Almanzo. Discovered the key to a secret garden. There were a million cats in my room; a black stallion

waited in the hall.

I was eager to ride.

I cherished the books, dreamt of them, taking them back reluctantly to their place on shelves named by Dewey. The wood floors creaked under two-story high ceilings of the library when I came back for more.

My teachers did nothing to stop me. In fact, they con-spired— encouraging me openly in my pursuit and on Fridays brazenly reading aloud from books of *their* own youth: Zeus and Loki, Tarzan and Jane. Cherished and coveted behind old worn covers, their words spilled out. Soon Olympus, Valhalla, and the jungles were mine.

I began to take chances and read whenever the need came over me: at lunch, at school, on the way to music lessons, waiting for my brothers at Scouts. I backpacked books. Found them out on shelves in tourist towns and carried them back to the picnic table at our campsites in the woods. Traded and collected with friends. Joined a children's book club. In a word, I was obsessed.

I was ruined by books at an early age. Now I am writing books of my own, sending readers to far off places like Norway, Ha-waii, and the North Cascades of the Pacific Northwest. Encouraged by my own book club inhabited by retired public school reading teachers, I sought other ways to meet readers: library and muse-um talks, book club kits. A surprise selection of one of my novels sent me on a long journey to Nacodoches, Texas and the Girlfriend Weekend where book club members wear tiaras and wrap them-selves in leopard prints, where best-selling authors dare to pile

their hair up Big Hair style, where books and readers reign amid laughter and fellowship in a supportive community.

There is no salvation for me now.

Only the Pulpwood Queens can rescue me. I'm no longer alone.

Trial by Tiara

P. Adrianne Pamplin

The first I heard of Kathy L. Murphy and the Pulpwood Queens Book Club was from my friend and former newspaper colleague Joe O'Connell. Joe was set to speak at Girlfriend Weekend about his new book *Evacuation Plan*, and he thought I might want to cover it for a local newspaper. At the time, I was in the throws of a three-month long bout of bronchitis and laryngitis. I couldn't go.

I was curious about this quirky bookstore/beauty shop called Beauty and the Book, so I went online and read about it and Kathy. I saw that tiaras were not only worn, but mandatory. Everyone looked gleeful in the pictures of past Girlfriend Weekends, and they were celebrating with wild costumes, and hats at the Great Big Ball of Hair Ball.

I had just come off a body and soul-crushing five years at University of Texas in Tyler getting a BFA in Visual Art. I'd had a wreck that had crippled my right hand at the start of the year, my knees were bone on bone, and my teeth needed major work. I had summoned every bit of physical, mental, and emotional strength to complete my senior year and graduate. I was worn down, broke, and not in any mood to contemplate putting on a tiara and prancing around like I was having a good time. I was sick and had been

turned down by doctors because I had no health insurance. I considered this frivolity not only out of my reach but downright painful to contemplate under my circumstances.

After a double knee replacement and doubling down on getting well and fit, I was in a better frame of mind when Joe messaged me that Kathy was also going to UTT to get her BFA in visual art. He thought I might offer help or advice in traversing college as an older adult in the art department. So I found her on Facebook and sent a friend request. I knew what she was in for: little sleep, professors who felt more comfortable with young students, confusing and sometimes insulting critiques, and so forth. I didn't want to discourage or frighten her, so I offered to answer any questions she had instead.

I watched her work progress and I was terribly impressed because she was a natural! I, on the other hand, struggled then and now with design, composition and any sense of depth perception! With an injured right hand, and my talent being mostly in writing, I settled into textured, organic abstracts to avoid being too literal. But Kathy's talent exploded in ceramics and painting, and I was proud for her.

Getting to know Kathy through Facebook drew me to the Pulpwood Queens again. I have loved to read since preschool, and a book club sounded like an excellent way to discover new authors, and to also blast my agoraphobic self out of the house into some semblance of community. But was I ready for the trial by tiara?

March 2019—the date I penned this essay—marked about a year and a half of attending Pulpwood Queens of East Texas. I

finally donned the only tiara-esque headpiece I had, which is a copper forged crown of leaves and berries I bought from an artist at the Texas Renaissance Fest. There, I did it! It didn't matter that no one else wore one that night. I took the plunge, and I felt pretty good about it!

My best years as a Pulpwood Queen are ahead! I am reading books I would not have, if not for Kathy's selections for the book club. A good book, followed by an interview with the author at each meeting is a delightful and inspiring event I will enjoy for years to come! So bring on the tiaras, big hair, and costume balls! There is a sparkly diamond tiara with my name on it, so I best start shopping!

Connections

Susan Peterson

Changing the world, one reader at a time—that was Kathy L. Murphy's goal when she started her book club, the Pulpwood Queens. That mission is conveyed every year when Pulpwood Queens and Timber Guys gather in East Texas for a weekend of authors, books, and readers. I have been to many book signings and book festivals over the years, but Pulpwood Queens Girlfriend Weekend is unique.

I attended my first Girlfriend Weekend by myself, in 2018, but once I entered that space for the first time, I knew it was where I belonged. I was with like-minded people who shared my love of books and reading, in as intimate an atmosphere as you can have with over 300 people!

To say I was star struck is an understatement, as the authors—50 or more—were bestselling authors I never dreamed I'd ever get to meet, let alone get a chance to spend an entire weekend with! But beyond the awe of being in their company, came the realization that these women and men already felt like friends, because I'd read their books and chatted with them on social media, and through their writing, I already knew who they were deep down, because they'd shared their stories with me. That isn't to say I wasn't tongue-tied the first time I saw Alyson Richman, Ran-

dy Susan Meyers, and M.J. Rose! I was standing in the back of the room when the three of them came in, and my heart was beating out of my chest, I was so excited! I didn't even know what to say, and then Alyson turned around and saw me, recognizing me immediately, and with a hello and a hug, I felt like I'd known her forever. This is the beauty.

The personal interaction is what sets Pulpwood Queens Girlfriend Weekend apart from any other author event. There were panels and book-signing sessions, which are always special. But where else is there a dinner for the readers, with authors dressed in costumes, acting as our very attentive waiters and waitresses! Being served barbecue by Jamie Ford dressed as a hippie, or Barbara Claypole White and Camille Di Maio dressed as Johnny Cash and Dolly Parton respectively, are experiences that are unique to Girlfriend Weekend that I will never forget.

It is a haven from the noise that constantly interrupts the quiet of our lives. It's a place where I can laugh out loud until my sides hurt or cry along with an author and her poignant story. Books and reading and the relationship between authors and readers should serve as an example of love, friendship, and support for the rest of the world.

The best way to make connections with people, the best way to understand people from different circumstances, cultures, and parts of the world; the best way to appreciate and remember those who came before us, is through stories. That is the beauty of Girlfriend Weekend. It gives us the opportunity to make connections through stories—with the people who read them, and the

people who write them. That is what will keep me coming back year after year.

In Our Sunday Best

Gregory Erich Phillips

It was Sunday, the morning after the infamous Great Big Ball of Hair Ball, my first time at the Pulpwood Queens Girlfriend Weekend. I came down to the lobby of the hotel in my Sunday best, having heard of a tradition for a group to attend services at the local church.

I waited in the lobby for a while, not seeing anyone I recognized, until the Pulpwood Queen Kathy L. Murphy emerged from the elevator.

"Why, don't you look nice," she said to me.

"Where's the group for church?" I asked.

"Oh," she said, "I didn't think anyone wanted to go this year. But I'll go to church with you."

Kathy, being Kathy, was already in her Sunday best. If I tend to wear a suit and tie for all occasions, Kathy is equally meticulous about dressing fabulous at all times. I gave her my arm and we walked out into the clear, cold East Texas morning.

I've personally experienced the forty-degree temperature swings that Januarys in Texas have on offer, and this morning was starkly on the lower end of that range. The warmth inside the neighborhood church, however, easily made up for the chill outside.

Kathy is a Methodist and I am a Catholic, but that difference is trivial beside our mutual love for God, and our belief that church is about the shared love of community—a place of welcome—above all else.

The Pulpwood Queens Book Club, too, is all about community. Books are what bring us together, but the club has become so much more than books, readers, and writers. It unites people from all over the country—people with stark differences of background, belief and experience—through the shared passion for books.

My first two novels, *Love of Finished Years* and *The Exile*, both Pulpwood Queens Book Club selections, were about outsiders—immigrants—looking to find their way in a new home. The idea of community has always been of huge importance to me. It comes through in my writing, and it means so much when I find a vibrant, welcoming and diverse community like the Pulpwood Queens.

Reading has a magical power in the way it broadens our horizons. Novels take you to places you've never been and put you into the very minds of characters that are utterly different from yourself or anyone you've known. Reading, then, becomes much more than mere entertainment. By placing us into the minds of characters, reading changes us from the inside. By walking with a character, we can understand another perspective in a truly intimate way. This is the magical power of reading in action—it opens our minds, fostering greater understanding and empathy across cultures, belief systems and life experiences. This is why a good

book can literally change the world.

Novels can also make you believe—if only for a little while—in beauty, in adventure, in goodness that's stronger than evil. Novels can make you believe in true love. And the more of us who believe in these things, the more they will become real in the corners of the world where we live.

I know one place in East Texas where these things have definitely become real.

The book business has changed by leaps and bounds over recent years. This has presented some challenges for authors, but it is also an exciting time for writers because never before has there been as much opportunity for writers and readers to connect. Publishers, bookstores and book clubs are just beginning to realize this. Yet the Pulpwood Queens Book Club has been doing it for 20 years.

Many reading groups focus on one or another type of book: historical, literary, romance, suspense, etc. Or they only select books that are in the mainstream. Kathy Murphy takes a different approach to the books she selects and the authors she invites. If a book is of high quality, genre is irrelevant, as is the hierarchy of author status. At Girlfriend Weekend, up-and-coming authors rub shoulders and share panels with *New York Times* bestsellers.

For authors, this makes for an intimate and fulfilling experience. For the readers (including us authors, who are of course, readers first) it exposes us to books and writers we might never have otherwise discovered. Since I first attended Girlfriend Week-

end as a completely unknown author the invitation meant the world to me. It did more than provide a platform for me to promote my book. Most importantly, it brought me into this community of authors and readers that has so enriched my life.

The welcoming community of the Pulpwood Queens is a reflection of its founder, Kathy L. Murphy. I never tire of hearing the story of how her book club began—specifically as a result of being *unwelcome* at another book club. Exclusion is not something that Kathy tolerates, nor does the organization she has built and fostered. I know I speak for many authors and readers when I remark on how valued I felt at Girlfriend Weekend. This brings me back to that morning when Kathy and I went to church.

I know what a mountainous task it is to put on an event of the scale of Girlfriend Weekend. Even if not for all the logistics of venue, vendors, presenters, and all the other moving parts, acting as host is an exhausting task in itself. On that Sunday, at the conclusion of a jam-packed conference, Kathy no doubt had many logistical, social and personal demands that needed her attention. But she dropped everything and for an hour or so was completely present with me on our walk to church and back. The honor and value she gives to every person she meets is contagious. I am convinced it is one of the reasons why the Pulpwood Queens Book Club has become such a phenomenon.

I had never been to East Texas before; now I think of it almost as a second home. I've learned some things through my adventures in that part of the south. I've learned the difference between "y'all," "you all" and "all y'all," and to use them properly. I've

learned that the word "pie" contains no diphthong, yet somehow has about four syllables. I've been educated on the difference between being naked and being nekkid. I've learned that "Oh, bless your heart" is not a compliment. Most of all, I've come to know a community of welcoming, warmhearted people who have accepted me with open arms. The joy of reading has brought a diverse collection of people from all corners of the country to be part of this wonderful community called the Pulpwood Queens.

My Pulpwood Queen Journey

Sandra Phillips

I suppose I am one of the lucky ones. I joined the Pulpwood Queens almost twenty years ago. I saw an article in the local newspaper that featured the group with a picture of women sitting in a circle, wearing tiaras, and discussing the book pick for the month. The chosen colors for the group were (and are) hot pink and leopard print. I was in my early fifties then and was thinking *this could be fun.* My friend Jean and I were on spring break at our jobs with Marshall Independent School District. We live about ten miles from Jefferson so we decided to make a day of it, antiquing and stopping by Kathy L. Murphy's book store/beauty salon. Well, anyone that has ever met Kathy knows that enthusiastic is one of the best words to describe her. We left her shop as signed-up members of the Pulpwood Queens, certificates in hand, our club t-shirts, and the name of the book to be discussed at the next meeting.

I have always needed excitement in my life. I gave a good twenty years to raising children and being somewhat subdued by my husband saying, "I would rather you didn't do *that* because you know I can't raise these kids by myself." Well, when I got the last kid out the door I got certified to SCUBA dive, I went white water rafting, hang-gliding, four-wheeling, snowmobiling, snow skiing, and even skydiving. So what does this have to do with be-

ing a Pulpwood Queen? Excitement comes in many ways. You read the book and "become" your favorite character, you travel, you do things you would never do in real life and feel emotions that you hope you never experience.

One month I was Mama Lucy from *The Bridge*. Another month I was Cutter from *The Garden Angel*, trying to save the old run-down historic family home from being bought by strangers. I loved getting to be a photojournalist in *Saints at the River*. What a tough spot she was in. I was a "bad girl" in the *Second Coming of Lucy Hatch*. I traveled all over the world while reading *Honeymoon with My Brother*. Every month I get to "be" someone else. In *A Gentleman from Moscow* I was Anna, the actress. In *The Promise* I was Catherine, fleeing a terrible scandal. For every book I have read over these twenty years I couldn't wait to read what "my character" would be doing next. I think this may have influenced my disposition, and *possibly* my accent.

Second only to reading the books is dressing up for the Pulpwood Queens Great Big Ball of Hair Ball during Girlfriend Weekend. I have been many characters, the most recent being a cowgirl making my entrance to the Ball, with my friend Jean, in our horses made out of boxes and lots of yarn. Probably my most memorable costume was when I was wearing a leopard top with sheer black sleeves trimmed with black feathers, black shiny pants, fishnet hose, clear plastic rhinestone studded spike heels, hot pink jewelry and tiara, the biggest black curly wig you've ever seen, more makeup than I usually wear in an entire month, and false eyelashes (my first time). To finish off this queenly outfit, I

had a sheer black cape, also trimmed in black feathers. As I went out the door my husband, looking over his glasses, said, "I sure hope the cops don't stop you."

Reading books, meeting every month, and going to Girl-friend Weekend was what I expected all those years ago when I joined the club. What I didn't anticipate was the lasting friendships that I would make with club members and authors. I can truly say that the Pulpwood Queen book club and Kathy have changed my life. These are the people that you can call at 3:00 a.m. if you need to. They are my "other family." Pulpwood Queens not only share the love of books, we are friends who share common interests and activities in our everyday lives.

Kathy Murphy and My Reading and Writing Life

Ricky E. Pittman, Bard of the South

"In a reading life, one thing leads to another
in a circle of accident and chance."—Pat Conroy

Billy Dunn, the friend who had encouraged me the most with my writing, said I should subscribe to the *Oxford American*. I did, and in the first issue I received, I saw an article about Kathy L. Murphy and the Pulpwood Queens of East Texas. I had the audacity to call and write her, and she encouraged me to attend her first conference, where I would be signing my self-published first novel *Red River Fever*. I attended. Kathy and I became friends, and I was so inspired that I continued as often as I could to attend the conference.

I consider myself a southern writer, but I am also a working musician—a guitarist, folksinger, and entertainer. Kathy has graciously allowed me to perform at several Girlfriend Weekends. At those events, I have been received well as a performer and panelist, and I have been invited to meet with various Pulpwood Queens Book Clubs. Some of those chapters supported my book signings at Barnes & Noble and introduced me and my books to schools and libraries.

Since that first meeting, I now have fourteen published books, and Kathy has been supportive in all my efforts. Her love of books and her heart to promote literacy is obvious and so needed in our society and culture. At her annual event, I always discover authors and books that change my life.

Every Girlfriend Weekend I've attended has blessed me with new friends, many moments of laughter and heart-wrenching stories that inspired me to read and write more and never take for granted the blessings of books and their importance. Each event has stacked memories in my mind—memories that will always be with me.

From my first Girlfriend Weekend in Jefferson, Texas, to the 2019 weekend, my reading life has circled back to where I am now. Meeting Kathy was indeed a significant and lucky accident of my reading life.

My Cousin, the Pulpwood Queen

Terry Pursell

I have a unique perspective on Kathy L. Murphy, founder of the Pulpwood Queens Book Club. I was there the day she was born. I'm her cousin. I was six years old when Kathy was born. She was a quiet and happy child, soon to be the oldest of three beautiful little girls. She was a bit of a tomboy but also an introvert and quite happy to play alone. Very smart but definitely shy. How she morphed into the confident, outgoing public speaker she is today, I can't imagine. My aunt Mary, her mother, was as beautiful as a movie star, and would never think of going out in public unless she was dressed to the nines. She liked to dress the girls up in frilly dresses too, but Kathy would have preferred blue jeans. Mary was a stay-at-home mom and kept a lovely home. I don't remember ever visiting their home when there was an item out of place. I was in awe of her. She was always kind and loving to me and interested in what I was doing. Buddy, Kathy's dad, was a man's man. He worked in the oilfield and was gone a lot. He liked hunting and watching football. The few conversations I had with him were usually about football. Mary and Buddy seemed like the perfect couple to someone on the outside, except they fought frequently which was like a thunderstorm and often left bruises. At those times the girls had to huddle in their room until the storm passed or go to our grandparents'

house.

Our grandparents were Helen and Dyke Maloney. I called them Helen and Dyke because Helen said she was too young to be a grandma. My mother was only sixteen when I was born, so Helen may have had a point. I lived with them until I was eight years old, after my parents divorced when I was a baby. That is where I spent most of my time with Kathy and her sisters, Karen and Karol. Helen and Dyke and I lived in a small rickety oilfield house in the Flint Hills of Kansas. We just called it "out home." Dyke was a pumper in the oilfield, and had a small herd of cattle and horses. Helen worked at the shoe and saddle shop they owned in town. After Dyke was done with his other jobs each day, he would drive nine miles to town and work on shoes and saddles until supper time. I attended a small one-room school in the country where I was the only kid in my grade. It was the same school that Dyke, Mary, and my mother had attended. We had a busy but happy life. Our grandparents had a way of relating to us that was not like we were kids, but equals. I remember Kathy once wrote of them that they had a way of sitting down and talking to you like you were the most important person in the world. Everybody needs someone like that in their life. There was nothing better than riding in the pickup across the bumpy pastures with Dyke, singing old western songs, telling stories, and talking about life in general. Kathy and her sisters loved being out home as well and came to visit every chance they got. They loved playing in the dirt, chasing chickens, exploring the outbuildings and barn near the house.

I believe that our values, beliefs, and sense of right and

wrong are established at an early age. I know mine were well formed before I left my grandparents' home at age eight. Everything after that is a reaction to your environment but doesn't change the core person you are. Kathy spent much of her early years with Helen and Dyke and has that same foundation as me. That is the bond between us. We are like-minded in many ways, but completely different in our personalities. Kathy is now a creative dynamo with the energy of a teenager, and I am comfortably retired and enjoy a day without obligations.

When I was eight, my mother remarried and took me to live with her. It was difficult to adjust to my new life. We moved a lot. Sometimes living in the basement of a night club, or the second story of a country club, and a couple of times in a motel. Visits to my grandparents and Kathy's family got fewer and fewer. I missed them deeply and longed to be out home. I treasure the memories of those early happy days and know that they define who I am.

Later in life, I confessed to Kathy that I envied her life with a stable family in a normal house and living in the same town growing up. She laughed and said it was far from normal, and that she envied me for all the opposite reasons. The grass is always greener, and we each learn to adjust to what life hands us.

A couple of years ago, Kathy was visiting us and we were discussing her upcoming college graduation. She asked me to attend her senior exhibition, a display of her art at the University of Texas at Tyler. I could tell that this was really important to her, a defining event in her life. I was honored that it was important to her that I attend and I wouldn't have missed it. It was a lovely

occasion and obvious to me the respect her teachers and fellow students had for her art and her accomplishment of returning to college after a nearly forty-year break. Not easy! Most people in that situation would never make it to graduation. I could tell that her daughters were as proud of her as I was. Finally, it was good to spend a couple of days with her, one on one, and talk about our lives and where Kathy goes from here with her newfound talent and degree.

Over the years, Kathy and I have stayed in touch, and have always had a mutual respect for each other's accomplishments. I married young, worked my way through college, and spent over forty years as a pilot in the Air Force and airlines. My last eight years of flying were international, so I spent countless hours droning across the ocean. To pass the time, I don't know how many times I've told my fellow pilots the story of my cousin Kathy. Owner of a bookstore/ beauty shop in a little east Texas town who started a book club and gained the notoriety of stars, like Oprah and Diane Sawyer. The book club spread like wildfire and is now the biggest independent book club in the world with over 750 chapters, and then she wrote a book about it. What a success story! The story continues, she goes back to college at near sixty and gets an art degree. She now lives deep in the woods of east Texas, like a Bohemian princess, painting, writing books, and inspiring the Pulpwood Queens. Kathy, you astound me! I can't wait to see what you do next.

Friendships

Alyson Richmond

I first came into the fold of the Pulpwood Queens Book Club back in autumn of 2016. My new novel, *The Velvet Hours,* had just released and the book focused on an antique and art-filled apartment that had once belonged to an elusive, Parisian courtesan by the name of Marthe de Florian and had been mysteriously shuttered for over seventy years by her granddaughter during World War II. One afternoon, I received a message from Kathy L. Murphy saying that the novel had piqued her interest in its themes of art, love, and world history, and she wanted to consider the book as a Pulpwood Queens selection. I immediately felt a connection to Kathy. She had just returned to school and was focusing on her art. My mother is a retired abstract painter and I felt we spoke the same language. We both loved books and the beauty around us. She was passionate and down-to-earth.

That January, I was officially invited to attend Girlfriend Weekend in Nacogdoches, Texas. From the moment I arrived at the auditorium, I felt the warmth and passion of all the Pulpwood Queen readers. It was an extraordinary feeling to be instantly enveloped in this amazing tribe of women who were thirsty to learn about the back stories and inspiration behind all the novels that Kathy had chosen for that year. What impressed me about the

group was their sense of comradery, their dedication to literacy, and their palpable enthusiasm for reading! What writer wouldn't love that? I made wonderful new friendships that weekend too. I relished meeting Scott Wilbanks, who had chivalrously brought his mother and father to the event, and Sara Knoll Dahmen, who impressed me with her handmade crockery as well as her passion for historical novels. I sat on a panel with Missy Buchanan who writes about maintaining a positive outlook on life as we age and reminds us not to forget the elderly. To this day, I still follow Missy's Facebook posts as they often resonate with me and fill my heart with a deeper sense of appreciation for what is around me.

I came back not just once to the Girlfriend Weekend, but twice! One year, I attended the Girlfriend Weekend with friends MJ Rose and Randy Susan Meyers and found new friendships with authors I had admired from a distance, like Alice Hoffman, Jamie Ford, and Lisa Wingate.

What I love about being part of this incredible group is that the thread that binds us doesn't end after the weekend ends. Readers become friends. I think of Betty Hunt, Tonni Callan, Susan Peterson, and Judith Barnes, and how happy I am to still feel connected to them through Facebook. Kathy Murphy has created something truly magical with the Pulpwood Queens and I believe the world is a better place because of her legacy and passion for books.

How I Met the Pulpwood Queen

Paul Roberson
Timber Guy and Webmaster

I met Kathy through her niece, Brookylnn, who I am very close to. Brookylnn kept telling me stories about some book club called the Pulpwood Queens. I was always a little confused as to what a Pulpwood Queen was, but I was intrigued. She told me this was the biggest book club in the world. I always wondered if she was telling me the truth as I couldn't imagine that the biggest book club in the world would be in the little town of Jefferson, Texas.

So one day I decided to visit Kathy at the Beauty and the Book salon in Jefferson to see for myself. Going to that salon that day was the equivalent of Alice jumping down the rabbit hole. I met this bigger-than-life personality who had a passion for books and reading the likes I had never known. When you are around Kathy, it seems like the world revolves around her and you are just drawn to her. I always pride myself on being a great judge of character, and I could see from day one that this woman had a heart the size of Texas. She just made everybody feel welcome with her warmth and her smile.

I decided to join her club that day and I immediately went home and read her book. You always feel closer to a person once you get insight into their life. Reading her book just made me want

to give her a big ol' hug. I could tell this was a woman who lived by kindness and generosity. She would do anything to help anybody and she believed in paying it forward. I try to live my life that way, and when you meet people who live that way, it's like meeting family you never knew you had.

Kathy invited me to her book club in Jefferson so I could meet the other members. I was nervous, which was weird for me because I have always been the token black guy all my life in everything I've ever done. This was different though because Kathy's book club is primarily made up of women. I didn't know what to expect going to a big hair, tiara wearing, Pulpwood Queens book club. I really felt I would be out of place. As it turned out, my misgivings where completely unnecessary as I have found the women who make up the Pulpwood Queens to be the most accepting, heartwarming, and fun group of people I have ever met. I had found my people in the most unlikely of places.

At the meeting, I heard Kathy telling one of the other members about how a guy she had hired to build and run her website had basically stolen it from her. He was charging her hundreds—sometimes thousands of dollars—for jobs that I could do in twenty minutes. Outrageous stuff!

When she finally realized what he was doing and wanted to end the relationship, he locked her out of her own website and disappeared. So I offered to try to recover her website, because I felt that was a way I could contribute to the group and help Kathy. I tried to break into the old website, but he also had hijacked her email address to her hosting account. I decided it would be better

to just rebuild the site from scratch. I used a website called ar-chive.org to recover her old content and then built the new web-site on Wordpress. Kathy was so happy to have her website back. She wanted to pay me, but I told her that I would do it for free. That was my way of paying it forward. I believe God puts people in our lives to help us in our hour of need. He knew I could help her, and so he had me join her book club exactly when she needed someone to help her with her website.

Eight years later, we are still great friends and have made it through many Girlfriend Weekend adventures. I am so thankful that I found this amazing woman and that I get to be a part of a great group of people who have the same love for reading as I do.

All Hail the Queen!

The Spark

Rebecca Rosenberg

Never ignore a spark. Because a spark turns into a flame!

No, I'm not talking about my house that burned with six-thousand others in the Northern California fires. I'm talking about a spark of friendship you feel when meeting someone special for the first time. That's the spark I felt with Patricia V. Davis at the San Francisco Writing Conference more than a decade ago. She was teaching a writing class and her words sparked my inspiration. She held up an orange and listed the infinite ways to describe that orange, ways I never imagined. I wanted to find out more about Patricia and bought her memoir, *Harlot's Sauce: A Memoir of Food, Family, Love, Loss, and Greece.* I was moved by the gut-wrenching honesty she poured on a page.

Then Patricia spoke at Redwood Writers and again sparked my interest. After her talk, I boldly asked her to teach a writing class at the Sonoma Valley Children's Center where I headed up a teen writing group. She graciously accepted, and from there we had dinner, became friends, and she supported me through the maze of finding an agent and publisher.

Patricia's spark fueled many flames when she created a Women's PowerStrategy Conference for women young and old. The conference attendees were treated to a couple of dozen wom-

en speakers, all there to mentor and inspire. Patricia asked me to speak about starting my lavender business, which had grown from a family business to the largest in the country, serving five-thousand stores.

More sparks flew when I invited Sharon Cohn, owner of Breathless Wines, to serve her delicious sparkling wine to the conference attendees!

A couple years later, Patricia met Kathy L. Murphy who selected her *Secret Spice* series for the Pulpwood Queens Book Club. On Patricia's suggestion, I submitted my first novel, *The Secret Life of Mrs. London,* to Kathy to read and she selected it for the book club too. I video-chatted with many Pulpwood Queens clubs about my novel, and I experienced their questions and reactions firsthand, a rare treat for an author.

To keep the friendship flame burning, we formed a new Facebook Group called Breathless Bubbles and Books with Sharon (Breathless's owner), Patricia, myself, and ten other Pulpwood Queen authors, including the Pulpwood Queen herself, Kathy L. Murphy.

Next thing I knew, we were all at the Pulpwood Queens Weekend in Jefferson, Texas, talking books, barbeque, quaint tea houses, and late-night saloons. Many new friends were made that weekend, many new ideas birthed, many feelings shared. The Breathless Bubbles and Books authors spoke together on a panel about their fabulous books with a room full of Pulpwood Queens readers. The warmth, friendship, and connections during that weekend make me a believer in that first tiny spark, that I barely

noticed at the time.

What would have happened if I had been too shy to talk to Patricia?

And, the spark doesn't stop there! In March 2020, Breathless Bubbles and Books will have a Women's Celebration of Books, just in time to commemorate 100 years of the women's vote.

Never ignore a spark.

A Screenwriter Meets a Queen

Clare Sera

"You want to read a book?"

"Me? Always."

"It's about a ladies club."

"Okay. I like ladies."

"They wear leopard print and tiaras."

"Oh."

"They like big hair. In fact they have a Great Big Ball of Hair Ball every year. Get it?"

"Yeah. I get it. But... I'm not sure it's my..."

"It's a book club. And they drink."

"I'm in!"

I was given the book *The Pulpwood Queens' Tiara Wearing, Book Sharing Guide to Life* by a Hollywood producer to "see if there was a movie in it." Oh, laugh emoji, was there a movie in it?! There are five hundred movies in it, one for each nutty book club and crazy character, and that is part of the dynasty that is Kathy L. Murphy.

When a screenwriter is given a book to see if she thinks it could make a good movie, the first thing on the list is, "is this story visual?" Um, check. Next is, "does it have heart?" Oh boy does it. And the million dollar question, "Is the main character compel-

ling?"

I could write this whole essay on how compelling Kathy is, was and will always be. I certainly wrote a movie based on it. It sits on an executive's desk at Dreamworks/Amblin and if you're the praying type, pray they finally decide to make it! The hardest thing about turning Kathy's life story into a film was deciding what to leave out. The woman is a mother of two, a hairdresser, a bookseller, a fine artist, an entrepreneur, an involved townsperson, a shoulder to cry on, a dreamer of big haired dreams. And not just for herself. She dreams other people's dreams alongside them. That's what makes her tiara shine.

I arrived at Girlfriend Weekend 2015 with a pen and a pad, ready to take notes on this woman and the weird and wonderful world she had created for herself. Dreamworks had purchased the right to make this movie and I was tasked with writing it. I was definitely going to take this job seriously. Only... you can't take anything too seriously when you're around a couple hundred leopard-print-wearing, book-sharing, margarita-mixing, utterly fantastic women (and a few good men, it should be noted). However, I most certainly took notes as both authors and book club members would sidle up to me and share the most delicious bits and pieces of their lives with Kathy.

"Did you know Kathy did Joan River's hair?"

"Kathy loves to roller skate, you should put that in the movie."

"Kathy got us all to stay at a haunted hotel one time. We were so nervous, we all went to our rooms and then one of the

women screamed and we came running and screaming and she cried, 'That is the dirtiest commode I have ever seen.'"

"Kathy wanted us to go read books at nursing homes, but I couldn't speak loud enough."

"I believe God smote Jefferson, Texas, because it wronged her and it is still trying to recover."

"Did you know I went through college on a rodeo scholarship?"

It was love at first chinwag. These women were unabashed Kathy fans, unabashed devourers of books, and just plain unabashed. They ranged from as young as twenty to as spry as "eighty something, honey." They arrived in their tiaras; some were diamond, some were twine and forest twigs, and some were towering representations of the id. And these tiaras stayed on all weekend long. I loved that. They were queens and this was their kingdom.

Even the venue—in ancient times a department store—had fairy lights hanging from the ceiling and "thrones" draped in velvet tucked about here and there as if to acknowledge this was no accountants' seminar. Not this weekend.

By the time Kathy took the stage to begin the "official goings on" one of the older, be- diamoned ladies snuck up behind me. "*Psst.* You have a glass?" I did not. She quickly supplied one, along with a giant pitcher of margaritas she was sneaking the back row of ladies. Never been so glad to be in the back row. It was a zinger of a drink.

All weekend long, Kathy kept checking in, which amazed

me, given just how packed each day was and she was the center of all of it. But she never seemed harried, always had time for a story of a different weekend, or an introduction filled with praise and a rundown of everything wonderful this person had ever done.

She'd had a dream, she said: To get women who might not normally be drawn to the world of books to become part of a club. Southern women, specifically. She's a champion of book reading, but she's also a champion of women. It's in the way she sees them and relates to their struggles both interior and exterior. Kathy's had her share of both. I got lost that weekend. And I don't mean metaphorically. I quite literally got lost in the backwoods of Nacogdoches, Texas, trying to find the Great Big Ball of Hair Ball, which was being held in somebody's barn, which, it soon became obvious, was not on Google maps.

I turned down a couple of dirt roads a couple of times that no matter which way I turned at the fork dumped me back out at the one gas station in the area. It was getting late and I was getting tense knowing I was going to have to get out and ask the cashier in the little convenience store for directions. Thing is, I was dressed as Audrey Hepburn in *Breakfast at Tiffany's*. I had a big hair piece, giant false lashes, and a tiara pinned so tight there was no way I could remove it just for one question. And the cashier was a guy in a real worn cowboy hat, no lie, and did I mention we were in the backwoods of Nacogdoches, Texas?

Imagining all the possible responses I might get, I pulled up and parked. I stumbled as my high heels fought with the ruffles at the edge of my dress and spilled out of the car. The cashier was

watching, but his expression did not change. And so Holly Golightly approached the Texan at the gas station convenience store at the corner of backwoods and nowhere at about 9:00 p.m. on a Saturday night in January. Barely a car drove past the whole time I was there.

I cleared my throat, then paused as I realized I hadn't thought through exactly how to ask for directions to "the barn."

He looked me up and down and said, "Take the second left after you hit the first dirt road and keep going longer than you think you should."

"Oh, I... Right, thanks."

"You have fun with the Pulpwood Queens, now, y'hear?"

He did not add, "Holly Golightly," but at that point I would not have been surprised. Kathy's reach and influence was, and is, far and wide. What a lucky break for Texas. What a lucky break for me. And, if all goes well and the book becomes a movie, what a lucky break for the world. Her story is one worth telling. And boy, is it visual.

A Tale of Two Friends and a Ripple

Brownie Shott and Jonni Webb

Brownie Shott:

The ripples created by a single person can be truly phenomenal, and nowhere is that more visible than the impact of Kathy L. Murphy on my friendship with my very best friend in the universe. Let me back up a bit and tell you how it began.

A *Houston Chronicle* article introduced me to an unusual woman with a bookstore inside a beauty shop in the small town of Jefferson, Texas. This introduction led to a pilgrimage for me to meet Kathy L. Murphy (Kathy Patrick back then) and to visit her Beauty and the Book.

Soon after this discovery, I was planning a trip to the 2003 International CHARGE Syndrome Conference in Cleveland, Ohio. (CHARGE syndrome is a genetic condition made up of many different birth anomalies affecting eyes, ears, heart, cognition, etc.) The conference is held every other year, and my family turns it into a road trip vacation, having fun experiences along the way. The drive provided a perfect opportunity for a detour to Jefferson on our trip home. Fortunately, I have a remarkable husband who is used to following my travel detours–some of which I plan, and many that just develop because of an intriguing sign along the way.

We were tired, as you can imagine after traveling for two

weeks with two boys, aged ten and thirteen, but I was so excited about meeting Kathy and seeing this unusual bookstore. Actually, I was the only one excited. Everybody else was tired, hungry, and ready to be home, which was still five hours down the road.

As we entered the charming town of Jefferson, it felt magical. The anticipation I felt about meeting Kathy was almost overwhelming. I knew that I was about to encounter a kindred spirit who shared my intense love of books and who had actually done something about her passion. When I first saw the lovely building that housed Beauty and the Book, it transported me back to my hometown of Darlington, South Carolina, where a very southern and very sweet elderly woman had a small bookstore in the front parlor of her antebellum home. I went there many Tuesday afternoons to watch the bookstore while she went to women's church meetings. Many of my best childhood memories involved books and libraries.

I bounded from the car, rushed up the steps to the door, and felt my excitement crumble. Beauty and the Book was closed for lunch, and I knew my people were not going to be interested in waiting around. In doing my research about Jefferson, I had also learned about the Hamburger Store. So, my crew headed over there for lunch. Inside, I was praying that the bookstore would be open when we finished. As we finished up eating, my previous anticipation morphed into anxiety that I wouldn't be able to meet Kathy and visit her shop. Just then, a lady passed by my table to stand at the cash register near us. She was striking, with beautiful blonde hair piled high on her head and clothed in bright colors.

When I saw her profile, I nearly jumped out of my skin with joy. I knew I was about to meet Kathy Patrick!

I introduced myself and learned that she was at the Hamburger Store for a Rotary Club meeting in the back. I was so excited to meet her and have even a few minutes to talk with her. Unfortunately, she had to get back to the meeting, and we had to get back on the road so there was no visit to Beauty and the Book. Our meeting was just long enough for her to tell me about Girlfriend Weekend, an incredible gathering filled with books and authors. The rest is history.

After meeting Kathy, I made a very excited phone call to my new friend Jonni Webb. We had just met in 2002 as *Coffee News* franchise owners and had an immediate connection that has grown into a strong and beautiful friendship. I convinced her that we had to be at the next Girlfriend Weekend. That first event cemented our connection even further since we had days to spend together, and as a result, we have not only attended every Girlfriend Weekend since 2004, but we have become travel partners, visiting locations all around the United States. Our experiences at Girlfriend Weekends have created new ripples in both of our lives, including amazing friendships and even a book club that has brought many others into the world of Kathy Murphy and the Pulpwood Queens.

Jonni Webb:

At Brownie's urging, we began our annual trip to Jefferson in 2004, her coming from Texas and me from Mississippi. It was just

to be a girls' trip right after Christmas to meet up, relax, visit, and meet authors! I vividly remember the first year reading *And My Shoes Keep Walking Back To You* by Kathi Kamen Goldmark, before arriving and then sitting there staring at her on stage. I was so star-struck! She actually wrote the words I had just read. To meet the author was an amazing treat for me and I was immediately hooked!

Over time, other girlfriends joined us, but for most of the years, Brownie and I just savored this fun time together. No "at home" book club, just two friends who loved books and traveling together.

A few years in, an acquaintance in the Jackson, Mississippi, area approached me about starting a Pulpwood Queens Book Club. My first selfish thought was "No, I don't want to change up our annual trip by adding more people to it! It's great just like it is." I finally gave in and we decided to start one anyway. By basically just sending out emails to our friends and asking them to share it with their friends, we set a date to meet at Lemuria Books, our amazing independent bookstore in Jackson, and waited to see if anyone would come. That first night we had fifteen ladies show up who, for the most part, did not know each other. We named ourselves the BB Queens chapter of the Pulpwood Queens (Books and Booze) and committed to a monthly meeting. Since then, our group has traveled to Girlfriend Weekend numerous times, winning Best Book Club on a couple of occasions, and always having a blast. We have become close friends with authors and other readers, which would never have happened if we were not a part

of the Pulpwood Queens. Our own book club has now grown into two separate clubs with more than thirty total members, some of whom have even been featured Pulpwood Queen authors themselves. All of our lives have changed for the better.

So, the ripple effect keeps getting bigger and bigger, bringing more and more ladies together as readers and friends. Kathy Murphy has created something huge that is having an incredible impact on more lives that she can possibly imagine. And, yes, my best buddy Brownie and I still anxiously look forward to our weekend in January trip together to Jefferson as much as we did nearly twenty years ago.

Stirring the Pot: Who Knew Pulpwood Gumbo Could Taste So Damned Good?

Shari Stauch

It's no secret—or perhaps it is and I'm outing an entire genera-
tion of readers and writers—many of us suffer from introvert-itus.
We're not unfriendly, mind you. We're simply content to be holed
up in that perfect spot in the den, preferably next to a fireplace,
with a cat, the only sound the turn of a page, the click of a key-
board, or the scratching of a pen.

So what happens when someone threatens to broadside that
peaceful retreat?

Step back five years: I'm gathered with a small group of
speakers at an authors' conference in Charleston, South Carolina,
having a post-panel chat with the Pulpwood Queen, Kathy L. Mur-
phy. Kathy is a force, the unsinkable Molly Brown with a Calami-
ty Jane frontierswoman spirit. Even as we're just getting to know
each other I sense her energy, but also her kind heart. I envy her
ability to draw in the people around her, her big voice and big sto-
ries providing a natural gravitational pull.

But then comes the question any self-respecting introvert
dreads. "Y'all are coming to Girlfriend Weekend in January, *right?*"
Kathy asks. She's looking right at me as her eyebrows rise a little.
It's a big open room; there's nowhere to hide.

Now I've been living in the South long enough to know a native Chicago expletive dripped in sarcasm just won't do. So, instead of muttering something clever about the twelfth of never or cooler climes in hell I bite my damned Yankee tongue and opt for the time-honored southern alternative: "Well, bless your heart for asking; I'm sure going to try!"

I'm willing to admit that at the time I didn't mean it. Not even a little bit. The thought of being locked in a giant hall with hundreds of chattering women for a full weekend wasn't in my wheelhouse. It wasn't even in the same neighborhood. And did I mention there'd be a full-blown (pardon the pun) "Great Big Ball of Hair Ball?" I shudder even writing the words.

But the others in our small group seem really excited. Bless *their* hearts; I'm temporarily saved as they pepper Kathy with questions about dates and schedules and what to wear. A bit more envy creeps in, mixed with pure panic. What to wear? Seriously?

But by the time Girlfriend Weekend rolls around six months later, I've reluctantly committed to attend. I tell myself it's "just for my authors" but maybe I'm just as curious to see what all the fuss is about.

The setting is Nacogdoches, Texas, a couple hours from the Houston airport and from much of what most of us would consider modern civilization. I'm traveling with three other PQ newbies and by the time we arrive it seems as though the entire little town has been plastered in pink. Stores and restaurants have truly laid down the pink carpet for arriving book clubbers and we're all impressed by how friendly the locals are. We're still not compre-

hending what a stellar event is about to transpire.

And then the games begin, kicking off with a party where selected authors serve the attending readers some barbecue fare. The mood is festive of course, but it's more than that. As someone who loves 21st century marketing and the oft-used but seldom fitting term "disruption," I realize I've landed smack dab in the middle of one of the great disruptions of our time.

Yes, friends, in a time when everyone's talking about how to put books and thoughts into different "containers" (ebooks, audio, graphic novels, interactive blog serializations, etc., etc.) the Pulpwood Queens have hearkened back to a golden age of reading by embracing the inimitable printed page. They're scooping up real books calling out to be opened and discovered. Yes, they're grabbing up real books, getting them signed by real authors, and engaging in real discussions.

And in a room full of self-described introverts we each discover we're not, not really. We've just longed for a forum like the Pulpwood Queens Girlfriend Weekend to embrace our inner book geeks and make camp with our real tribe.

Over the next two days we attend every session, and I'm mesmerized. Kathy and her trusted bestie, Tiajuana, manage to corral and quiet the hundreds attending before each panel begins, a feat I'd liken to herding cats. But such is the power of books and book lovers. Each session brings together authors with fascinating backgrounds and books with diverse settings, yet on every panel Kathy magically ferrets out a common theme amongst them. I can't help but think of a good gumbo, where each of the ingredi-

ents begins as a wonderful taste sensation on its own, but when blended with its friends becomes something so much more.

A dozen sessions, hundreds of laughs, and yes, even a costume ball later and it's official. I renounce my introvert-itus, uttering new vows that I will never miss another Pulpwood Queens Girlfriend Weekend, ever.

And so, in subsequent years the gumbo has grown to include readers from more states and other countries, because everyone who heads to Girlfriend Weekend wants to return, (and bring a girlfriend). We've met artists and activists, doctors and teachers, lawyers and housewives, all spicing up the stew, the intoxicating aroma of their ideas engaging all our senses as the head Pulpwood Queen continues to stir that pot.

I've kept my vow. I have embraced my new sisters in books and will head to my fifth Pulpwood Queens Girlfriend Weekend in 2020. I, along with my sisters, eagerly look forward to the twentieth anniversary celebration of the Pulpwood Queens and especially of the Queen herself, who has disrupted the book space in the most elegant way imaginable: serving up heaping portions of book love.

Royal Support

Kathryn Taylor

The countdown was in its final days and the time was drawing close. Weeks of preparation and anticipation were nearing an end and I was about to meet royalty! I had purchased Kathy L. Murphy's book as a show of support in a Facebook group of which I was a member. I had won a drawing to attend her annual convention in Texas. My bags were packed, accommodations made, cowboy hat and tiara in hand. I was about to attend my first Pulpwood Queen Girlfriend Weekend and meet the Pulpwood Queen, Kathy L. Murphy, in person!

I had only recently discovered Kathy and subscribed to her book club. I had been following the Queen closely on Facebook and Twitter and was certain that I had a sense of the enormity of her personality, her message, and her following. I understood that as a mere mortal, I would have to stretch my limits beyond anything that I could imagine if I wanted to appreciate the group in which I was about to find myself for the Girlfriend Weekend. I had only recently had my first book, *Two Minus One: A Memoir*, published. I was aware that I would be mixing and mingling with some high-profile authors. Yet I was feeling more excited than I had been about anything since first learning that I had been selected a winner—and later named a panelist—to this annual event.

I had two uneventful flights, a rental car and an hour's drive to Jefferson, Texas. I checked in at the Captain's Castle. I had dinner with Shari Stauch and other authors. It was time! I walked into the Jefferson Convention Center with Michelle Cox, another author from my She Writes Press cohort. I grabbed my author welcome packet, and there she was–Kathy L. Murphy! She was truly bigger than life! She was surrounded by a large group of friends and admirers and walking towards us. She was calling out, "Kathryn, Michelle," as though she had been waiting for only us and her evening could now begin. I had brought a small gift to thank her for her hospitality, which she graciously accepted. Her generous thanks left me breathless and needing to find a seat in hopes of regaining some of the oxygen that had been lost by the brief exchange. After all, it was my first time meeting the Queen! Despite my planning and preparation, I was overwhelmed!

The room continued to fill, and the crowd began to settle. It was time for opening remarks and a warm welcome from the Queen. I pinned on my elaborate nametag and briefly skimmed the updated weekend itinerary as I followed along with the outline the Queen was presenting. Clearly, this would be an intense weekend of listening, sharing, and learning, and I was becoming worried. I had only been an "author" for two months since my book was released, and I could feel my "author persona" quickly slipping away. At the end of her remarks, it was now time to meet one another. Then it was time—horror of horrors—for each of the authors to mount the stairs to the stage, take the microphone in hand, look out at the amassed talent, and introduce ourselves. As I listened

to others introduce themselves, share where they were from, and talk about their books–yes, *books*, as it seemed that all were prolific writers of scores of successful books which were strategically displayed on the tables for all to peruse and purchase—I was beginning to have trouble breathing.

Gently nudging Michelle, who was still at my side, I whispered my concerns. I was unsure of my ability to climb the stairs to the stage and have words come out of my mouth. She whispered words of encouragement and then said, "It's our time to go up." Listening, watching, dreading my turn up the stairs, I tried to remain calm and practice the information that we had been directed to provide. And then, it was my turn.

On wobbly knees, I climbed the three stairs to center stage and took the microphone passed to me from the previous author. Looking out at a sea of faces, I fumbled with the words that I was required to say. I was paralyzed by stage fright. My "author persona" completely disappeared from me. I managed to provide my name and the title of my book, but I felt completely embarrassed, like an overwhelming fraud. I apologized for my nervousness and suggested I didn't belong amongst such an esteemed and talented group. I felt my knees begin to totally buckle. I prayed that I could exit before collapse.

Then I heard the sweet, recognizable voice of novelist Nicole Seitz, whose in-laws live near me, call out, "Kathryn, it's Nicole! You know me! From across the street!" A quick moment of eye contact, a warm and welcoming smile, and I was again safely off the stage, in my seat, and out of the spotlight.

Finally, with introductions completed and the long day over, I could slink back to my room for some much-needed rest, or so I thought. As people milled about and grouped for drinks and post-conference reflections, I was approached by a variety of individuals that I had never met. That is when I discovered what true royalty was and the real meaning and purpose of the Pulp-wood Queen, her convention, and her following. I was assured that I belonged in the room, that I had an important book with an important message to share, and that my humility and honest presentation—"stage fright" would have been the term I would have used to describe my performance—were refreshing. I was touched, genuinely surprised, and moved by the support of these gifted writers. But I was still looking for an exit route! When at last I was back in my room, after drinks and debriefing with a group of authors, I fell asleep knowing that I had made a fool of myself. I knew that it was not the first time, nor would it be the last, but that it did not reflect on the value I held as a human being. I held that message in my heart and appreciated the external confirmation from those newly met authors who offered their support.

The next day I awoke knowing that I was on a panel pre-sentation immediately following the opening remarks from the Queen. I was unaware of what the questions for the panel might be or what direction the conversation might take. As I entered the Convention Center, the same writers from the previous night, and new ones too, made a point of coming up to me in a show of sup-port. I was gently encouraged and once again mounted the stairs to the fearful stage. But this time, I knew I was not alone. I settled

in with the other authors and did my best to breathe. I noticed the smiles of encouragement from the panelists around me as well as those from authors and readers in the audience. The Queen herself made a point of reminding all of those present, including me, that I did belong within this special group. She would sit beside me if necessary until I felt strong enough to understand and internalize the meaning of that statement. I nearly cried with joy and relief. Encouraged by such overwhelming support and reassurance, I was able to not only answer questions directed to me but also to participate in ad lib comments and conversation. I could even offer heartfelt smiles throughout the presentation!

What I discovered during my time with these wonderful people reconfirmed my belief that writers, like teachers, are collaborative and supportive of one another. It did not matter that I was a first-time author. I had written a story. I had published a book that was receiving positive and important praise. I had accomplished more than many people accomplish in a lifetime. If I published just one book, that was enough. My story and my personality had touched others. I was accepted and legitimate. My "author persona" had been returned to me by this generous Queen and her loyal following. They instilled in me a confidence to do it again.

I wrote my story for my benefit and am honored at what has transpired. I do not anticipate repeated books or repeated praise. If I find I do have another story to tell, I will do it as I did with the first. It will be for the purpose of creating, and nothing else. And I will want to share it with the Pulpwood Queen and all

my new-found friends at the next convention. As one of the conference attendees shared with me, "You never know when you are born whose prayers you were put on earth to answer." I believe many prayers were answered that weekend, both mine and others, and I was honored to have had that experience!

Kathy Murphy, My Best Friend

Heidi Surber Teichgraeber

In the village of Eureka, Kansas, there once lived two sets of princesses. The Murphy family had three sisters: Kathy, Karen, and Karol; and the Surber family also had three sisters: Becki, Heidi and Erika. The Surbers moved to the street called Myrtle and the Murphys lived on St. Nicholas. Lo and behold, their backyards backed up to each other. One day, Kathy and Karen met Heidi and Erika while playing outside. They discovered they were in the same grades at Mulberry School, three blocks away! Hallelujah! This was the beginning of friendship, fun, and incredible memories that began fifty-six years ago and continue to this day.

Kathy and I, along with Karen and Erika, loved our time together playing in the backyard. Summer was for water fun, making the old iron swing set into a waterfall with a garden hose, or using our old wagon as a perfect lagoon for the mermaids that would frolic there on a hot summer day. Our imaginations ran wild as we played dress-up as princesses, movie stars, or singers using the old cellar door as a runway and the back step as a stage. (Who knew we would still be playing dress up fifty-six years later?) Mud pies were also a favorite pastime. These simple playtimes forged a very strong bond at an early age for these four sisters.

Kathy and I loved Mrs. Colvin's second grade classroom

and we were scared to death of Mr. Elliott, our principal. We hated wearing pants under our dresses when it was cold but loved being warm on those freezing cold days when we had to walk to school in zero-degree weather and twelve inches of snow! We enjoyed about a year and a half being backdoor neighbors and schoolmates. Then the bad news came. The Murphys were moving all the way across town! We were devastated. Thankfully, our time apart was slight. When sixth grade rolled around, the Murphy girls and the Surber girls were reunited! The Murphys had purchased the coolest house in the old neighborhood! It was a repurposed old barn. On top of that, it had a giant doghouse that had been turned into a clubhouse. The fun was about to begin!

We were now sixth graders at Mulberry Junior High. These were the years we walked or bicycled everywhere. We might go to the city pool or to a softball or baseball game at the two different parks, which were about two miles apart. We could go hang out at one of the two low water bridges in town. At some point, we always ended up at the Lo Mar Drive In, a family-owned hamburger stand that sold ten-cent hamburgers (by our senior year they were twenty-five cents), five-cent Cokes, and the very best thing to order on a hot summer day, a five-cent chocolate marshmallow nut cup!

In school, the years were flying by. After doing all that walking and biking, we were in great shape for Mrs. Jones' gym classes. YUCK! We would square dance, play kickball, go bowling, play basketball, and get ready for the Olympics. Yes, gymnastics was on the schedule with balance beam, uneven parallel bars, and

a floor routine. Kathy and I were not the most athletic. I had absolutely no upper body strength and I think I can say the same for Kathy. That whole rope climbing exercise? We couldn't get off the ground! And with gymnastics, we were lucky to do a summersault on the ground let alone on the balance beam! Then there was basketball. I couldn't hit the rim or the backboard but was the queen of fouls! Kathy couldn't dribble, but did make a few baskets. Then there was the dreaded end-of-year track meet. It was a requirement that everyone in the school *had* to participate in three events. Heaven help us! Kathy and I were non-athletic, but we did a few things really well: we could sing and we could cook.

In ninth grade, Kathy and I were in home economics together. We were partners in the cooking detail. We were to invite someone associated with the school and serve them a full course dinner. We chose to make my mother's spaghetti and meat sauce with garlic bread, a salad and a dessert. We invited our neighbor, Mr. Norman May, who was also our school district associate superintendent. Everything was going well; Kathy was doing her job and I mine. Then it was time to serve. I insisted we pile the noodles on the platter and the meat sauce on top, just like they do on television. Kathy and our teacher, Carolyn Perrier, were very skeptical, but I continued to insist. We almost had meat sauce all over the floor and Mr. May! I was so embarrassed, and Kathy and Mrs. Perrier were kind enough not to give me the "I told you so" look. It all tasted great but didn't look very pretty like on television.

Then there was chemistry lab our junior year. Naturally, Kathy and I were partners. We were instructed to wash and clean

the test tubes, then pour different chemicals into the tubes and run special tests on each tube. I would shake out the moisture in the tubes and dry them. Suddenly, Kathy asked where was the tube with the mercury? Unfortunately for me, the moisture in the tube was not water, but liquid mercury, which was now all over the floor. Kathy's shocked expression was priceless.

From sixth grade until our freshman year at Kansas State University, we were inseparable. We had a very large group of friends with whom we shared fantastic memories: Pam Winfrey, Cynthia Hibbard, Karen Evans, Elaine Wallace, Diana Schwartz, Janice Rockhill, Connie Doeden, Rhonda Conner, and Vicki Oakman. Plus we had lots of guy friends, who will remain unnamed. Our junior high memories included snow days in front of my family's fireplace playing Twister, drinking hot chocolate, and dancing to records. We would laugh until we couldn't stand up. Speaking of dancing, all students loved the Tornado Cave during the lunch hour. An entire hour for lunch! Kathy and I would dash home for lunch, eat a sandwich, dash back to school together and dance to "Mony, Mony," "Sweet Pea," "Dizzy," "Build Me Up Buttercup," the Beach Boys, and oh so many more!

Suddenly, we were leaving our beloved Mulberry where I had been since second grade and headed to the giant Eureka High School a block away. Kathy and I were going to spend three fast years at Eureka High, our lockers always close to each other. Most of our schedules were the same those years, including English class with dear Mr. Laaser. He also taught us creative writing our senior year, so we had class with him twice a day. I believe that

Kathy got her start writing during that class and from being on the yearbook staff.

Band and choir were other classes Kathy and I shared. We both played the clarinet. I'm not saying we were very good, but we weren't horrible. We stuck it out from fifth grade through our senior year, while others dropped out from band. We just couldn't do that to our teacher. It came in handy for me later as a music major in college!

Some of us were lucky and had our learners' permits in our sophomore year. Beginning on January 30, 1972, I could drive to school! So if Mother didn't need the car, I could pick up Murphy in our yellow and white Ford Galaxy and head to EHS a few blocks away. Oh, the memories of those cars we were allowed to drive. The Murphys had two Cadillacs, a 1961 lavender one and a fabulous 1957 bright two-tone pink one. We felt incredibly cool riding in either one, but that 1957 Caddie was the coolest! It had the biggest backseat you have ever seen in a car. One of our favorite pastimes was dragging Main and River Streets every Friday and Saturday night—but always be home by 11:00 p.m. or midnight for our curfew. We would take turns driving, me in the Ford Galaxy 500, or sometimes me driving my dad's rust-colored Ranch four-on-the-floor pick-up, Pam in the Buick, or Kathy in one of the Caddies. (Our senior year, her dad bought her an ivory-colored Volkswagon bug. So awesome!) Since we are discussing driving, there was on incident that happened right in front of all our friends at the Lo Mar Drive-In one afternoon after school. For some crazy reason, Kathy and I decided to jump in a guy friend's car and take

off driving. Kathy was at the wheel, I was riding shotgun with my Coke. We just took the car on a drag, and as we were turning back into the Lo Mar, WHAM! All of a sudden, the car was moving by itself, my Coke went flying, Kathy was frozen, and we ended up in the vacant field hitting a pole! One of our other guy friends had hit us from behind, in our other friend's mother's car! Luckily everyone had insurance and our friend's mother was very kind about it. We never did that trick again!

The very best memories that we shared were of camping with the Winfreys. Pam Winfrey's parents owned a small camping trailer that could sleep five. It was just bigger than a little teardrop camper, so you get the idea. On several occasions Pam would invite a couple of friends to go camping. We would travel to different reservoirs in Kansas, the Kansas State Fair, and our local lake, seven miles north of town. It was a total blast! By our senior year, sometimes the Winfreys let us camp by ourselves. They were very sweet to trust us so much.

Our trip with the Winfreys to Colorado is one none of us will ever forget! Rocky Mountain National Park, Estates Park, Leadville, Cripple Creek, and more! Fabulous places to go, and by then, all of us were too big to stay in the camper! So, a tent it was! Mr. and Mrs. Winfrey bought us a tent with cots and sleeping bags. The catch—we had to pitch the tent ourselves, and by golly, Pam, Elaine, Kathy, and I figured it out. Did we always get along? Most of the time we did. There were a few little cat fights or catty remarks, but never made by Kathy. Those memories will always be cherished. I'm so grateful to the Winfreys for hauling four teenage

girls, a camper, a bicycle built for two, ten-speed bikes, tent, and all the camping gear. Such a gift!

I could go on and on about those days at EHS. But then, in a blink of an eye, we graduated—with real tornadoes above our heads! (And twenty years later, at the twentieth anniversary of our graduation, the weekend of July 4th, another tornado!)

After the summer of 1974, we were on our way to Kansas State University. KSU and Manhattan, Kansas, would never be the same! Nor would Kathy and my relationship be like it had been. We saw each other only occasionally. Our lives went in different directions. I was into my music, my sorority, new friends, and, of course, my boyfriend. Eventually, we both married, had children, and began our adult journeys. There was a distance between us geographically as well as emotionally.

After college graduation, my husband and I moved back to Eureka. I loved it when Kathy moved back to Eureka after completing Crum's beauty college. She was and is the most incredible hair professional I have ever known. Because she is an incredible artist! Even when Kathy moved forty-five miles from Eureka, I still would go to her to cut and style my hair. It was well worth the drive to Emporia! Kathy eventually moved to California. We might see each other when she would come back to Kansas, but rarely. Not until Kathy moved to Jefferson, Texas, married, and started her family, were we able to reconnect at a class reunion in 1994.

I was so proud of all Kathy's accomplishments. She had worked as a book rep and was doing all kinds of great things. Then she opened a beauty salon and added a book store! Kathy

had two beautiful daughters. Then of all things, Kathy created her own book club, and a very *fun* book club at that. Oh my goodness, the next thing we heard, Kathy Murphy was going to be on TV! On "Good Morning America!" My friend, my dear best friend, my crazy, fun-loving, non-athletic "Murph the Surf" was going to be *famous*. I decided that for my fiftieth birthday, I was going to go to Jefferson and see what this Pulpwood Queen Girlfriend Weekend was all about! OMG! I hadn't had so much fun in all my adult life! What a complete blast!

I would see Kathy's parents occasionally and they would get me caught up on all of her activities. But nothing brought us back together like the Pulpwood Queens. Something to do with books and dress-up, who would have imagined? We were apart for many years, but books brought us back together. The Girlfriend Weekend also brought our sisters Karen and Erika back together too.

Since 2006, the Pulpwood Queens have done many things for Kathy and me, beyond reuniting us. The different themes of Girlfriend Weekend started a new passion I didn't know I had. I had always loved vintage clothes, but I had never searched for them in thrift stores or online. In 2007, the Weekend theme was *Hairspray*. I decided I wanted a real, authentic dress from that day and age of the early '60s. I wasn't able to find one at any store, not even a replica. So, I went online to shop for a special net and tulle dress. I found a bright red dress that was perfect and big enough to fit me. (Man, those women were small back then!) I was named "Miss Hairball" in that outfit! Thus began my thrill of shopping online

for vintage clothing, searching and researching all types of vintage clothing stores, vintage styles from different time periods, as well as finding matching accessories. Gloves, jewelry, under garments, hats, ribbons, hair styles, wigs, shoes, boots, bustles, crinolines, hoop skirts, parasols, bags, purses, and—did I leave anything out? Oh, my latest happy place to search is estate sales! I credit all of this to my dear friend Kathy!

When the Girlfriend Weekend theme was the Gilded Age, I felt like I was in heaven! I couldn't wait to explore the vintage shops in Los Angeles when I went to see my daughters. Luckily for me I found a gorgeous black velvet, fish-tail beaded evening gown from the mid to late 1800s. It was half price as the store was having a moving sale, otherwise, it wouldn't have happened. After some alterations and the purchase of some more fabric, hoop slip, and crinolines, I was ready—and I was forever hooked on vintage.

Since then, I have haunted many a resale shop, vintage and otherwise. I've found gorgeous satin and lace wedding dresses for less than $20.00. I've made wedding veils, wedding bouquets, hats and headpieces with flowers and feathers, tulle and netting. Now even though Kathy and I took home economics and learned to sew a couple of outfits, sewing wasn't really a pleasure. So I hope if anyone wants something custom from me, please note it would most likely be held together by pins, sticky tabs, and hot glue. I have been asked to do vintage style shows for several community groups in Butler and Greenwood County, Kansas. It is so much fun and we have had models of all ages!

And so, as life has a way of coming full circle, I am so very,

very honored to present a vintage fashion show for the twenti-eth anniversary of the Pulpwood Queens Girlfriend Weekend! My sister, Erika, will be helping me, as well as many Pulpwood Queens modeling the various vintage fashions. I would have never guessed in a thousand years that Kathy and I would begin a new and fabulous relationship because we loved to play dress-up and recreate what we read and saw on television. And that brings me to my last story.

One of our most favorite movies to watch was *The Wizard of Oz*. The 2010 Girlfriend Weekend celebrated the 70th anniversary of the release of *The Wizard of Oz*. (Kathy does the Wicked Witch of the West laugh to a tee, by the way.) There we were, two Kansas girls who grew up loving musicals, books, and the land of pretend, and we were together again! Kathy was beyond ecstatic to announce the theme for the next year. In honor of our beloved musical, Kathy asked me to sing the incredible "Somewhere Over the Rainbow" during the end of Girlfriend Weekend. I had sung this selection many times over. But that year, in that time and that place, meant more to me than any other time that I had been asked to perform the song. This wasn't just about a performance, it was about sharing a love for a special person, a special occasion, and revitalizing special memories of a lifetime ago.

There are truly not enough words to express the great things Kathy has done over the years for so many people, all be-cause of her love of books. Her heart is as big as all of Texas—big-ger!

There is an old saying that I think it is very fitting for Kathy

and me. A good friend is like a good book: If you stop reading the book, you can always pick it up again at any time and the book is just as good as when you left it. So it is with a good friend, a true friend, a friend you bonded with over fifty-six years ago! *I love Kathy Louise Murphy!* Kathy has been loyal and true to me, a sister since the beginning! I'm honored to say that Kathy Murphy is MY BEST FRIEND!

 As the great journalist Paul Harvey would say, "And now you know the rest of the story!"

Before She Was the Queen

Helen Thompson

Kathy L. Murphy and I go back to a time before she was the adored leader of the largest book club in the world.

Thirty years ago, Kathy was a bookseller for Barron's Books in Longview, Texas. Barron's was, hands down, my favorite bookstore, and Kathy quickly became one of my favorite people. I remember the first time I asked her for a book suggestion and she handed me *Charms for the Easy Life* by Kaye Gibbons. I absolutely loved that book and came to love Kathy Murphy for her book suggestions and, most of all, for her friendship.

Kathy helped me choose books for our new little library at Chapel Hill Independent School District based in Mount Pleasant, Texas. She brought big-time authors to our tiny school. Kimberly Willis Holt won the National Book Award the week she spoke at Chapel Hill. It didn't matter how small our school was, Kathy brought authors because she knew the kids loved them.

Our Pulpwood Queens group originally met in the school library. When I retired and opened a deli, the book club moved with me. Then a public library job became available and we all moved once again. Over the years members have come and gone, but Kathy and her dream behind a book club where everyone belonged remained.

For years our group has laughed and cried together and hotly debated the merits of each book. While we've loved most of the choices, we have sometimes wondered what possessed Kathy when she chose certain books. Great or not-so-great, we've discussed them all.

Girlfriend Weekend is the highlight of the Pulpwood Queens' year. We all gather to listen to our favorite authors and to visit with Kathy. Every year the programs get better and every year Kathy shines! I am always amazed at the number and quality of authors who assemble to visit with us. It's like a huge family reunion and Kathy is there as our matriarch.

Thank you, Kathy, for many years of friendship and fun. Through the good times and the bad, you've been there for us all.

Long live the Queen!

A Delight and an Inspiration

Jo Anne Tidwell

Kathy is the most unforgettable character in my life! She is talented, interesting, and kind-hearted. Her wit and humor are unsurpassed and it is a pure joy to be with her as she tells of her adventures. She is such a great storyteller! Girlfriend Weekend is a perfect example of all her talents. She brings authors, book club members, and future writers together for a most informative and fun weekend. Discussing books with the many authors she has invited to Girlfriend Weekend is an opportunity to be treasured—and one we would not have if not for her meticulous planning. Her generous spirit is lovely as well as her loyalty and her positive attitude. All this is reflected in the Pulpwood Queens with much enthusiasm. With a warm heart and smile for all, Kathy is a delight and an inspiration.

Her diversity in choosing our monthly reading selections keeps me interested as I sometimes read a book or writer I would not ever have considered otherwise. Some of my favorite selections include Bren McLain's *One Good Mama Bone*, *Hotel at the Corner of Bitter and Sweet* by Jamie Ford, *The Prayer Box* by Lisa Wingate, and Ann Weisgarber's *The Promise*. It is always a pleasure to discuss our book selection and to share each other's opinions. It makes for lively conversation! Kathy's willingness to share

her ideas and promotion of literacy touches many.

Kathy is truly remarkable. Quite simply, she just makes you feel good when you are with her. I've been on some road trips with her and we always had a wonderful time. I'm so happy to have her as my friend and I absolutely love being a Pulpwood Queen member!

Leopardlicious

Carolyn Turgeon

On November 1, 2006, a few days before my first novel *Rain Vil-lage* was published (and shortly after launching my first author website), I received an email from one Mrs. Kathy Patrick with the subject line, "Your new website is leopardlicious!"

"I love everything you wrote on your site," she began, "and I would love to go to a burlesque show. I have never seen one but I have seen Natalie Wood as Gypsy like a kazillion times and I'm a big fan of Mae West. Besides books, I adore theater, the arts, roller skating, yes pink drinks that feature anything orange or cranberry, camping (would love to own a Gypsy caravan), and collect any-thing Tarzan, old suitcases, travel memorabilia, costume jewelry, vintage tiaras, and ROCKS!"

Obviously, Kathy was—and is!—my soulmate.

I met her in person a few months later, in January 2007, when I attended my first Girlfriend Weekend in Marshall, Texas, and a few months before *Rain Village* was the April pick for that year, and I'll never forget the dazzle of all those authors—several of whom have become life-long friends—dancing in their leopard print and glitter, and how the whole thing was so unpretentious, so celebratory and such *fun*. And Kathy, at the center of it all, "vi-vacious, larger than life, a fun-loving, tiara-wearing blonde Texas

woman decked out in fake fur and rhinestones," as I described her in a piece I wrote about the event for *Shelf Awareness*. I'd spent years in graduate school and also lived in New York, where I'd seen plenty of the cutthroat and soul-crushing aspect of publishing. And then here was a woman who made books fabulous, life-changing, joyful again.

That was also the first time I visited Kathy's shop, Beauty and the Book, which was like something from my childhood (and adult) dreams. As I described it then, "There's a tree dripping with Mardi Gras beads and a bra or two in front, and a long Southern porch with three vintage hairdryers lined up in a row. When you walk inside, into a leopard-covered hallway, plastic vines hang down from the door frame leading into the main shop. The store itself is filled with books (many of them book club selections) and stuffed leopards and Marilyn Monroe prints and a castle-shaped birdcage and a fireplace with a mantle covered in sparkly things. Behind the front table is an elaborate throne. Just past this main room is a beauty parlor that's just as wild and full of wonders, each wall hanging or trinket attached to a story of its own." It was like a jewelry box flung open, one of my favorite places I've ever been.

In the years since, Kathy's supported every one of my novels, and the faerie and mermaid handbooks I've done, and she's been the number one supporter of *Enchanted Living* (formerly *Faerie Magazine*), which I've run since 2013. I've visited her in Texas and accompanied her once to an event in Nacogdoches for which she added a fairy doll right to my blown-out tresses. We went to

that burlesque show, too. I don't remember what year it was, but she visited New York and we went to a kitschy Chelsea restaurant shaped like a trailer park and then saw an old-time woman-run burlesque show at a club down the street.

I was with Kathy, too, when we drove together to the Shreveport airport and Kathy headed to Anchorage, Alaska, for the first time to meet a new chapter there, run by Pulpwood Queen Mary Grove. Then, in 2010, I got a job at the University of Alaska at Anchorage's Low-Residency MFA Program, and was myself getting ready to visit Alaska for the first time. Kathy told me that I had to meet Mary Grove myself. I contacted Mary, hoping to maybe meet with her and her fellow Anchorage Pulpwood Queens for dinner. In typical Pulpwood Queen fashion, Mary went above and beyond: she offered to pick me up at the airport, let me stay at her house, and threw a big dinner where I could meet everyone. And so I met and fell in love with another group of book-loving tiara-wearing ladies. When, that summer, I gave a public reading as part of UAA's residency program, Mary and the other Pulpwood Queens showed up in tiaras, hooting and hollering and making all the other faculty members think that I have my own private fan club.

Mary asked, too, if I'd visit the Pulpwood Queen chapter she'd started at the Hiland Mountain Correctional Facility—the first and only chapter of incarcerated Pulpwood Queens—and do a special reading for the inmates. Of course I went. It was pretty astonishing, sitting with a room full of women as thirsty for stories, for the escape and magic that they bring, as those ladies were. It was especially powerful to read a scene from my novel *Mermaid*, which was coming out the next year, and transport those ladies to

a world under the sea. We all know the power of story, but I'd never seen it illustrated so starkly and movingly. I visited the Hiland Pulpwood Queens every summer after that, until I left the UAA program in 2017, and was able to entice some of my fellow faculty members to accompany me and transport those ladies to all kinds of other places. I remember the poet Anne Caston accompanying me one year (along with novelist Joann Mapson); there was a big group, maybe sixty ladies, and Anne reduced nearly all of them to tears in her quiet, devastating way.

In 2018 I attended Girlfriend Weekend for maybe the tenth time. I have lost count! Later that year Kathy and her best friend Tiajuana stopped through and stayed with me in Baltimore, and I got to show them a little of the crazy city I'd made my home in the years since I first met Kathy. They even came with me to a rehearsal for a Hitchcock-themed water ballet I was performing in that summer (in a scene based on Kathy's beloved *The Birds*, of course!) and I have no doubt they would have been right there performing with me if they hadn't lived so far away. We ate cheddar and bacon pancakes and visited the American Visionary Arts Museum and hung out in my own jewelry-box-flung-open apartment. Mary Grove passed away a few years ago and Tiajuana passed just recently, of course, and I'm so grateful to have had that time with those exuberant, spangled ladies who made the world more magical wherever they went.

And I'm so grateful to Kathy, for all the ways that her huge life has made my own bigger, wilder, more enchanted—more leopardlicious, in fact. What a gift she's been, to me and to so many other authors and readers around the world.

A PQ Newbie

Barbara Claypole White

I used to gaze with Cinderella eyes at Facebook posts about the Pulpwood Queens, posts written by friends who had snagged the attention of the queen herself, Kathy L. Murphy. Everything about Pulpwood Queens seemed larger than life: the annual extravaganza with the Great Big Ball of Hair Ball, the A-list authors, the leopard print flamboyance.

And I believed it was all out of reach.

I can fake like a pro at author events and book clubs, but I'm a recovering introvert. I don't dress up in costumes, I don't dance, and I don't own anything that sparkles. (Or rather, I didn't.) I'm a reserved Brit, y'all, and 90% of my clothes are black—with the occasional splash of gray. In 2018, however, Tonni Callahan of A Novel Bee became convinced that I belonged in Kathy's glittery, pink tribe.

When Tonni called, babbling about a last-minute vacancy for Girlfriend Weekend, I was shoving Christmas presents into a suitcase, preparing for a flight to England. I literally dropped everything and called the phone number she gave me. Kathy Murphy's cell. Despite my shakes and jitters, Kathy put me at ease instantly with her laughter, her optimism, and her energy. I didn't hesitate to sign up, even though my travel budget was shot. Even

though I'd planned to spend January hiding from the world in my garret with novel six. Even though she mentioned costumes and dancing.

Then January rolled around, and fear replaced enthusiasm. I had to create not one but two costumes. Was this a competitive author sport? Was I going to be Baby in the corner without Patrick Swayze to rescue me? Could I put my own spin on the favorite-country-and-western-singer costume by morphing into a member of the Sex Pistols? (Confession time: I grew up in the era of English punk; I'm not a country and western kinda gal.)

My husband, a distinguished professor and former rock critic, provided the answer: "Dress up as Johnny Cash, the man in black." Black, I can do. I pulled out my pointy-toed author boots and black jeans, borrowed a silk shirt from his closet, and bought a cheap wig and an inflatable guitar. My guitar strap was a Dr. Martin shoelace. As I packed the outfit—plus the slutty sheriff ensemble for my Wild West costume—I vowed to toss snotty Brit awkwardness to the wind and embrace the moment. Which probably explains the plastic tiara and rhinestone cowboy boot earrings that also made the final cut.

"Is this going to help sell books?" a friend asked, staring at the tacky earrings.

"Nope," I replied.

"Remind me why you're going?" she said.

"Because my gut told me I should."

I always listen to my gut.

I landed at the airport, and Tonni met me with squeals,

hugs, and a bottle of Texan artisan gin, which I managed to drop, shatter, and salvage. (For the full story, you'll have to read novel six, *The Gin Club*.) In Tonni's car, I fell into the first of many conversations that would forge new friendships and stretch beyond that weekend. By the time she'd dropped me at the Old Mulberry Inn and Cottages, I knew the real reason I'd forced myself outside my comfort zone: Pulpwood Queens is a community.

The importance of community is a recurring theme in my life and in my writing—as a mental health advocate and as an author with a passion for creating characters who battle the isolation of invisible disabilities. With five novels in print, and two in the drawer, I also know that it takes a village to get published and stay published.

Over three intense, exhausting, exhilarating days, I discovered there's no hierarchy at Pulpwood Queens—only a sense of belonging and an endless sharing of real-life stories. The chatter started every morning over three-course, five-star breakfasts with two of my favorite people in the industry—author Camille di Maio and blogger/reviewer Susan Peterson—and continued in the restroom, walking into the downtown to grab meals, and while shopping at Murder by the Book or in the Jefferson General Store.

After making a throwaway comment about Leonard Cohen, I talked for a good half hour with a reader whose son-in-law drummer had toured with him. Another author shared her passion for baking; I talked about my passion for chipping away at the stereotypes of mental illness. In between, I fangirled over Anne Garvin, hugged Bren McClain, picked Tim Conroy's brain for ad-

vice about my rock star poet son, joined the Breathless and Bubbles sisterhood, and hitched a ride back to the airport with Colleen Oakley.

Looking through the photos of my first Pulpwood Queen's experience, I see one thing: happy faces, especially on the members of a book club rocking the Saturday ball in cow outfits. My favorite photo from the weekend was one I snapped on a whim. Kathy and Tiajuana Anderson Neel were on stage handing out awards, when I looked across the back of the room. Against the far wall, bloggers and volunteers were hanging out with *New York Times* bestselling authors Julie Cantrell and Lisa Wingate. They were all looking at the stage, smiling, as if being together in that huge space was the most natural thing in the world.

I carried a small part of the Pulpwood Queens vibe home with me: a sparkly, light-up, pink cowboy hat. The only pink thing I own, it sits in the corner of my office where no one is allowed to touch it. To me, that hat represents the crown jewels, and I will wear it at the Pulpwood Queens 20th anniversary with pride.

Girlfriend Weekend: A Family Tradition

Reavis Wortham

Texans are big on family. We'll hug your neck every time we see you, and follow you to the car to say goodbye when you leave. We say yes ma'am and no sir, please and thank you, and when we're close to someone who is an elder, we'll call them Miss Christine or Mr. Rob, instead of Mr. or Mrs. Thornton. I grew up in that world and always look for that same philosophy with friends, businesses, associations, and organizations.

Although I've been a self-syndicated newspaper and magazine columnist since 1988, my first novel, *The Rock Hole*, wasn't published until 2011. Not long after that release I first heard about Kathy Murphy and the Pulpwood Queens. The wife of a good friend attended Girlfriend Weekend that year in Jefferson, out behind the Pine Curtain, and came back with stories about meeting authors and hundreds of other readers at that event. She was thrilled to go out for supper each night, to find herself eating with folks she'd been reading for years or heard about for the first time on a panel just that day. (By the way, I didn't write "dinner" because where I come from we eat dinner at noon, unless we're in a school cafeteria and that's lunch. Supper is the evening meal, preferably at 5:00.)

I'd only been to a couple of writers' conventions and fes-

tivals by that time and didn't know such events even existed. Of course, I was so green that when *Kirkus Reviews* named *The Rock Hole* as one of their Top 12 novels of 2011, I didn't know who or what they were.

After speaking with my friend upon her return from that Pulpwood Queens event, I reached out to Kathy and introduced myself as a new author. After five minutes on the phone I wondered if she wasn't kinfolk I'd never met. Bubbling with enthusiasm I could feel through the phone, she told me all about her organization, her own goals for herself and the Queens and for the careers of every author that she'd met. Truthfully, I wanted to hire her as my public relations representative.

Right then and there she put me on her authors list and told me I was going to be in Jefferson the next year. That's right. She told me I was going to be there, and I went, because I don't think anyone knows how to say no to this wellspring of goodness.

Growing up as a fourth-generation son of the Lone Star State, I always heard the old saying, "Everything is big in Texas." That extends to bookclubs. The next January I was stunned to see how many people were in attendance at the world's largest association of bookclubs, all under the oversight of Kathy Murphy, who hugged my neck the minute we met. From that moment I was part of a swirl of panels, discussions, and evening events. I've met and become friends with a number of returning authors who almost always point at Kathy saying, "isn't she something?"

I've been part of that swirl ever since, attending each year with this wonderful family of authors, fans, and readers. Last year

I served as co-host at the 2019 Girlfriend Weekend, (and representing the Pulpwood Guys), introducing attending authors, panels, and the books selected by Kathy as the books of the month to be read by the clubs.

It's been a great ride since that first event, and it isn't even close to over. I'll be back next year as co-host of the 2020 Girlfriend Weekend, because it's the place to be for authors and readers alike. And because Kathy told me I was going to be there. I don't mind. Nothing beats being around people of like mind, talking books and great stories.

Girlfriend Weekend is now a family tradition and I can't think of better kinfolk. It's the perfect gathering of folks who love books, who must read or perish, and who want to meet and discuss what they love—the music of words.

AFTERWORD

And Yet

Jonathan Haupt

For Pat and Nicole, without whom there would be no story to tell, and for Kathy, Tiajuana, and Susan, without whom there would be no one to tell it to...

Omens, harbingers, presages, and portents abound in this life, if you are attuned to bear witness. On Thursday, January 17, 2019, just before 10:00 p.m. and within minutes of leaving the hardscrabble Dollar General in Jefferson, Texas, in the companionable presence of Pulpwood Queens author Nicole Seitz and her newly purchased discount toothbrush, I witnessed a shooting star over the Shell station at the corner of Walcott and Broadway.

They say there's always magic in the air. On Broadway.

To Nicole's eyes—those of an accomplished artist, novelist, editor, teacher, runner, mother, wife, sister, aunt, and friend—the comet was an otherworldly glowing green. To mine, it was a brilliant flash of luminous gold against the blackness of that bigger-than-Texas night sky. That we did not experience our shared universe in the same way, that our senses and sensibilities were drastically different, was already well established between us by

this point, 139 days since we began our book tour for *Our Prince of Scribes: Writers Remember Pat Conroy.* (But who's counting?) And yet, in that moment, with Nicole at the helm of our rental SUV in charmingly quaint Jefferson, we experienced a wonderment together, one of several in that curious weekend of immersion into the idiosyncratic world of the Pulpwood Queens.

And that's how I've come to think of the unstoppable dynamo Kathy L. Murphy, her beloved high sheriff Tiajuana Anderson Neel, and all of the remarkable readers, writers, and supporters who collectively make the Pulpwood Queens such a force for good in this world: as a wonderment—a source of unexpected but well-earned awe and inspiration, as evidence that dreams can be lived, that magic is still possible, and that stories (like shooting stars) will find you in the most unexpected ways. The remembrances shared in this anthology are by turns candid, comic, and confessional, but always heartfelt in their generosity and gratitude for the life-affirming experiences shared among those who have become a tribe, a family in the truest, best, and most inclusive sense of that word. It is an honor to be counted among them and to be invited into the stories of this keepsake anniversary collection—and I applaud the affable and indefatigable Susan Cushman for editing this impressive volume.

At the aforementioned Dollar General, elicited by Nicole's floral Girlfriend Weekend name badge, we had been introduced to a clerk's heartrending familial story. Days later, just before our exodus from Jefferson, I was back in that store parking lot a second time. If there was a shooting star in the sky then, it was not to be

seen midday. But something else now illuminates that moment in my memory and always will. I read once in a fine essay that some people in this life shine so brightly that it can be blinding. Against this distraction, it can be difficult to see them as they truly are, as they might otherwise be seen. In that moment, I waited, awestruck, as Nicole, living her faith as only she can, made a thoughtful gift of her name badge's flower for a heartsick grandmother-to-be behind the counter. That will always be my purest vision of Jefferson and of Nicole, each radiant with kindness for the sake of kindness alone. James Dickey once wrote—or perhaps *prayed* is the more apt verb here—that "More kindness will do nothing less than save every...one of us." This was such a moment.

It was the second time I was moved to tears that weekend by an act of kindness. The second of three, in the end. Moments like this, small and large alike, peppered that Girlfriend Weekend because the hearts of the Pulpwood Queens overflow with the same Great Love Pat Conroy himself advocated and treasured. While the full account of the store clerk is a beautiful one, rich with the empathy that threads together the tapestry of our human experiences, that is Nicole's story to tell. Or not tell.

This is mine.

For the better part of my former university press publishing career, the Pulpwood Queens Girlfriend Weekend had been the stuff of legends and lore, extravagant tales told to me by Pat and Cassandra King Conroy, Bernie Schein, Mary Alice Monroe, Patti Callahan Henry, John Warley, Bren McClain, Jana Sasser, Susan Cushman, and others in a pantheon of writer friends who had ex-

perienced it firsthand over the history of the storied gatherings. They spoke with reverence, as one does when recounting larger-than-life adventures and fellow adventurers. While I had the always memorable pleasure of encountering THE Kathy L. Murphy at book festivals and writers conferences across the South and in co-editing her exceptional essay in *Our Prince of Scribes,* none of this—NONE. OF. THIS.—had prepared me for going through the looking glass into the realm of the Pulpwood Queens myself.

I cannot think of that weekend without smiling a Cheshire grin, feeling my heart expand once more with the joy of fond remembrances, and breathing deeply in a sense of lasting pride in getting to play a modest cameo role in a story still unfolding in these pages and in the lives of the writers and readers who have also come to know and treasure and believe in the camaraderie and generosity of the Pulpwood Queens. The experience is transformative and restorative, and, like any experience worth having, not without its risks.

Invited by Kathy, I had been asked to moderate a panel discussion of *Our Prince of Scribes* to include both Kathy and Nicole alongside our fellow Scribes Tim Conroy, Bren McClain, John Warley, and Patti Callahan Henry. And I opted into co-presenting with Tim an adaptation of a talk we had developed together about his brother Pat as "failed poet," one which included guest readings by our fellow tribe of Scribes. It was my great privilege to participate in both well-received sessions. Our dear Scribes performed brilliantly in their roles, leaving our audience and me thunderstruck as we each represented our esteemed Pat in ways that brought

him back to life in that convention center as we spoke and laughed and cried and remembered.

But now, some four months later, all of that, as grand and perfect as it was in those moments, seems to be such a small part of the Girlfriend Weekend experience, just one or two glittering shards in a bright kaleidoscope which, much like the essays in this volume, offers a colorful glimpse into the benevolent hearts of the Pulpwood Queens.

While the authors assembled that weekend in Jefferson included an impressive array of established voices—Ann Weisgarber, Paula McLain, Lisa Wingate, Julie Cantrell, Patricia V. Davis, Reavis Wortham, Michael Ferris Smith, and Peter Golden, to name just a few—Girlfriend Weekend was also an opportunity to meet and discover heretofore unknown voices like Kathryn Taylor and Connor Judson Garrett, both with debut books which had also garnered the coveted blessing of Pulpwood Queens Book Club selection. You don't need me to tell you how talented all of these writers are; by this point you've met most of them in the pages of their own books. Or in the pages of this one.

They were marvelous. And yet. And yet, the truest and most lasting gift of the weekend wasn't being in the good company of these writers. No, it was decidedly the readers who defined my Pulpwood Queens Girlfriend Weekend experience. What a delight it continues to be to remain in touch with many of them, and to encounter them as storytellers, characters, and muses in several of the essays included herein. I think often of Brownie Shott, Jonni Webb, Leslie Puckett, and Susan Marquez, who were so kind

and welcoming over dinner at the Austin Street Bistro, and of the ineffable Alligator Annie who honored me with a photograph in her "handsome man of the day" series. (We can safely assume the criteria was loosely defined and that Mark E. Green and Joe Formichella must not have been available at the time.) We'll always have Jefferson, dearest Annie.

I think as well of the exquisite Heidi Surber Teichgraeber and Becky McCollum who were so far beyond generous in their support of our nonprofit Pat Conroy Literary Center through Kathy's annual fundraiser auction. Pat wrote in *The Prince of Tides*, "the only word for goodness is goodness, and it is not enough." Heidi and Becky embody this goodness in their inherent kindness and sense of charity. *Thank you* is simply not enough, but let's begin there. And thank you as well to all of the authors and Pulpwood Queens Book Club members who contributed so generously to the auction's record-setting year in support of the Conroy Center. What a remarkable gift all of you are!

With equal parts joy and sadness I think also of Kathy's steadfast shoulder-companion, the eagle-eyed, kind-hearted, gregarious and adventurous spirit Tiajuana Neel, who was the quintessential Pulpwood Queen in addition to her official role as executive director. Tiajuana ruled the check-in table, the fundraising auction, and so much more with an iron fist wrapped (quite literally) in an oven mitt. She delivered acts of kindness and grace that no one else may have ever seen, not for recognition but simply because she was in a position to offer her help and goodness to others. She may or may not have aided a certain Mr. K. Spilsbury with

an anonymous auction bid as well. I guess we may never know. Leo Tolstoy wrote, "it's much better to do good in a way that no one knows anything about it." A fictitious Texas Ranger later put it more succinctly: "never take off the mask." Gracious Tiajuana did more good for more people that weekend and over the course of her lifetime than any one of us ever saw or knew, but we are all better off for it—and grateful as well—for having been welcomed into her caring presence. She gave the best hugs in Texas, because she had the biggest heart. May her sweet soul rest in peace, venerated always for the love she entrusted to each of us and to all of us.

Then there are of course Betty Hunt Koval and her husband Bill, who personify the Pulpwood Queens commitment to literacy year-round; the indescribable Margie Dilday, the best breakfast companion ever; the utterly fantastic Merrilee Hall, Karen Reed, and Gigi Moore Sinyard; Girlfriend Weekend newbie Nancy Kimball Mellon riding shotgun with literary badass Claire Fullerton; Kathy's lovely and charming daughters Madeleine and Helaina, their mother's dreams come true; and so many more readers who touched my heart with their stories, their laughter, their heartaches, their Great Love of Kathy and books and writers and one another. There are more than can be named here.

Except for one more, who cannot and must not go unnamed.

Shirley Reiman, the high priestess of the House of Seasons Inn, is the epitome of all that is best about the Pulpwood Queens and Jefferson, Texas. She is wonderment incarnate—a generous host and gracious guide who always puts others first, a master-

ful steward of cultural treasures, a stalwart believer in the transformative power of education and of books, and an exceptional caretaker of the countless stories entrusted to her in earnest. If I had gone to the 2019 Girlfriend Weekend and met no one other than Shirley, she alone would have been enough to convince me that every wonderful hyperbole ever spoken about the Pulpwood Queens Girlfriend Weekend was an understatement. Thank you, Shirley, for every single gift of your time, your wisdom, and your friendship. Breakfasts have not been the same since.

Among Shirley's many treasures shared so thoughtfully with Nicole and me during our stay as her guests was a peek into what our mentor Pat Conroy had written in the guest book at the House of Seasons during his first visit to Girlfriend Weekend with his daughter Melissa in 2010: "A great way to dream life away in Texas. The town was uncommonly lovely, the hospitality a work of art, I would love to write a novel in this time and in this place. I had the time of my life…. A fabulous memory."

What he said.

Ditto, dear Pat. Ditto, indeed.

Now having experienced a Girlfriend Weekend myself and time-traveled through twenty years of tender memories recounted in this collection, it becomes easy to see why Pat so loved the Pulpwood Queens and so admired Kathy Murphy in particular. He found the validation and hope he had been seeking at that point in his writing and reading life. Coming to the welcoming hamlet of Jefferson and being immersed in the joyous gathering of impassioned readers and the writers they championed restored Pat's

faith in the business of authorship and in the power of story to espouse difficult truths through beautiful art while also mending hearts and souls.

We could all use a little mending of hearts and souls every now and again. Maybe now more than ever. It takes acts of faith, of communion, of revival—in the spiritual sense and in the very human sense as well. That's what Kathy offers year-round through the Pulpwood Queens Book Club, punctuated annually at Girlfriend Weekend, and now also encapsulated, prescribed, and immortalized in the pages of this essential collection.

And yet. And yet, there's more to come. If the first twenty years of the Pulpwood Queens are a portent, a sign of what is to follow, then the future will be very bright indeed. Y'all consider yourselves duly invited. BYO tiara, an open mind, a generous heart, your toothbrush, maybe a costume or two, and an imagination bigger than a Texas night sky illuminated by the shooting star that is the queen herself, Kathy Murphy.

Happy anniversary, Pulpwood Queens and Timber Guys!

Here's to the next twenty years.

CONTRIBUTORS

Christa Allan is a born and bred NOLA girl who recently moved to Houston so she could annoy her grown children in person. She is the mother of five and Grammy of two lovely grandgirls, and doesn't scare easily because she taught high school English for twenty-five years. She and her husband are both retired and spend their time doing exciting missions grocery shopping and gardening and amusing their neurotic dog, Herman. Christa writes women's fiction with hope, humor, and heart that often deals with timely issues affecting women and families. Her latest novel, *Since You've Been Gone,* has been an Amazon bestseller. She's written *Walking on Broken Glass, The Edge of Grace, Threads of Hope and Test of Faith. Because You Loved Me* and *All They Want for Christmas* are her two indie novels. When not staring in the refrigerator looking for some hidden calorie-laden treat, Christa can be found at her website (www.christaallan.com), Instagram (@christaallan.author) and Facebook (https://www.facebook.com/christa.allan).

Johnnie Bernhard, a former English teacher and journalist, has been published in the following publications: *The Mississippi Press*, the international *Word Among Us, Southern Writers Mag-*

azine, *Southern Literary Review*, *The Texas Review*, and the Cowbird-NPR production on small town America. Her entry, "The Last Mayberry," received over 7,500 views. Johnnie's first novel, *A Good Girl* was short listed in the 2015 Faulkner-Wisdom Competition. It was a featured novel for the 2017 Mississippi and Louisiana Book Festivals, represented at the 2017 Texas Book Festival, short listed in the 2017 Kindle Book Awards, a nominee for Best Fiction by the MS Institute of Arts and Letters, and a nominee for the 2018 PEN/ Robert Bingham Prize. Her second novel, *How We Came to Be* was selected for panel discussion at the 2018 Louisiana and Mississippi Book Festivals. It was selected as a 2019 summer read by *Deep South Magazine* and a 2020 selected read for the Pulpwood Queen International Book Club. It is also a nominee for Best Fiction by the Mississippi Institute of Arts and Letters. Her third novel, *Sisters of the Undertow*, is set for publication in 2020.

Tamra Bolton is a writer/photographer who loves to travel. She has written and illustrated a children's book *When I Was Small* and is working on a book about her dad's experiences during World War II. Tamra's work has been published in *National Geographic Traveler*, *Texas Wildlife Association*, *Fido Friendly*, *Travel Post Monthly*, *Parade*, *Motorcycle.com*, *Country Woman*, *Farm and Ranch Living*, *Lifestyle*, *IN*, *FWT (Food, Wine and Travel)*, and *Oakland Magazine*. She is also a licensed wildlife rehabilitator, exercise, diet and fitness expert, and life coach. For fun, Tamra searches estate sales for first edition titles she loves.

A national award-winning veteran journalist, investigative reporter, feature writer, communications specialist and editor, **Lea Anne Brandon** has also worked as a public relations professional and non-profit executive. A resident of Jackson, Mississippi, she has recently transitioned into state government positions as a communications specialist, ombudsman and public liaison, first as assistant secretary of state and now as communications director and stakeholder coordinator for Mississippi's Child Protection Services. Writing remains her lifelong passion with a creative non-fiction book nearing completion and a compilation of memoir essays about to be submitted for publication. She is married to a college professor and former state economic developer. Lea Anne is a member of the "BB Queens," the Jackson, Mississippi chapter of the Pulpwood Queens Book Clubs.

Missy Buchanan is a popular writer-speaker on issues of faithful aging. She just completed her ninth book for Upper Room Books, *Beach Calling: A Spiritual Journal for the Middle Years and Beyond*. She has appeared twice on "Good Morning America" with Robin Roberts and has been a speaker for numerous conferences, including The Festival of Wisdom and Grace at Lake Junaluska, NC, the Presbyterian Older Adult Ministries Network National Conference at Lake Tahoe CA, the American Society on Aging Conference in San Diego, CA, and the National Boomer Ministry Conference in Dallas and San Antonio. Missy has traveled both nationally and internationally to speak for senior living communities and church organizations, including those in South Africa and Scotland.

Julie Cantrell is an award-winning *New York Times* and USA TO-DAY bestselling author, editor, and speaker. Her work has received special recognition across both faith-based and general audiences, as she aims to build a bridge of communication and understanding between the two. Learn more: www.juliecantrell.com and www.bluesparked.com

Tracy Lea Carnes is the author of the novel *Excess Baggage*, a humorous yet inspiring glimpse of Kelly, a careerless thirty-year old woman, who moves back home to her tragically dependent mother after the death of her overbearing father in order to rediscover herself. In 2010 she appeared as a feature author at the Pulpwood Queen's Girlfriend Weekend. Her new novel, *The Dance*, is forthcoming. Tracy is also an award-winning playwright who currently lives in Shreveport, Louisiana.

A novelist and award-winning journalist, **Kathryn Casey** is the creator of the Sarah Armstrong mystery series and the author of eleven highly acclaimed true crime books. Library Journal chose *The Killing Storm* as one of the best mysteries of 2010. Her latest true crime book, *In Plain Sight*, investigates the Kaufman County prosecutor murders, a case that made worldwide headlines. A frequent commentator and analyst, Casey has appeared on Oprah, 20/20, Dateline, the Biography Channel, The Travel Network, Nancy Grace, Investigation Discovery, and many other television and radio programs. Ann Rule called Casey "one of the best in the true crime genre."

Stephanie Chance is the bestselling author of *Mamma Mia, Americans Invade Italy,* a nonfiction account of hair-raising adventures as Stephanie leads groups of Americans on adventures throughout Europe. Stephanie is the author of *Beautiful Seductions*, a coffee table book filled with home decor and images and stories from her travels. Stephanie is a comical, outgoing Italy lover with European genes stretching across the deep, blue pond. As a paralegal, she worked sixteen years with a renowned attorney in East Texas. Then, in a blink of the eye, she launched a "one-of-a-kind" shop unlike any other in the world, Decorate Ornate. This store is packed floor to ceiling with rare finds from all over Europe. And, in the same year, 2000, Stephanie started her Italy tour business, taking two or three groups of Americans all over Europe every year. When not in her shop, you'll find Stephanie in Italy and France in search of castle doors, religious relics, and home decor for Decorate Ornate, or zigzagging through Europe with the Americans by her side.

Judy Christie is the author of eighteen books, both fiction and nonfiction. She co-authored, with fellow Pulpwood Queen Lisa Wingate, *Before and After: The Incredible Real-Life Stories of Orphans Who Survived the Tennessee Children's Home Society*, published by Random House.THE INCREDIBLE REAL-LIFE STORIES OF ORPHANS WHO SURVIVED THE TENNESSEE CHILDREN'S HOME SOCIETY Her novel *Wreath, A Girl* is a two-time Pulpwood Queen Teen Book of the Year. A former newspaper editor and award-winning journalist, Christie holds a Master of Arts degree

in literature from Louisiana State University in Shreveport and a bachelor's degree in journalism from Baylor University. She and her husband live in rural Colorado. For more info: www.JudyChristie.com or www.Facebook.com/JudyChristieAuthor.

Tim Conroy is a poet and former educator. His work has been published in journals, magazines, and compilations, including *Fall Lines, Blue Mountain Review, Jasper, Marked by the Water,* and *Our Prince of Scribes: Writers Remember Pat Conroy.* In 2017, Muddy Ford Press published his first book of poetry, *Theologies of Terrain,* edited by Columbia, South Carolina, poet laureate Ed Madden. A founding board member of the Pat Conroy Literary Center established in his brother's honor, Tim Conroy lives in Columbia.

Christopher Cook is the author of many stories and novellas as well as the award-winning novel *Robbers* and the story collection *Screen Door Jesus & Other Stories.* A native of Texas, he has lived in France, Mexico, and the Czech Republic since 1994. His books are available in numerous foreign editions, and his stories have been included in many anthologies. His last book, *Tongues of Fire,* published in France, is available in English as an eBook. His novel *Robbers* is under option with Sony TV Studios. Cook is a member of the Texas Institute of Letters. His website is www.christopher-cook.com.

Michelle Cox is the author of the multiple award-winning Henrietta and Inspector Howard series as well as "Novel Notes of Local

Lore," a weekly blog dedicated to Chicago's forgotten residents. She suspects she may have once lived in the 1930s and, having yet to discover a handy time machine lying around, has resorted to writing about the era as a way of getting herself back there. Coincidentally, her books have been praised by Kirkus, Library Journal, Publishers Weekly, Booklist and many others, so she might be on to something. Unbeknownst to most, Michelle hoards board games she doesn't have time to play and is, not surprisingly, addicted to period dramas and big band music. Also marmalade.

Sara Dahmen is a metalsmith of vintage and modern cookware and manufactures pure metal kitchenware in her garage in Port Washington, Wisconsin for her company, House Copper & Cookware. She has published over 100 articles as a contributing editor, has written for Edible and Root + Bone, among others, and spoke at TEDx Rapid City. Her historical fiction series, *Flats Junction* (Promontory Press, Inc), with *Widow 1881* and *Tinsmith 1865* as the first novels, is optioned for multiple feature films and is in production, while her non-fiction book on cookware, *Flame*, is due out in Spring 2020 (William Morrow/Harper Collins). When not sewing authentic clothing for 1830s reenactments, she can be found hitting tin and copper at her apprenticeship with a master smith, reading *The Economist*, and spending time with her husband and three children. Sara is also in development of an unscripted television series with Dawn's Light Media highlighting her career as a woman coppersmith.

Patricia V. Davis is the author of *The Secret Spice Cafe*, a trilogy of magical realism novels set aboard the *RMS Queen Mary*. She also writes non-fiction and is the founder of Women's PowerStrategy™ Conference. www.TheSecretSpice.com

Jessica Dougherty and her husband Joe own Funky Finds. They host handmade and vintage markets twice a year in Fort Worth, Texas and are dedicated to promoting small business owners that include makers, pickers, and independent authors. The rest of the year they enjoy their quiet home outside Jefferson with their son Connor. Jessica and Connor have enjoyed reading together since the day he was born and enjoy books compliments of the Dolly Parton Imagination Library that became the local Rotary club's passion project under the direction of Kathy Murphy.

Introduced to books as a toddler by her parents, **Sharon Feldt** has had a seventy-year love affair with literature. She grew up with Golden Books, Nancy Drew, Jack London, Rudyard Kipling and Edgar Allen Poe. As a teacher she read thousands of books to her students. She taught them about the writing process and involved them in creative writing projects. When she retired in 2009, armed with a wealth of material from "the mouths of babes" she began to write her own books. She is the author of three children's books: *The Stable*, *The Scary Hair of Sarah O'Shea*, and *Sarah O'Shea and the Wacky Faucet*. Three more await publication. Sharon has written magazine articles, published poetry, and currently contributes monthly articles to a community newspaper, *The Community*

Chronicle. Her work is also published in the Silver Leos Writers Guild Anthology *Storyteller Road*. She assisted students in a creative writing class, The Write Stuff, with the publication of an anthology of their works: *Tales from The Treehouse*. January 2019 she launched the first issue of an area magazine, FENCEPOST, of which she is editor-in-chief. She lives with her husband in a rural North East Texas community with their two cats, Willie and Waldo, who also love books. They are the mascots of the Bright Star Literary Society book club, which has met continuously at the Feldt home every month for the past ten years. The love affair continues.

Jamie Ford's debut novel, *Hotel on the Corner of Bitter and Sweet*, spent two years on the *New York Times* bestseller list and went on to win the Asian/Pacific American Award for Literature. His second book, *Songs of Willow Frost*, was also a national bestseller. His work has been translated into 35 languages. (He's still holding out for Klingon, because that's when you know you've made it.) His latest novel, *Love and Other Consolation Prizes* was published September 12, 2017. When not writing or daydreaming, he can be found tweeting @jamieford and posting on Instagram @jamiefordofficial.

Joe Formichella is the author of five novels, including the current *Lumpers, Longnecks and One-Eyed Jacks*; and three works of non-fiction. *Here's to You, Jackie Robinson: The Legend of the Prichard Mohawks*, a 2005 PQ pick, was re-released as *A Condition of Freedom*. *Murder Creek* was a *Foreword* magazine nonfiction book of

the year and a finalist for a national IPPY award for true crime. His novel *Waffle House Rules* was a PQ pick in 2019 and a county-wide read for the Alabama bicentennial. Joe lives near Fairhope, Alabama, with his wife, author Suzanne Hudson at Waterhole Branch Productions, where he also does audio work for authors via ACX and for entities like Radio Archives. Contact joe_formichella@yahoo.com, and both his personal and the Waterhole Branch Productions Facebook pages.

Claire Fullerton is from Memphis, Tennessee, and now lives in Malibu, California. She is the author of *Mourning Dove, Dancing to an Irish Reel, A Portal in Time*, and a contributor to *A Southern Season*, with her novella, *Through an Autumn Window*. Her work has appeared in *Southern Writers Magazine, The Dead Mule of Southern Literature, Celtic Life International*, and others. She is represented by Julie Gwinn of The Seymour Literary Agency. www.clairefullerton.com

Connor Judson Garrett, 2017 Edward Readicker-Henderson Travel Classics Award recipient, honed his craft as an advertising copywriter in Los Angeles. He is the author of two poetry books—*Become The Fool* and *Life in Lyrics*, a collection of over 60 poems written on My Typewriter, the typewriter app he created. His writing has appeared in *Private Clubs Magazine* and ads for major brands such as Texas Pete and Ziprecruiter. His debut novel *Falling Up in The City of Angels* was released in the summer of 2019.

Echo Garrett's latest collaborations *Warrior's Code 001* and *Step Out, Step Up* have also been Pulpwood Queen picks. *My Orange Duffel Bag* won the 2013 American Society of Journalists & Authors Arlene Eisenberg Writing that Makes a Difference award given every three years. She was named 2013 Georgia Author of the Year by the National League of American Pen Women. *Why Don't They Just Get a Job? One Couple's Mission to End Poverty in their Community* won a 2010 silver IPPY award. Her work has been published in 100+ media outlets including *The New York Times, Delta Sky, Parade,* and *Success.*

Peter Golden is an award-winning journalist, historian, and novelist, and the author of nine books. He has interviewed Presidents Nixon, Ford, Reagan, and Bush (41); Secretaries of State Kissinger, Haig, and Shultz; Israeli Prime Ministers Rabin, Peres, and Shamir; and Soviet President Gorbachev. His third novel, *Nothing Is Forgotten*, was published in April 2018. He is currently working on a novel about John F. Kennedy during the 1950s.

Mark Green is an author, speaker and entrepreneur after completing a total of thirty-four years of service to the U.S Army, retiring as a Lieutenant Colonel. His education includes a law degree from William Taft University, Santa Ana California, and a master's degree in Organizational Management from Concordia University St. Paul. He now dedicates his time to helping fellow veterans and their families obtain remarkable resilience and experience triumphant transition. He is a published author of two books along with

co-author Echo Montgomery Garrett: *STEP OUT, STEP UP: Lessons Learned from a Lifetime of Transitions and Military Service* and *WARRIOR'S CODE 001: 7 Steps to Vital Resiliency*, which were developed from his experiences. He has four wonderful children, two boys and two girls. Mark resides in Florida with his son Adam and wife Denise.

Jim Grimsley is a playwright and novelist who lives in Goldsboro, North Carolina, after teaching for twenty years in Emory University's creative writing program. He is the author of *Winter Birds, Dream Boy*, and *How I Shed My Skin*, a memoir. He has received numerous awards for his writing, including an Academy Award in Literature from the American Academy of Arts and Letters.

Jonathan Haupt is the executive director of the Pat Conroy Literary Center, the founding director of the annual Pat Conroy Literary Festival, and the former director of the University of South Carolina Press, where he created the Story River Books fiction imprint with Pat Conroy. With novelist and artist Nicole Seitz, he is co-editor of the anthology *Our Prince of Scribes: Writers Remember Pat Conroy*, published by the University of Georgia Press and awarded a Silver Medal for Best Regional Nonfiction by the Independent Publisher Book Awards. Haupt's articles, book reviews, and author interviews have appeared in the *Charleston Post & Courier, Beaufort Lowcountry Weekly, Beaufort Lifestyle* magazine, *Pink* magazine, *Shrimp, Collards & Grits* magazine, *Fall Lines* literary journal, and the Conroy Center's *Porch Talk* blog. He serves as an associate producer and consultant to the SCETV author interview program *By the River,* on the board of

directors of the South Carolina Academy of Authors and the Friends of South Carolina Libraries, on the American Writers Museum affiliates steering committee, and the South Carolina Humanities advisory committee. He lives in Beaufort, South Carolina, with his wife and their pack of rescued pets.

Jennie Miller Helderman is an award-winning writer who transplanted from Alabama to Atlanta in her gray-haired years. She's a Pushcart Prize nominee who has written four nonfiction books and many magazine articles. Her profile of the Sandy Hook teacher who saved her first-graders won national honors. Jennie is also an advocate for women's and children's issues from the grassroots to the national level. Her nonfiction narrative, *As the Sycamore Grows*, about Ginger McNeil's escape from abuse in a padlocked cabin without a phone or electricity, was voted Bonus Book of the Year by the Pulpwood Queens Book Clubs in 2012.

Mary Ann Henry writes women's fiction that "turns conventional ideas about Southern womanhood on their heads." (Kirkus) Freely admitting to being an unconventional Southern, female character herself, she is passionate about trees, enjoys solo and adventure travel, studying spirituality in other cultures, and helping new authors find their voices via national and international writing workshops. Her short story collection, *Ladies in Low Places*, was a featured book with the Pulpwood Queens Book Club in 2016. She divides her time between the ocean and the mountains and is currently polishing the final draft of a novel.

Kathy Hepinstall is the author of eight published novels, six literary fiction titles and two young adult novels (published under the name of Kathy Parks). She and her sister Becky, co-writer of the 2015 novel *Sisters of Shiloh*, are longtime fans of Kathy Murphy and the Pulpwood Queens. Kathy's latest novel, *The Book of Polly*, was Costco's National Book of the Month in March 2018. She lives in Austin, Texas with her husband, Michael.

Becky Hepinstall holds a bachelor's degree in history from the University of Texas at Austin and is a member of the National History Honor Society, Phi Alpha Theta. She lives in Ridgecrest, California with her husband, Jesse, and their four children. She is the proud new mother of a very rambunctious puppy and is very tired.

Betty Herndon and her husband Jim have two grown children and one grandchild. They moved to Linden, Texas in 2012 after Betty retired from MCI Financial Services in Dallas, where she was a vice president and contracts administrator. She loves sitting on her front porch and reading or playing with her two dogs (Jerry Lee and Ernest Tubb), or just listening to the birds chirping and watching the dragonflies flitting around. She loves to travel and has been to all the lower forty-eight states as well as most of the Canadian provinces and several foreign countries. Betty is always ready and willing to take the next trip!

Named #2 in the most recent listing of the top *100 Reasons to Love Nashville* by Nashville Lifestyles magazine, **Robert Hicks** was de-

scribed as Nashville's "Master of Ceremonies." They went on to say that "being a *New York Times* best-selling author should be enough—but not for Robert Hicks, award-winning author of *The Widow of the South, A Separate Country* and *The Orphan Mother.* His passion for words is equaled by one for preservation, saving the history-steeped places associated with the Battle of Franklin. Born in South Florida, he moved to Williamson County, Tennessee in 1974 and lives near the Bingham Community at "Labor in Vain," his log cabin. A lifelong collector, Hicks was the first Tennessean to be listed among *Arts & Antiques'* Top 100 Collectors in. In December 2005, the Nashville *Tennessean* named him "Tennessean of the Year" for the impact *The Widow of the South* has had on Tennessee, heritage tourism and preservation.

Laurel Davis Huber grew up in Oklahoma and Rhode Island. Her debut novel, *The Velveteen Daughter*, won the Langum Prize for American Historical Fiction. A former English teacher and college development officer, she now lives in New Jersey with her husband. She is working on her second novel.

Suzanne Hudson is the author of the short story collections *Opposable Thumbs* (finalist, John Gardner Fiction Award) and *All the Way to Memphis*. Her first novel, *In a Temple of Trees*, was re-released in 2017; and her second novel, *In the Dark of the Moon*, a PQ pick in 2005, was re-released in 2016. The author of 2018's *Shoe Burnin' Season: A Womanifesto* (pseudonym: RP Saffire; a PQ pick in 2019), and 2019's *The Fall of the Nixon Administration*, a comic

novel, Hudson lives near Fairhope, Alabama, at Waterhole Branch Productions with her husband, author Joe Formichella. Contact rps.hudson@gmail.com, personal Facebook page, and the Waterhole Branch Productions Facebook Page.

Alexandra Jenkins is graduate of Texas A&M University, Texarkana, where she received a bachelor's degree in Mass Communications with a minor in English. Alexandra is currently working at a local print shop in Texarkana, Arkansas as a Customer Service Specialist. She hopes to return to school soon to pursue a master's degree, ultimately followed by a PhD. She is an avid reader and an aspiring author. Alexandra has worked as a personal assistant to Kathy Murphy for Girlfriend Weekend for the past two years.

River Jordan is the author of four critically acclaimed southern gothic novels and two spiritual memoirs: *Confessions of a Christian Mystic* and *Praying for Strangers*. The anthologies *Southern Writers on Writing*, *Southern Sin*, and *A Second Blooming* have featured her work. She travels the country speaking, is a regular contributor to *Psychology Today's* Spirituality blog, and hosts and produces the literary radio program *Clearstory*, which airs from Nashville, Tennessee, where she makes her home.

Cassandra King is an award-winning author of five novels and two nonfiction books in addition to numerous short stories, essays, and magazine articles. Her latest book, *Tell Me A Story* (William Morrow 2019), is a memoir about life with her late husband,

Pat Conroy. A native of LA (Lower Alabama), Cassandra resides in Beaufort, South Carolina, where she is honorary chair of the Pat Conroy Literary Center.

Bobbi Kornblit's award-winning second novel, *Red Carpet Rivals*, was inspired by her years in Hollywood before moving to Atlanta. She walked down glamorous red carpets with her late husband, Simon, a leading movie executive. Her debut book, *Shelter from the Texas Heat*, was set during the "Kennedy Camelot Years" to the present. It received the Best Book Women's Fiction NABE Pinnacle Achievement Award. Bobbi earned a B.A. from The University of Texas and a Master of Art in Professional Writing degree from Kennesaw State University. Kathy L. Murphy and the Pulpwood Queens hold a special place in her heart! www.BobbiKornblit.com.

Betty Koval has been a Pulpwood Queen since 2009 as the head Queen in Blytheville, Arkansas but has since moved to Decatur, Alabama. In Blytheville, she worked at the local Chamber of Commerce and helped start and maintain the local Dolly Parton Imagination Library, which puts books into the hands of children who otherwise would not have them available. Koval attends OLLI (Osher Lifelong Learning Institute) on the campus of University of Alabama Huntsville. She has two daughters and four grandsons. Koval was the recipient of the Doug Marlette Award at the 2019 Pulpwood Queen Girlfriend Weekend. This award is presented for a lifetime of promoting literacy.

Kacey Kowars teaches English at The First Academy in Orlando, Florida. He hosts The Kacey Kowars Show and has written two books in his "A Celebration of Words" series. His third book *A Celebration of Mysteries* will be published in December 2019. HIs wife, Sharon Foley, is an active member of the Pulpwood Queens. Kacey has been a Timber Guy since 2005.

Caroline Leavitt is the two-time *New York Times* Bestselling Author of *Is this Tomorrow* and *Pictures of You*. *Cruel Beautiful Year* was an Indie Next Pick, and a best book of the year from BlogCritics and The Pulpwood Queens. Visit her at www.carolineleavitt.com.

Marjorie Herrera Lewis is an award-winning sportswriter formerly with the *Dallas Morning News* and the *Fort Worth Star-Telegram*. While writing *When the Men Were Gone*, she became inspired to try her hand at coaching football, and was added to the Texas Wesleyan University football coaching staff in December 2016. Marjorie has degrees from Arizona State University, The University of Texas in Arlington, and Southern New Hampshire University. She also has an undergraduate certificate from Southern Methodist University, and a graduate certificate from Cornell University. She is married and has two grown daughters and one son-in-law.

Judithe Little's WWII-era historical novel *Wickwythe Hall* has been called part Downton Abbey, part Darkest Hour. *Wickwythe*

Hall has won numerous awards including the 2018 Next Generation Indie Book Awards for Historical Fiction and the 2018 IPPY Award for Best Regional Fiction (Europe), and was a Foreword INDIES 2018 Book of the Year Awards Winner—Honorable Mention. Judithe earned a Bachelor of Arts in Foreign Affairs from the University of Virginia. After studying at the Institute of European Studies and the Institut Catholique in Paris, France, and interning at the U.S. Department of State, she earned a law degree from the University of Virginia School of Law, where she was on the Editorial Board of the *Journal of International Law* and a Dillard Fellow. She is a practicing attorney and lives with her husband, three teenagers, and two dogs in Houston, Texas, where she's at work on her next historical novel set in France.

Bren McClain's debut novel, *One Good Mama Bone*, from Pat Conroy's Story River Books won the 2017 Willie Morris Award for Southern Fiction. It was also named Pulpwood Queen 2017 Book of the Year, a 2017 Great Group Reads by the Women's National Book Association, a Southeastern Independent Booksellers Association (SIBA) Okra pick, longlisted for SIBA's Southern Book Prize and a finalist for the 2018 Crook's Corner Prize. She is at work on her next, either titled *Miss Eula Bates* or *Took*, which received the gold medal for the Faulkner-Wisdom Novel-in-Progress.

Celeste Fletcher McHale lives in Central Louisiana on the thousand-acre farm that has been home to her family since 1858. She and her family raise registered Angus cattle plus a variety of goats,

chickens and whatever stray dogs or cats happen to wander up to the porch. When she isn't writing, she enjoys watching LSU play football, baseball and basketball...well, she enjoys it sometimes. Other times, she throws things at the TV and goes to confession a lot.

Laura Lane McNeal was born and raised in New Orleans, received two undergraduate degrees from SMU and an MBA from Tulane. She was an advertising executive, journalist and magazine editor who now enjoys writing full-time. Her debut novel *Dollbaby* was a 2015 Pat Conroy Fiction Awards Finalist, 2014 Goodreads Choice Awards Top Ten Finalist, *New York Post* Must Read, Indie Next Pick, SIBA Okra Pick, Library Reads Pick, and a *Southern Living* Summer 2016 Must Read, among others. *Dollbaby* has been optioned for film by Gulfstream Productions. She has recently completed two additional novels.

Susan Marquez is a professional freelance feature writer who resides in Madison, Mississippi. Curious by nature, writing gives her the excuse to ask questions and dive deeper to find the story-behind-the-story. Never did she imagine that one day she'd be writing her own story—a memoir that revolves around her daughter's unthinkable accident. A graduate of the University of Southern Mississippi with a degree in radio-TV-film, Susan enjoys encouraging other writers through her work as president of the Mississippi Writers Guild. "Being a member of the Pulpwood Queens Nation has opened many doors to me, and I'm forever grateful to Kathy Murphy for bringing this tribe of authors and readers together."

Michael Morris is the author of the award winning novel, *A Place Called Wiregrass*, and *Slow Way Home,* which was named one of the best novels of the year by the *Atlanta Journal-Constitution* and the *St. Louis Post-Dispatch*. His novella, *Live Like You Were Dying*, was a finalist for the Southern Book Critics Circle Award. *Publisher's Weekly* named his latest novel, *Man in the Blue Moon*, one of the best books of 2012 and the Pulpwood Queens voted it Book of the Year. He holds an MFA in Creative Writing from Spalding University and currently resides in Birmingham, Alabama.

Jennifer Mueller was a Peace Corps volunteer in Kenya a few years back. She traveled quite a bit. A lot of the places she's written about she's been to; a lot of them she hasn't. Memories of rafting on the Nile in Uganda, living in a Montana ghost town, Puerto Rican beaches, African safaris, Mayan ruins, European youth hostels, forts on the Ghana coast fill her scrapbooks. She still travels in her head every time she writes, even if she doesn't get out as much as she wishes. Jennifer currently lives in the Pacific Northwest and looks forward to filling many more pages.

Tiajuana Neel retired from the communication industry where she spent twenty-two years in sales and customer services. She was involved with the Pulpwood Queens almost from the beginning, volunteering in every way she could to help make the Girlfriend Weekend the most memorable experience, and in 2019 she was named Executive Director. In 2017 she won the Doug Marlette award for promoting literacy. She was a lifelong resident of

Longview, Texas where she lived with her husband Mark A. Neel and their cat Cissy, as well as two tarantulas, Stella and Luther. She's the mother of four children, eleven grandchildren, and twelve great grandchildren. She loved reading, crafts, traveling & entertaining. [Ed. Note: Tiajuana passed away on April 19, 2019. Read more about her in the Dedication in the front of the book.]

Award-winning author **J.L. Oakley** writes historical fiction spanning the mid-19th century to World War II, with characters standing up for something in their own time and place. Her writing has been recognized with a 2013 Bellingham Mayor's Arts Award, the 2013 Chanticleer Grand Prize for *Tree Soldier*, 2015 WILLA Silver Award for *Timber Rose* (Pulpwood Queen bonus book) and the 2016 Goethe Award Grand Prize for *The Jossing Affair*. *Mist-chimas* is a 2018 Will Rogers Silver Medallion winner. When not writing in noisy cafes and researching history, she demonstrates 19th century folkways at English Camp on San Juan Island.

Adrianne Pamplin is Secretary for the East Texas Poetry Society, and a state and nationally published poet. She has a BFA in Visual Arts and a minor in anthropology from University of Texas in Tyler. She was a career journalist in broadcasting and newspaper, earning first place awards from the Texas Associated Press Broadcasters, the Suburban Newspapers of America/Local Media Association, the Dallas Press Club, and Keep Texas Beautiful organization for her environmental coverage of North Richland Hills. Adrianne lives with husband Ed and two house rabbits in Longview, Texas.

She also enjoys playing dulcimer and tenor ukulele, and continuing with her visual art training.

Susan Peterson has loved to read for as long as she can remember, devouring Nancy Drew and the Bobbsey Twins before she moved on to Victoria Holt and gothic romance. Her younger brothers used to say all the books she read showed a girl running from a castle, and they weren't wrong. She has been married for 41 years, an Air Force wife for twenty of those years, and has one daughter. She was a teacher's aide for 29 years, and after she retired her reading world grew exponentially. She learned the importance of reviews and promoting authors, and in 2018 she began a Facebook group called Sue's Booking Agency. Nothing makes her happier than discovering new authors and introducing them to readers.

Gregory Erich Phillips is the author of two award winning novels, *Love of Finished Years* (2018) and *The Exile* (2019). Both were official book of the month selections for the Pulpwood Queens. He tells inspirational stories through strong, relatable characters that transcend time and place. He is also an accomplished tango dancer and musician. Gregory and his wife Rachel live in Seattle, Washington. Visit Gregory at www.gregoryerichphillips.com.

Sandra Phillips lives in Marshall, Texas. She grew up on the banks of the Big Cypress Bayou that flows into Caddo Lake. She was educated at a small country school, and then went to Stephen F. Austin State University. Sandra is retired and enjoys traveling, photogra-

phy, water sports, gardening, and reading. She has been a member of the Pulpwood Queens of East Texas for almost twenty years.

Rickey E. Pittman, the Bard of the South, is a storyteller, author, and folksinger. He was the Grand Prize Winner of the 1998 Ernest Hemingway Short Story Competition, and is originally from Dallas, Texas. Pittman presents his stories, music and programs at schools, libraries, organizations, museums, historical reenactments, restaurants, banquets, and Celtic festivals throughout the South. An adjunct college English instructor with an M.A. from Abilene Christian University, he has fourteen published books, four music CDs and several single digital releases.

Lt Col Terry E. Pursell is a USAF retired pilot living in Enid, Oklahoma with his wife of fifty years, Jan. He grew up in the Kansas Flint Hills and graduated from Emporia High School. He has a B.A. in Mathematics, and an M.A. in Management and Business Administration. Terry served twenty-two years as an Air Force pilot, and twenty years as an airline pilot, retiring from Delta Air Lines in 2015. His travels have taken him to thirty-five countries. Terry and Jan have two children, Lori Moreno and Casey Pursell, and four grandchildren. In retirement, Terry enjoys golf, cards, and travel with his family.

Alyson Richman is the number one international bestselling author of seven novels including *The Velvet Hours*, *The Garden of Letters*, and *The Lost Wife*. She is a graduate of Wellesley College

and a former Thomas J. Watson Fellow. Her novels have been published in twenty languages and have been bestsellers in several countries. *The Lost Wife* is currently in development to be a major motion picture.

Paul Roberson has been an online marketing practitioner for over ten years. He is currently helping authors build better business models through creative digital marketing. He also functions as the webmaster for the Pulpwood Queens Book Club.

A California native, **Rebecca Rosenberg** lives on a lavender farm with her family in Sonoma, the Valley of the Moon, where Jack London wrote from his Beauty Ranch. Rebecca is a long-time student of Jack London's works and an avid fan of his daring wife, Charmian London. Her books include *The Secret Life of Mrs. London, Lavender Fields of America, Gold Digger, The Remarkable Baby Doe Tabor, Silver Dollar (2020), Champagne Widows (2021)*

Clare Sera's childhood love of books became a love of all things story including theatre and film, where she finally settled as a writer. Her screenwriting credits include the family films *Blended* and *Smallfoot* and it is her pride and joy to have penned the script for the film version of *The Pulpwood Queen's Tiara Wearing, Book Sharing Guide to Life* for Dreamworks Pictures. Fingers crossed it gets made soon.

Brownie Shott was born and raised in Darlington, South Carolina, but has lived with her husband, Tom, in Katy, Texas for the past thirty-six years. They have two sons, one who lives with them and one who is a jewelry designer in New York City, which provides a wonderful excuse to visit the Big Apple as often as possible. She and her husband own an advertising company and a bookkeeping company. Brownie has served on the Executive Board of the CHARGE Syndrome Foundation for the past twenty-two years. She loves to travel and turns every business trip into a short adventure. She is blessed with wonderful girlfriends some of whom she met as a result of being a Pulpwood Queen!

Shari Stauch, Founder and CEO of Where Writers Win (WritersWin.com), has been involved in publishing, marketing, and PR for thirty-five years, as an author, publisher, and author marketing consultant. She created Where Writers Win to help emerging authors and independent publishers grow their audiences. In March 2019 she opened Main Street Reads (MainStreetReads.com), an independent bookstore in historic Summerville, South Carolina, just outside Charleston. The store and website both feature a prominent display of Pulpwood Queens selected books!

Kathryn Taylor was born at the Great Lakes Naval Station near Chicago, Illinois and spent much of her life in the Chicagoland area. She is a retired teacher and taught in schools in Illinois, California, and Virginia before her retirement and relocation to South Carolina. It was there she wrote her book, *Two Minus One: A Memoir,* following the unexpected abandonment by her second husband.

An avid reader, enthusiastic traveler, and incurable beach lover, she resides outside of Charleston, South Carolina, which affords her the opportunity to enjoy all three of her favorite past times. This is her first book.

Heidi Surber Teichgraeber grew up in Eureka, Kansas, where she attended the public schools and graduated from high school. Heidi then continued her education at Kansas State University and graduated with a BS in Music Education. She has taught all grade levels of vocal music in public and private school and is currently an adjunct voice teacher at Butler County Community College in El Dorado, Kansas. Heidi has been an active volunteer in her community. She has worked with children and adults through church, 4-H and community choral performances. Heidi is a member of Christ Lutheran Church where she is director of vocal music and a member of CLC Council. She has been a board member of Stage One Productions, Wichita, the Kansas State University Choir Advisory Council, MENC, and KMEA, as well as numerous study clubs and organizations in Eureka. Heidi is married to Art and resides with him on their ranch outside of Eureka. They have four daughters, Alexa, Veronika, Mischa and Felicia. She enjoys traveling, reading, walking, horseback riding and singing.

Helen Thompson is a wife, mother and grandmother who spent thirty plus years in the classroom and library. Retirement didn't go well, so now she's the Director of the Public Library in Mount Pleasant, Texas. If she had spare time, she would spend it reading. If she had spare money, she would spend it looking for Frances

Mayes in Italy. One of her twin boys worked ten years in Italy. Visiting him made her want to go back and stay and stay and stay. Until then, her plan is to continue to enjoy her family.

Jo Anne Tidwell moved to Louisiana from Pennsylvania when she was nine years old. She has been married for fifty years, has two children, five grandchildren, and three great grandchildren! Their thirtieth anniversary found Jo Anne and her husband in the middle of the Atlantic Ocean being filmed for a National Geographic documentary about her husband's search and location of the World War II Japanese submarine, I-52 (The Search for Submarine I-52). *National Geographic* also featured this expedition in their magazine (Oct. 1999). Jo Anne worked at United Airlines in Virginia and moved back to Louisiana after retirement, and eventually to the small, quaint and charming town of Jefferson, Texas, where she has been a member of the Pulpwood Queens Book Club for many years. Life is good.

Carolyn Turgeon is the author of five novels—*Rain Village, Godmother, Mermaid, The Fairest of Them All*, and *The Next Full Moon*, most of them based on old-time fairy tales—and, more recently, *The Faerie Handbook, The Mermaid Handbook*, and the upcoming *The Unicorn Handbook*. She's also the editor in chief of *Enchanted Living* (formerly *Faerie Magazine*). She lives in Baltimore. See more at carolynturgeon.com.

Jonni Webb is a potter/artist, publisher, Pulpwood Queen and a puppy lover. She spends countless hours in her pottery studio listening to audio books while plying her trade. Coming from a pub-

lishing/advertising background (*Coffee News* and Front Desk USA Travel Maps), Jonni started her pottery career to showcase her creative side and to try to keep her sanity. Her work can be found at www.jrwebbart.com. She lives in Mississippi with her guy Tom, her two dogs, Cole and Oliver, and is Head Queen of the BBQueens of Jackson, Mississippi.

Bestselling author **Barbara Claypole White** writes hopeful family drama with a healthy dose of mental illness. Born in England, she works and gardens in the forests of North Carolina, where she lives with her family. Her novels include: *The Unfinished Garden*, which won the Golden Quill for Best First Book; *The In-Between Hour*, a SIBA Okra Pick; *The Perfect Son*, a Goodreads Choice Awards Semi-finalist; *Echoes of Family*, a WFWA Star Award Finalist; and *The Promise Between Us*, a 2018 Nautilus Award Winner. Barbara is an OCD advocate for the nonprofit A2A Alliance, which promotes advocacy over adversity. To connect with her, please visit www. barbaraclaypolewhite.com.

Spur Award winner **Reavis Z. Wortham** is the author of the critically acclaimed Red River historical mystery series. *Kirkus Reviews* listed his first novel, *The Rock Hole*, as one of their Top 12 Mysteries of 2011. *True West Magazine* included *Dark Places* as one of 2015's Top 12 Modern Westerns. Wortham's new high octane contemporary western series from Kensington Publishing, featuring Texas Ranger Sonny Hawke, kicked off in 2017 with the publication of *Hawke's Prey*. The second Sonny Hawke thriller, *Hawke's War*, won the 2019 Western Writers Association's Spur Award in the Best Mass Market Paperback category.

The Editor

Susan Cushman is editor of two previous anthologies: *Southern Writers on Writing* (University Press of Mississippi 2018) and *A Second Blooming: Becoming the Women We Are Meant to Be* (Mercer University Press 2017). She is author of a short story collection, *Friends of the Library*, a novel, *Cherry Bomb*, and a memoir, *Tangles and Plaques: A Mother and Daughter Face Alzheimer's*. Four of her books are official Pulpwood Queens book club selections, and she has been an invited author at three Pulpwood Queens Girlfriend Weekends. Her essays have been published in four anthologies and numerous journals and magazines. Cushman was co-director of the 2013 and 2010 Creative Nonfiction Conferences in Oxford, Mississippi, and director of the 2011 Memphis Creative Nonfiction Workshop. She has led writing workshops in Tennessee, Mississippi, and Alabama, and spoken on panels at literary festivals in Tennessee, Mississippi, Louisiana, Georgia, Alabama, and South Carolina. A native of Jackson, Mississippi, Cushman has lived in Memphis since 1988 with her husband William Cushman, with whom she will celebrate 50 years of marriage in June 2020. They have three grown children and four granddaughters.

Follow Cushman on her website: www.susancushman.com
read her personal blog: susancushman.com/author/susan/
and follow her on Facebook: www.facebook.com/sjcushman
Instagram: www.instagram.com/sjcushman,
and Twitter: twitter.com/SusanCushman

The Queen

Kathy L. Murphy is the founder of the Pulpwood Queens and Timber Guys Book Club Reading Nation, the largest "meeting and discussing" book club in the world. Murphy is the author of *The Pulpwood Queens' Tiara Wearing, Book Sharing Guide to Life* and its sequel, *The Pulpwood Queen Goes Back to School* (coming in 2020). DreamWorks optioned her first book to film to be called, "The Pulpwood Queen." She was the host of the online talk show featuring her authors, "The Beauty and the Book Show," sponsored by Random House Publishing. Filmmaker William Torgerson did a documentary of her annual Pulpwood Queen Girlfriend Weekend Book Club convention, "For the Love of Books," which won the Audience Choice Award at the Phenom International Film Festival in Shreveport/Bossier City, Louisiana. She is the two-time winner of The Lucile Micheels Pannell Award given to a bookseller for outstanding children's programming. She is also past recipient of The James Patterson Page-turner Award. She has been featured along with her book club on Oprah's Oxygen Network, The Oprah Winfrey Show, kicked off the "READ THIS" Book Club on "Good Morning America" with Diane Sawyer and Charlie Gipson, featured in *Newsweek, Time, The Wall Street Journal*, and *The Los Angeles Times*. In December 2017 Kathy L. Murphy graduated from the University of Texas in Tyler to receive her B.F.A in Fine Arts and minor in Art History. She lives in her little cabin in the woods, Murphy's Law, which also has on the property her art studio and art gallery, in the piney woods of East Texas.

www.thepulpwoodqueens.com

www.facebook.com/Pulpwoodqueen

www.twitter.com/Pulpwoodqueen

www.instagram.com/thepulpwoodqueen

www.shopvida.com/collections/thepulpwoodqueen

CPSIA information can be obtained
at www.ICGtesting.com
Printed in the USA
LVHW031401050120
642559LV00015B/1208/P